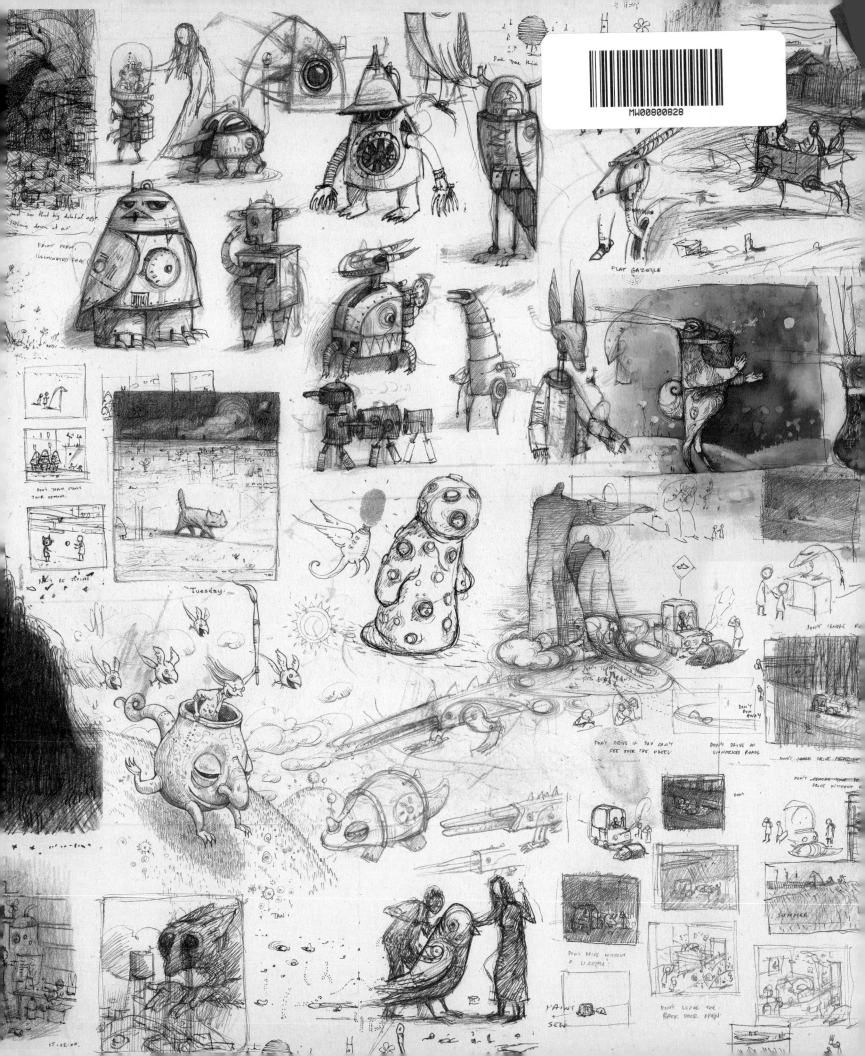

For Gary 'Gazman' Crew,
a bright light in the dark.

CREATURE

PAINTINGS, DRAWINGS, AND REFLECTIONS

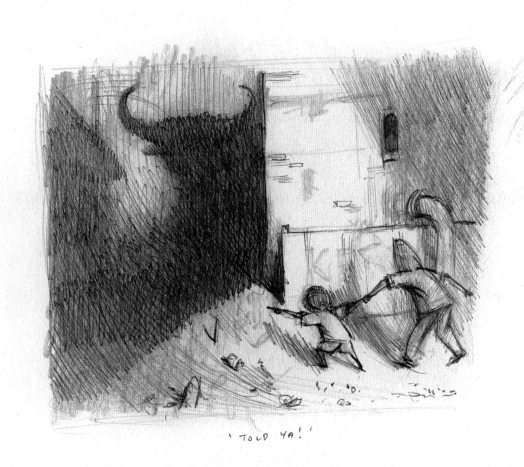

'TOLD YA!'

LQ

LEVINE QUERIDO

MONTCLAIR | AMSTERDAM | HOBOKEN

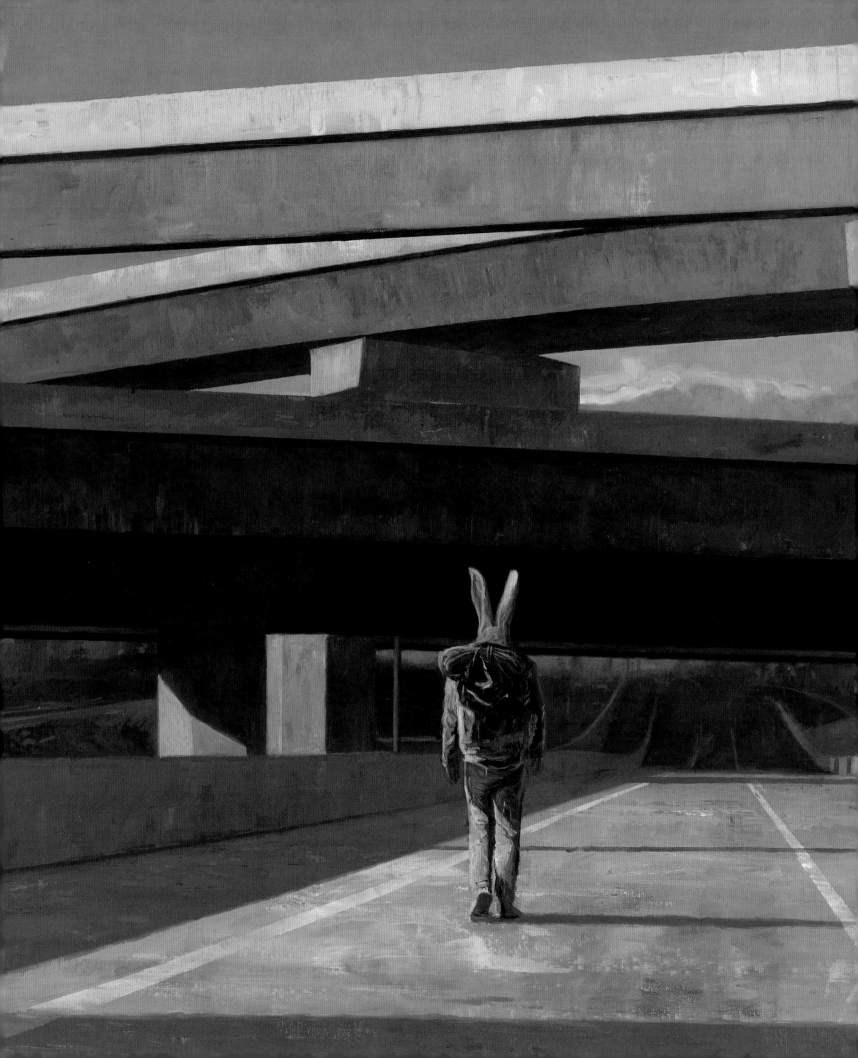

SHAUN TAN CREATURE

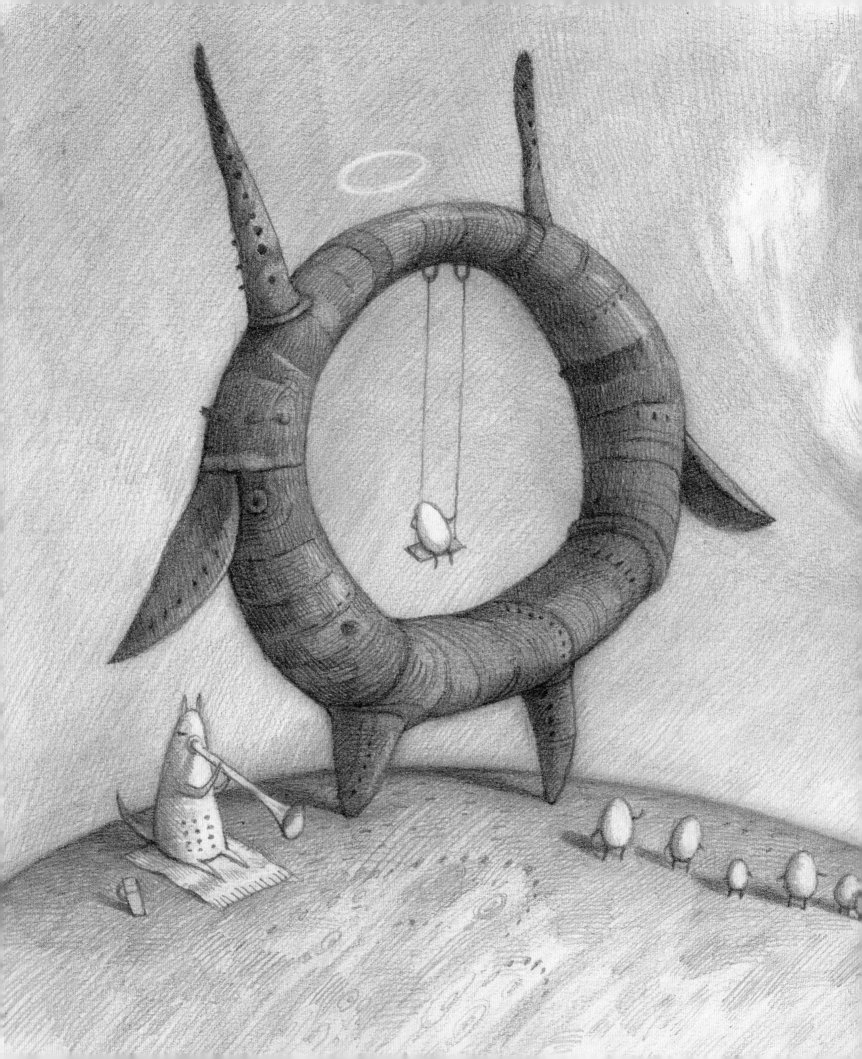

CONTENTS

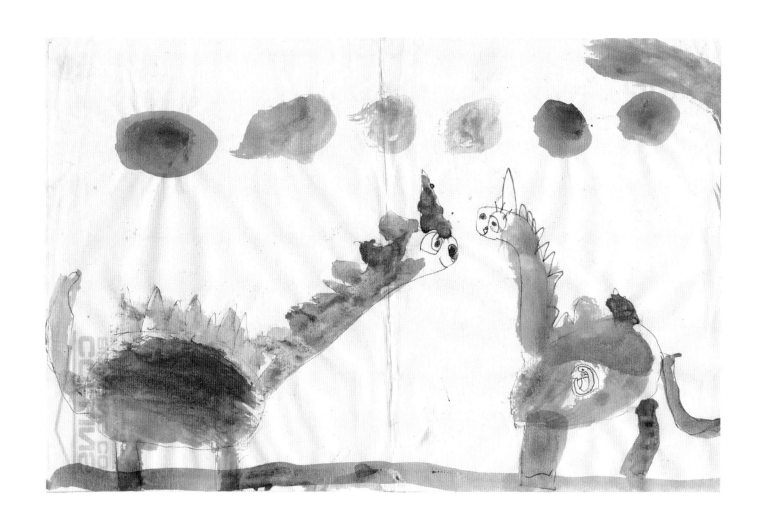

THREE DINOSAURS, 1977

INTRODUCTION

The first thing I remember drawing was a creature. While this was not the first thing I ever drew, it's the first that I remember drawing, maybe because even at the age of three the action of the pen on the back of builder's stationery from my dad's office was so effortlessly urgent, and the daubs of watercolor so fun to apply. In the picture there are three dinosaurs: a mother, a father, and a baby, the last visible only as a small coil inside the mother's belly. I think it was a response to vague stories about babies and seeing in an encyclopedia a strange picture of an embryo, a thing that I myself must have been once upon a time, complete with a tail. In retrospect I suppose it's a picture about being human, the mystery of existence and the importance of family in perpetuating that mystery. At the time, of course, my mind entertained no such meaning, at least not consciously. I wanted only to draw a creature, grab a pen and paper, prop my elbows high on the dining table, and draw an eye, a mouth, a nose, a very long neck. Then the zigzag of a reptilian spine, and so on.

Not much has changed since. I'm still drawing creatures in all their myriad forms, something that feels perpetually childish in the best possible way: primary, elemental, instinctive—all the artistic qualities I've learned to trust through the trials and errors of so many ground-down pencil stubs. I draw many other things, but for some reason, when my mind and sketchbook are cleared of all else, I often revert to a creature, either known or unknown. Given a lump of clay I will automatically render four legs or more, a tail, and proceed from there, as if my hands are thinking by themselves. After many revisions I might return to something more anthropocentric, even a straightforward human, as in the story of an immigrant in *The Arrival* (2006), which was originally conceived as a kind of bird-creature with an oversized suitcase. At every

beginning it's as if I need to throw the artistic pebble far across a pond of weirdness in order to see some meaning in the ripples, moving as they do back towards the shoreline of normalcy. Within that distant echo lies something intimate and familiar. Something that makes sense. Something human.

I don't think I'm alone here. We all have some fundamental attraction to nonhuman creatures, especially imaginary ones. Creatures are the abiding protagonists and antagonists of mythology, prehistoric cave drawings, chapel ceilings, and contemporary cinema. They are the agents of lore, the imaginings of explorers, scientists, and philosophers, the essential oil of fairy tales. They are, at a more primary level, the unresolved cast of our dreams, forever waiting offstage to emerge when we close our eyes and the curtain of night falls. In art and literature, fanciful creatures are the natural conduits for expressions of profound fear and love, along with every emotion in between, including those we find difficult to name. Especially those we find difficult to name.

The drawings in this volume refer to work produced over the past twenty-five years, in picture books and other story illustrations, including films and graphic novels. Others were created for no specific purpose beyond the desire to see what something looks like, or just to follow a sketched line to see where it goes, surely one of the simplest and most compelling reasons for drawing. In looking through old sketchbooks, folios, and canvas racks, the natural tendency is to search for a binding theme, if only to reduce the feeling of superficial randomness or check that the whole is larger than the sum of its parts. While that may be too much to ask—a certain randomness and incoherence seems part and parcel of any honest creative practice—at least one element persists like a recurring dream, a clue to some deeper preoccupation, and the subject of this collection. I struggle to think of any good story or image I've made over the years that does not contain a creature of one kind or another, going all the way back to the rows of clay and papier-mâché figurines I used to make as a child, lining garden beds and kitchen shelves or hanging from my bedroom ceiling on nearly invisible fishing lines, unbothered by gravity. Ever since childhood, the careful reality of any drawing often needed to be balanced by some odd little interloper, a glowing blue alien behind a wall or the illusion of hovering eyes in streetlights, a shadow of something curious draped across the foreground. Even my most straightforward observational sketches of local streets, parks, and houses will include a daub of paint or pencil jot on a wire or fence, the suggestion of a bird, butterfly, or snail—frequently the only imaginary element—quietly observing from the sidelines, as if such consciousness were necessary for the scene to exist in the first place. In more elaborate fictions these daubs and marks grow limbs, eyes, and tails. They take on new forms: junk robots,

faceless giants, unlikely pets, and displaced changelings, as well as more familiar terrestrial animals, albeit uncommon ones that feel out of place in urban life: water buffaloes, lungfish, crocodiles, bears.

Are these all permutations of the same basic idea? Maybe an attempt at self-portraiture, or representations of friends, family, day-to-day experiences, things I tend to avoid approaching in a direct, literal, straightforward way. I feel that this estrangement of character, uncluttered by recognition or familiarity, makes for a more satisfying examination, taps into more universal feeling, and is more open to reflection, as well as entertainment. Above all else, it's fun, a word that should be used far more often when talking about art and literature. It's fun to consider a life of office drudgery through a white-collar cicada instead of an ordinary human clerk. A tentacled freak on a beach touches some nerve of compassion that the depiction of a more conventional lost pet, like a dog or a cat, might not be able to access without predictable associations—and this too makes it fun. Mouthless, nonhuman heads offer a light invitation to deep conversation. Little clockwork animals are so full of the heart they are clearly missing. Nondescript beings in shadowy streets and lounge rooms long for our company, and for some intriguing reason that begs elaboration, we long for theirs.

Judging by the popularity of my stories involving creatures, from the odd stray in *The Lost Thing* (2000) to the nut-sized exchange student in *Eric* (2010), these feelings are as much universal as personal, and not weird at all. They also transcend age, being as interesting to very young readers as they are to very old ones, as well as to readers from diverse cultural and literary backgrounds. The true beauty of the nameless creature is that it can find meaning wherever it goes, allowing each reader to draw their own associations and interpretation in their private imagination, as much or as little as they wish. After all, a creature does not necessarily represent one thing or another; it just is. A mysterious being in a mysterious world, much like you and me, trying to fit in, trying to be unique, or just trying to make sense of things as best we can, to exist.

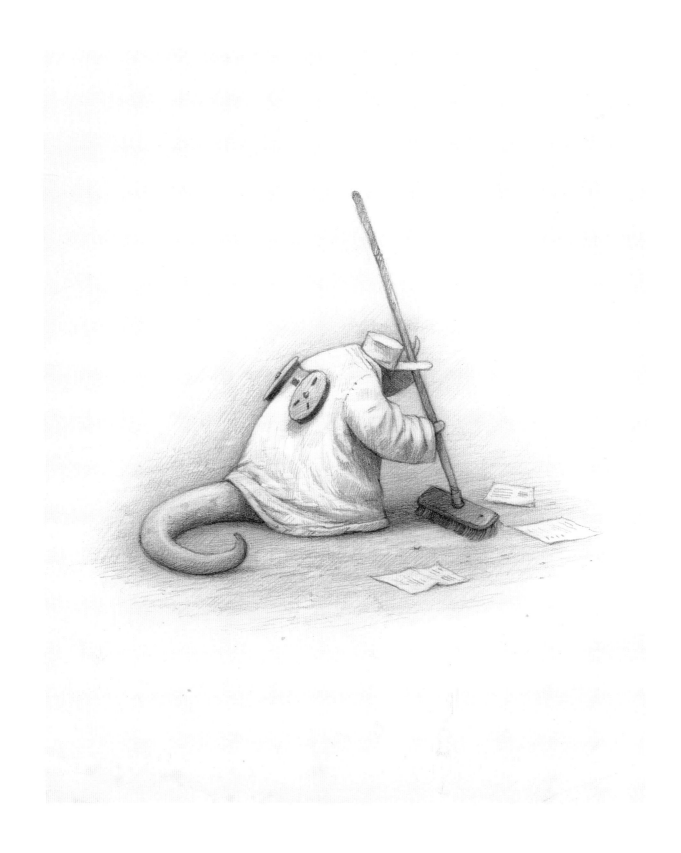

THE CLEANER

LOST THINGS

A world obsessed with prescriptive notions of belonging
is not such a great place to be.

The first picture book that I wrote and illustrated centered on a nameless, misplaced creature, a thing not unlike my artistic practice at the time. I had recently finished a degree in fine arts and English literature, which for all its academic buoyancy left me somewhat rudderless in the job market. I'd managed to scrape a basic living as a freelance illustrator by skipping between science fiction and children's publishing, as well as by painting a number of landscapes for my own interest when paying work was thin. Galleries were not very interested in these, and as a commercial illustrator I was increasingly working myself into a stylistic corner seeking the approval of clients, creating art that was professional but personally meaningless, a familiar hazard of the job. The avenues for genuine artistic expression in that field, especially in suburban Perth, where I was living at the time, seemed narrow to the point of closure. But this problem possibly papered over an even bigger one. Did I have anything worth expressing in the first place?

Certainly a feeling of creative need without clear direction is well known to many people with artistic inclinations. Eventually it dawned on me that this feeling was as sincere as any other, possibly even interesting. On the periphery of my paid work, I'd been doodling strange, faceless, weak-limbed animal-machines, mainly for my own amusement, without regarding them as particularly noteworthy. But I kept drawing them, kept thinking about them, kept seeing something truthful in them, these little creatures I called "things for people with more important things to pay attention to." The obsession grew and later became the subtitle of a resulting picture book entitled *The Lost Thing* (2000). Ironically, this came to be my most important work, emerging from a period of deep uncertainty, still in print decades later, widely translated and adapted as a successful short film. It also bears mentioning that my other "proper" freelance work of that time has since dissolved into obscurity.

The story concerns a boy who finds a large, unidentifiable creature on a beach. Believing it to be lost, he sets out to find it a home, but nobody else wants to know about it—not friends, family, or even the government—and understandably so.

It has no real function or meaning and is inconveniently large, hard to feed, and obscure to the point of invisibility. After a short misadventure, the story resolves, and the Lost Thing finds a sanctuary. The boy, however, returns to his far less inspiring "proper" life. Importantly, the central question of belonging persists. The rescued creature remains resolutely a "lost thing," but all the better for it, because a world obsessed with prescriptive notions of belonging is not such a great place to be. This story set the philosophical tone for many other books and paintings I've developed since.

Readers routinely ask if my "lost things" represent anything. I would say yes, but my thoughts on what that is exactly have changed often since the book was first published. In collecting all my drawings of lost things produced over the years, I'd suggest that they have something to do with the act of drawing itself. At its best, a good drawing has no purpose or place. It's not solicited or commissioned, it does not satisfy an existing need, it does not convey a message, it is often the most unassuming of doodles. It does, however, seek to reflect on some sincere observation or feeling. It tries to suggest something real in the only way it legitimately can: by being self-consciously unreal and peripheral, even absurd.

In the case of these strange, semi-mechanical creatures, that feeling is one of equal delight and disquiet. I think that has something to do with the division between culture and nature that we see every day, the conflict between human society and nature, where modern industry is so often at odds with its own support system, railing against the cyclical patterns of land, climate, and all living things. Everywhere we see a great river of invention on its way to a landfill—appliances, furniture, gadgets—a planned obsolescence that is reflected in the redundant technology of my critters, the mutant children of some antique future.

In the original story, I imagined a place in which nothing natural remains, only people and machines, a larger metaphor for a deficiency of spirit, as I think this also entails the death of art, music, and literature, and of imagination. Everything has a clear purpose, meaning, and place, but nobody recalls the overarching reason for this, or has the time or space to think about it even if they did. They are too busy doing "more important things" in some fundamentalist way. Into this world the lost things appear as strange extrusions, wriggling question marks, flowers growing from cracks. They don't know what they are and have no real meaning or purpose. In short, they are moments of hope, of unconstrained meaning, of something new emerging in a discordant world, a reminder that life—and artistic need—will always find a way.

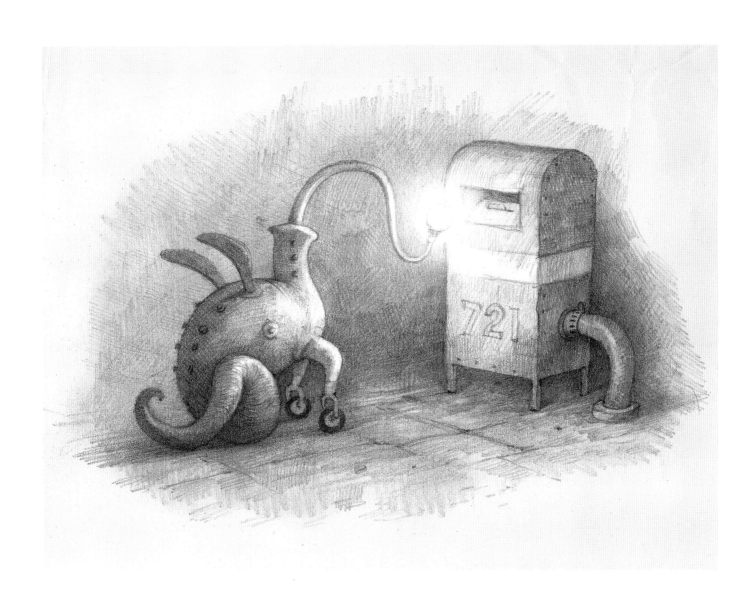

LIGHT CHICKEN ASKING FOR DIRECTIONS

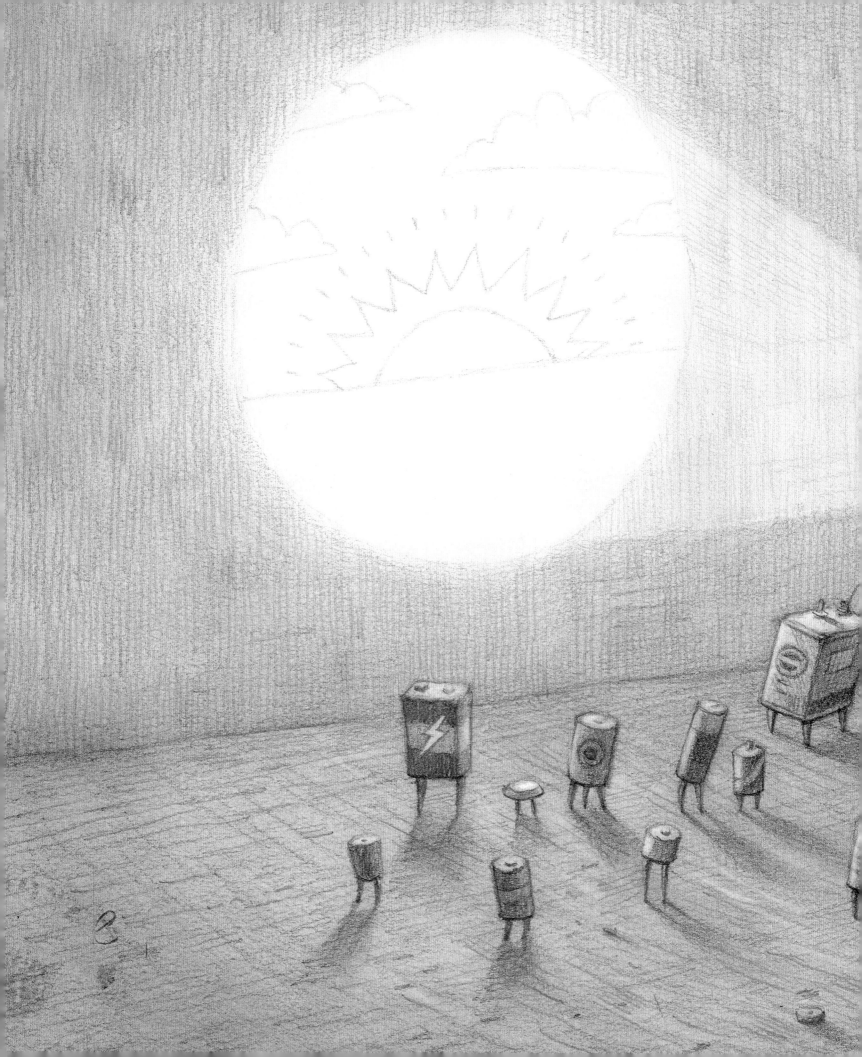

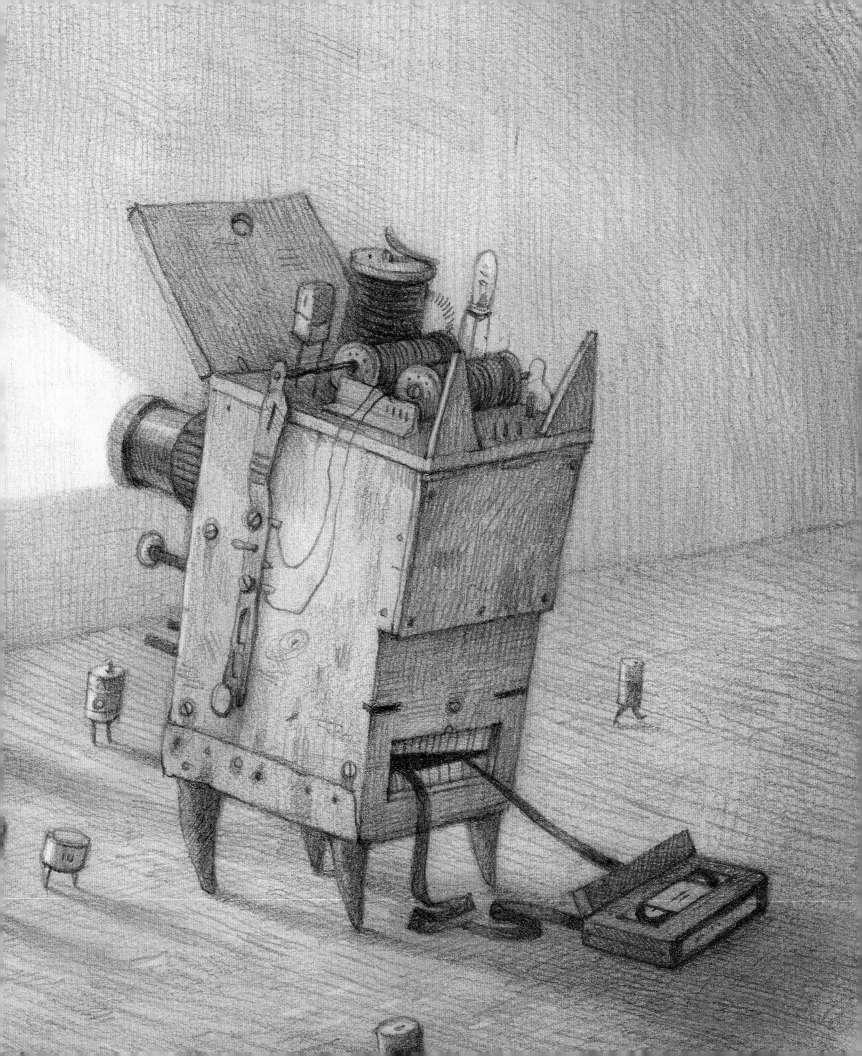

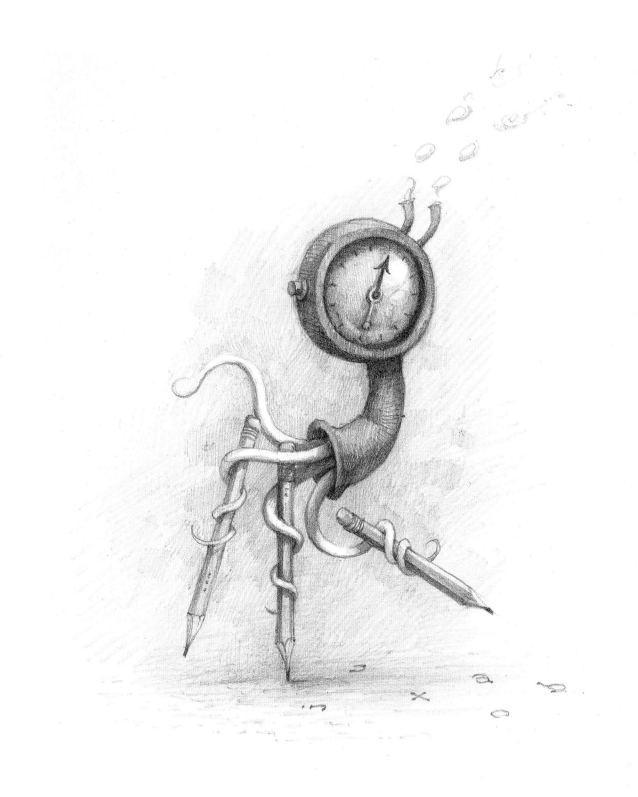

Previous: A MEMORY OF LIGHT | *Above:* WRITER

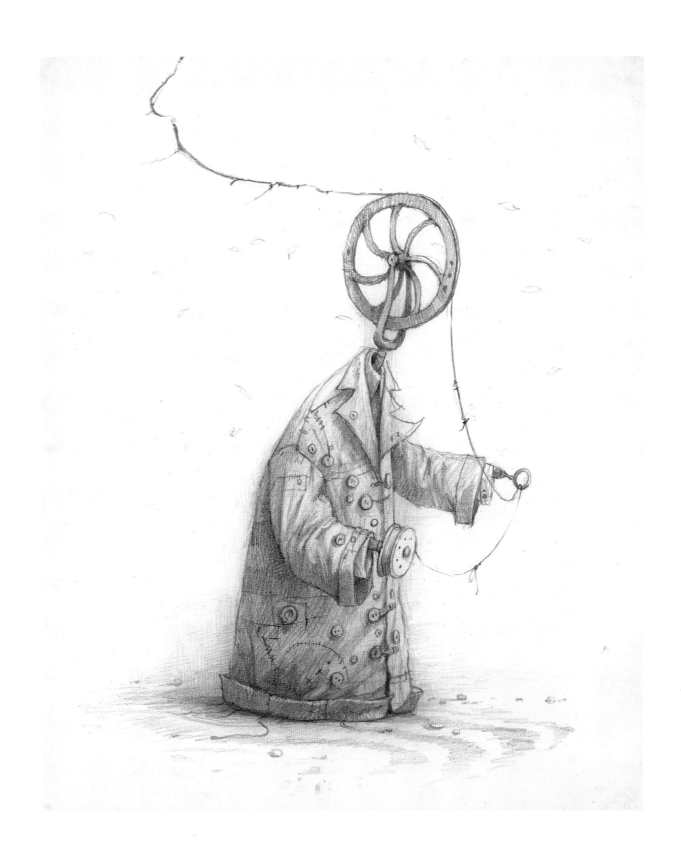

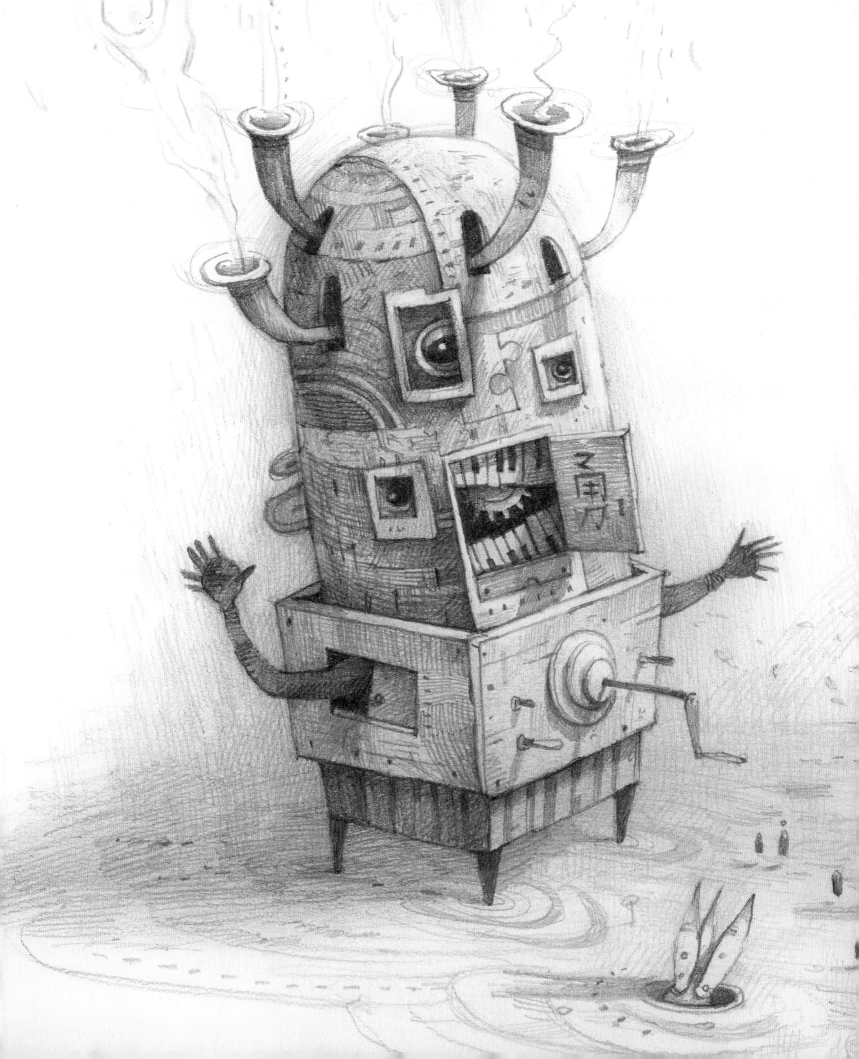

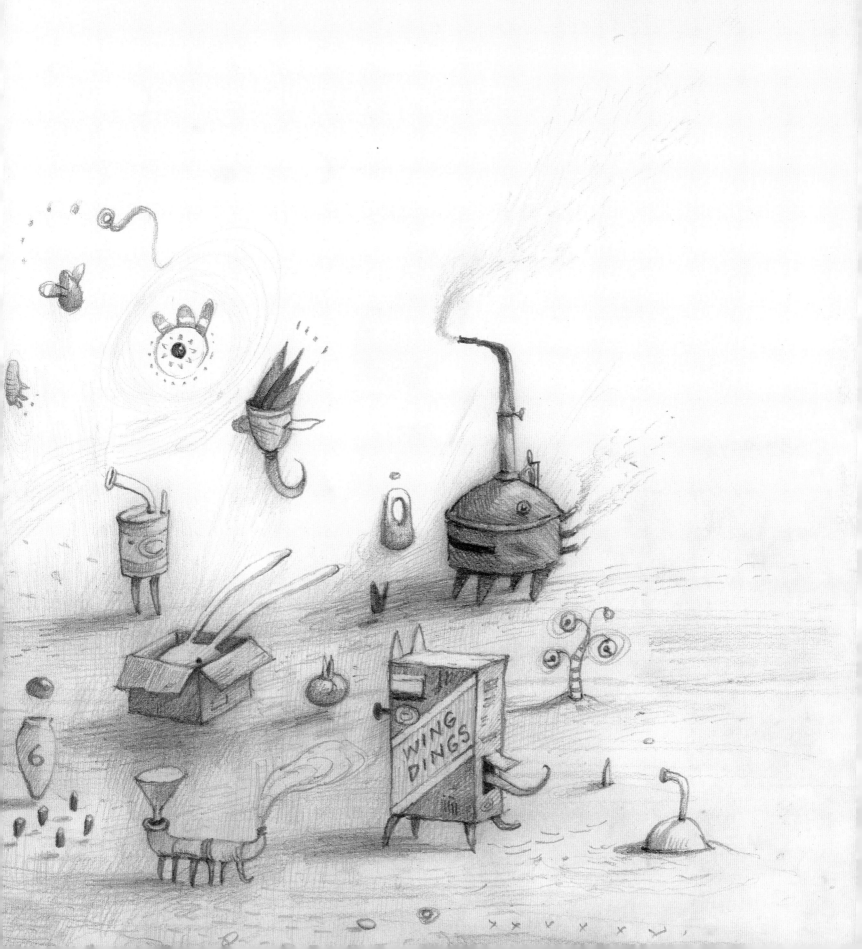

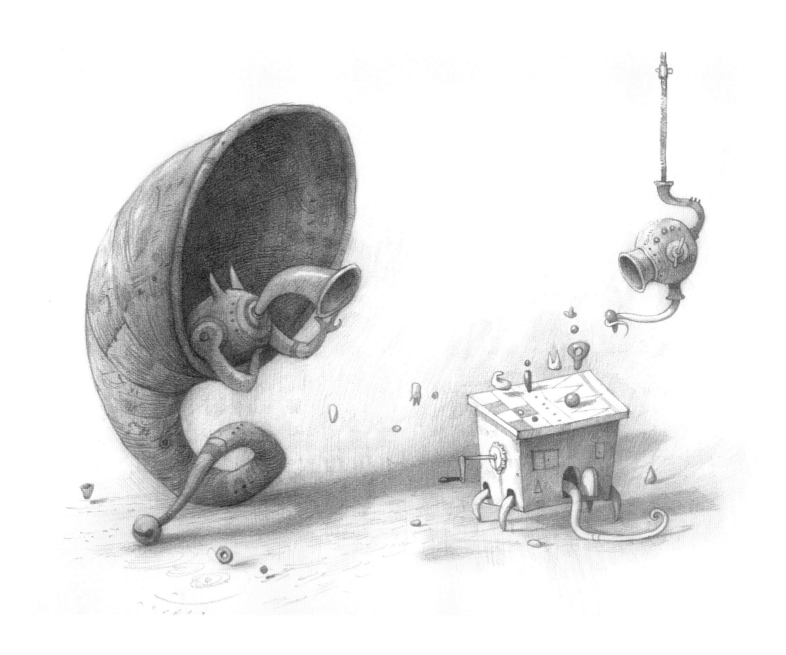

HERMIT HORN, FRONTGAMMON TURTLE AND DEEP-AIR DIVING BELL

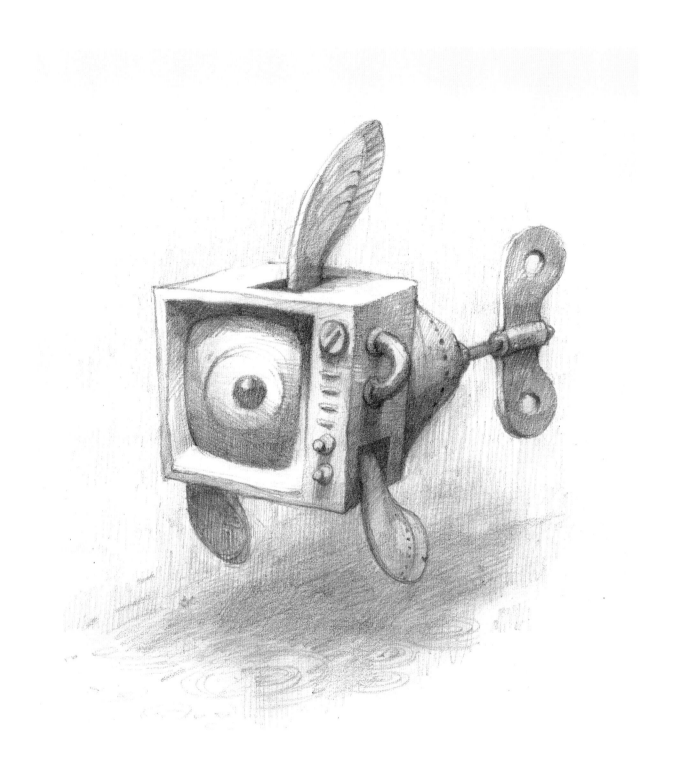

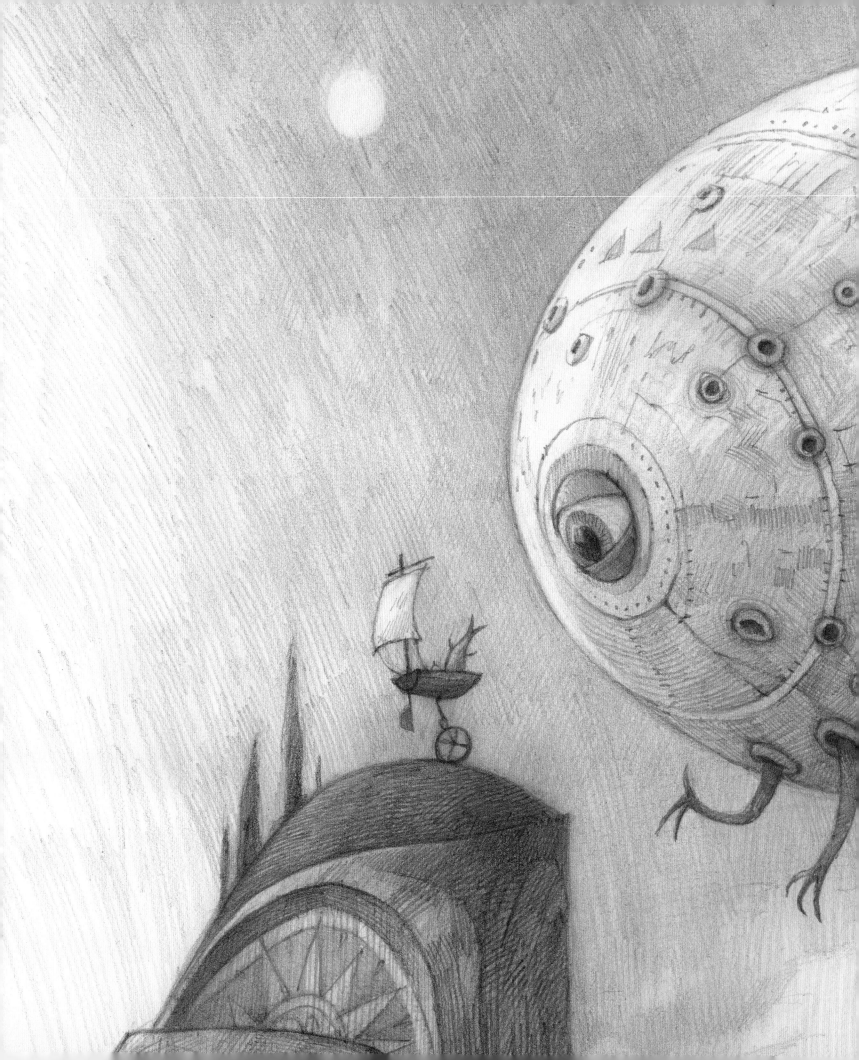

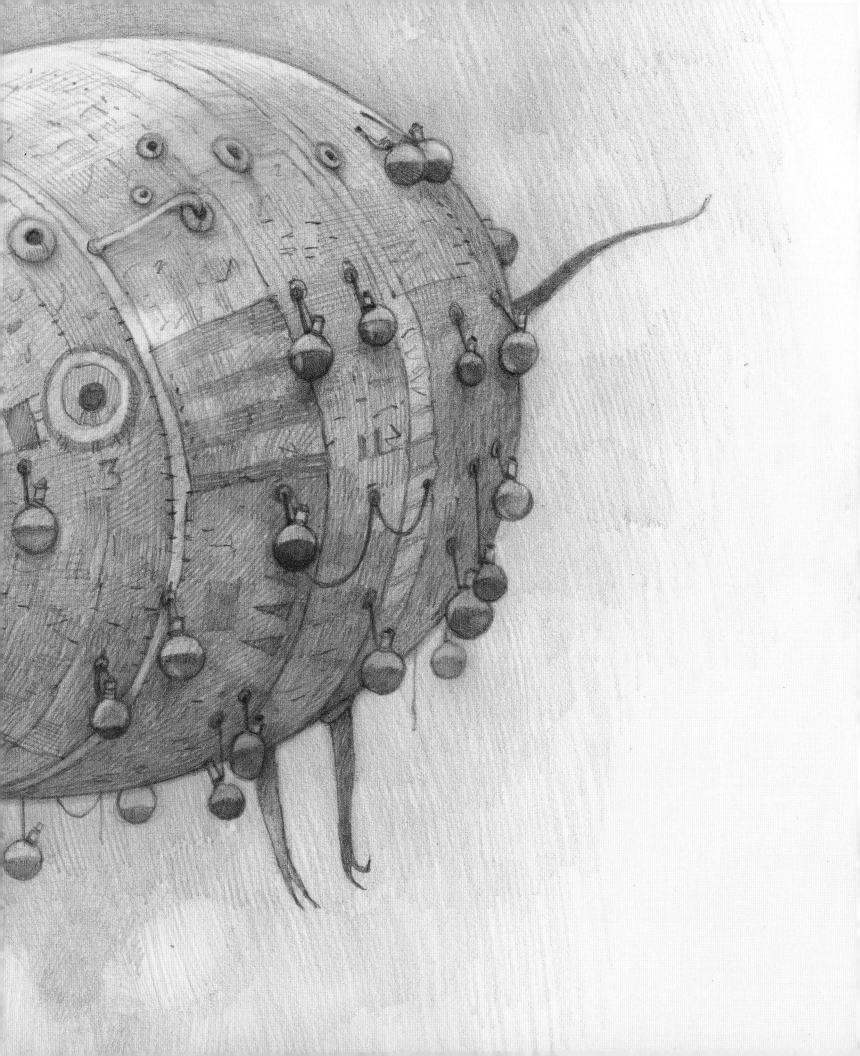

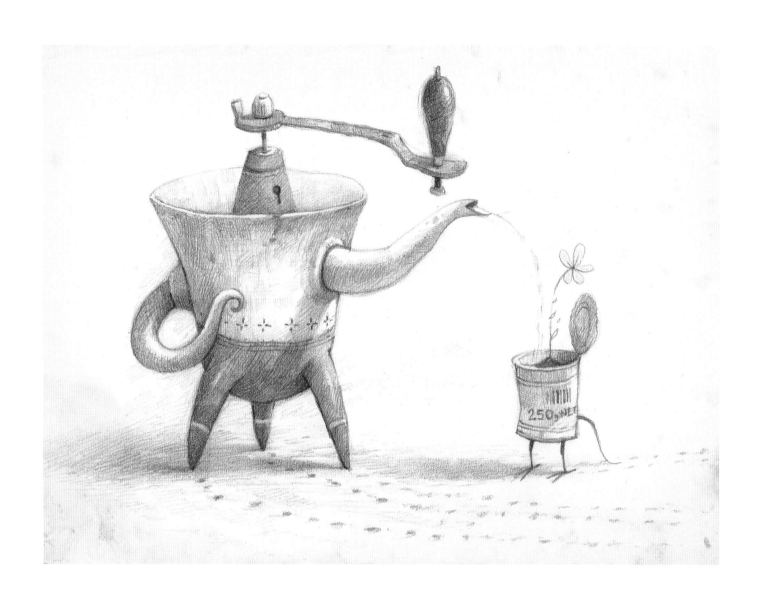

WATER GRINDER AND PROTÉGÉ

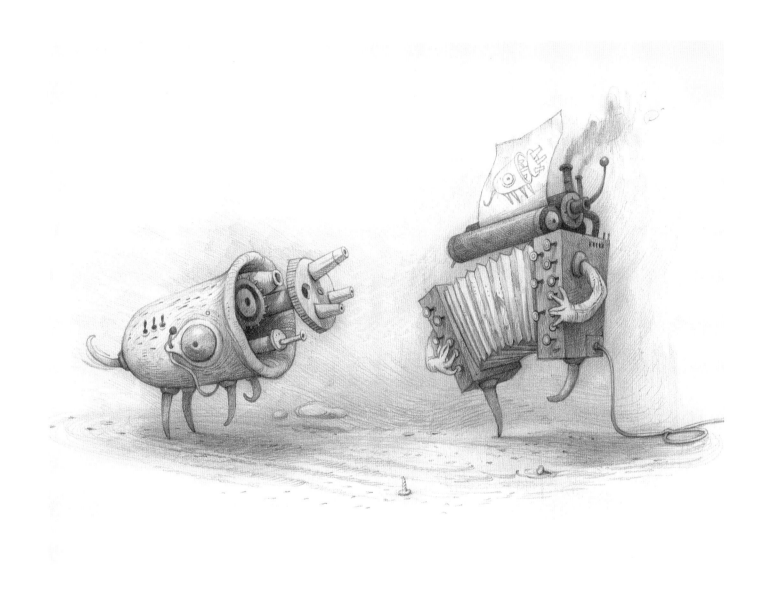

MICRO-DOG AND ACCORDIO

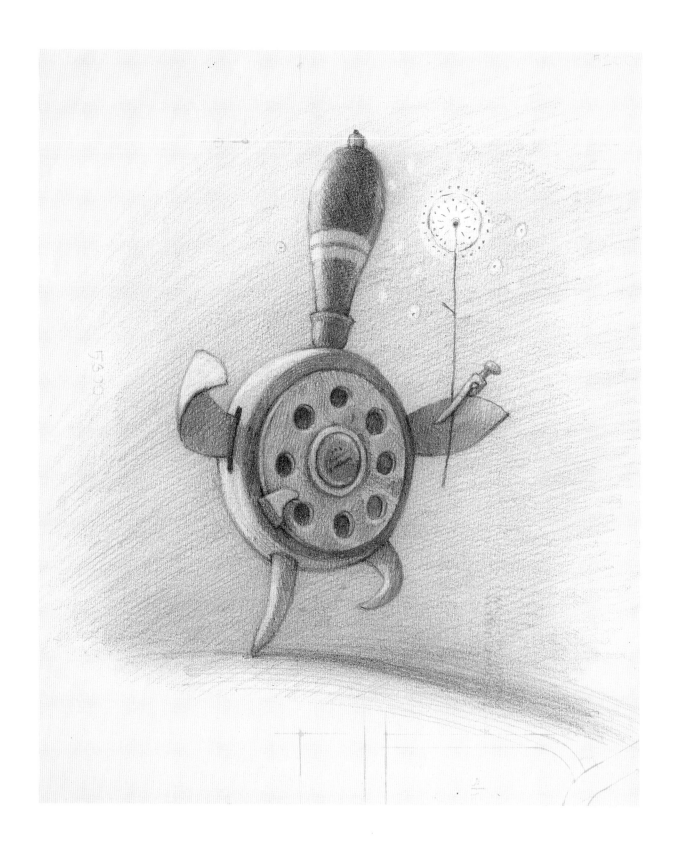

AMOROUS DIAL DUCK OF 1983

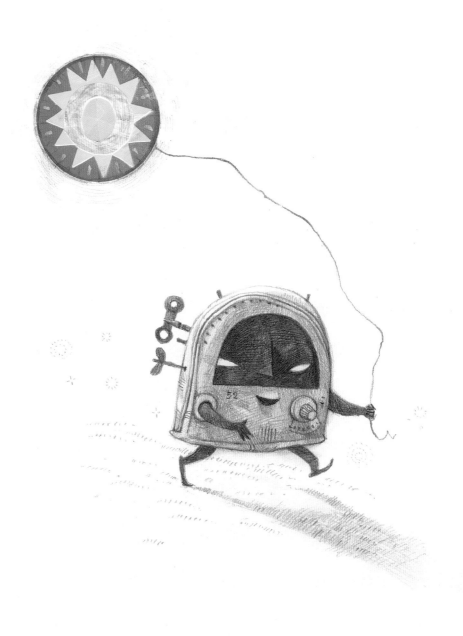

Above: KITE BOY | *Overleaf:* SLEEPER AND STORYTELLER

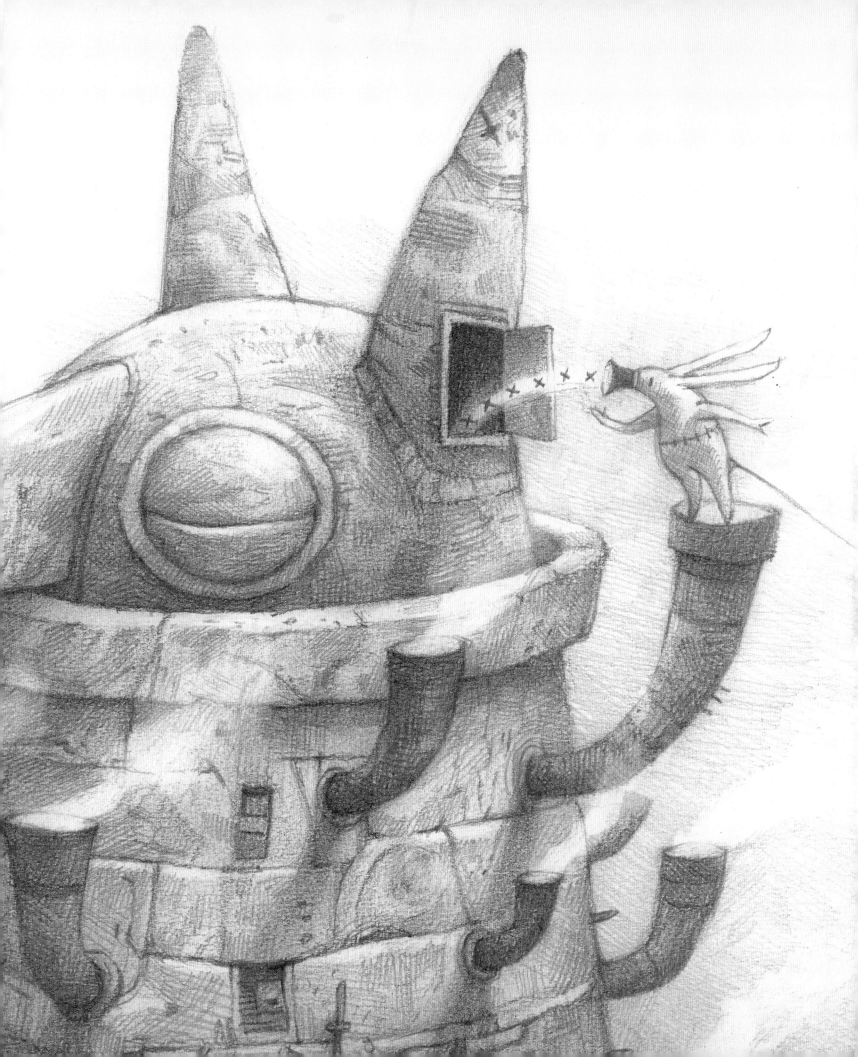

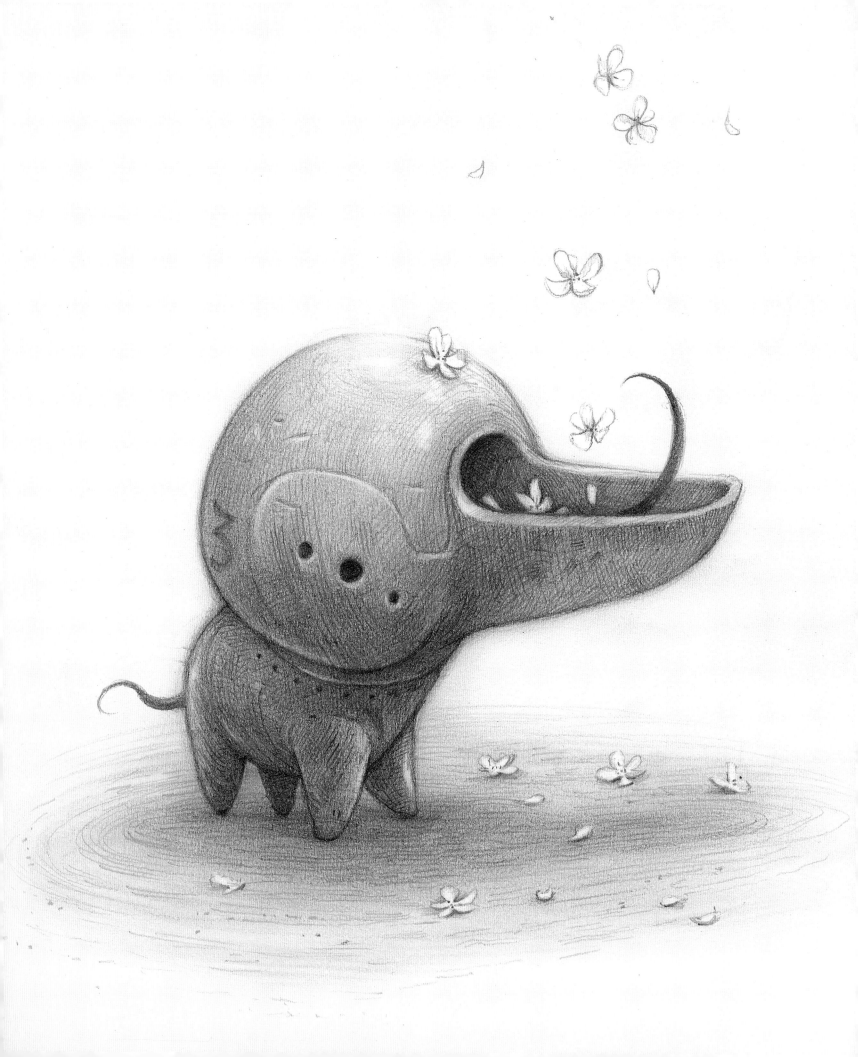

Above: COUPLE | *Opposite:* WAX-POWERED THRONE WITH UNIDENTIFIED DEITY

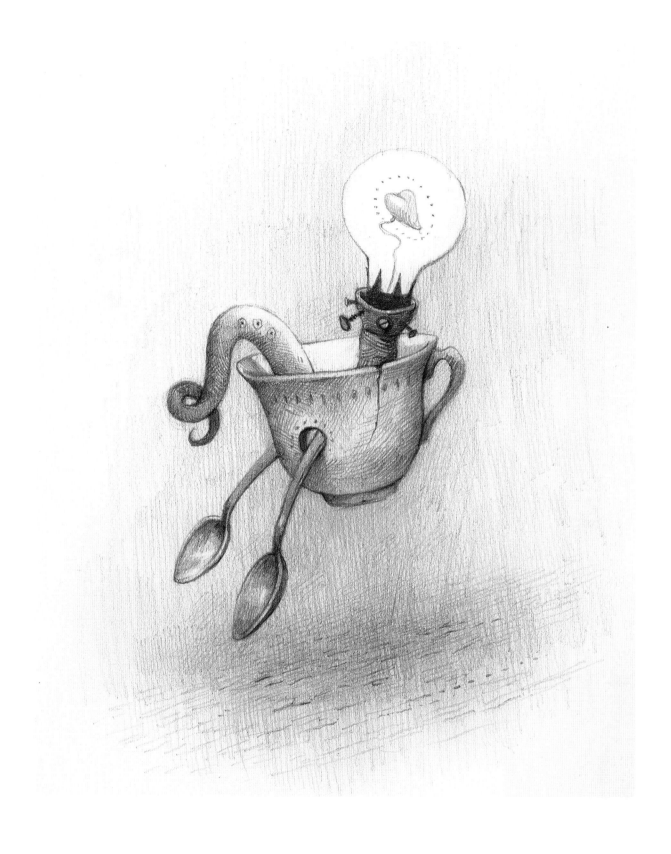

Previous: CAGEBIRD AND OBSTETRICIAN | *Above:* CIRCUMNAVIGATOR

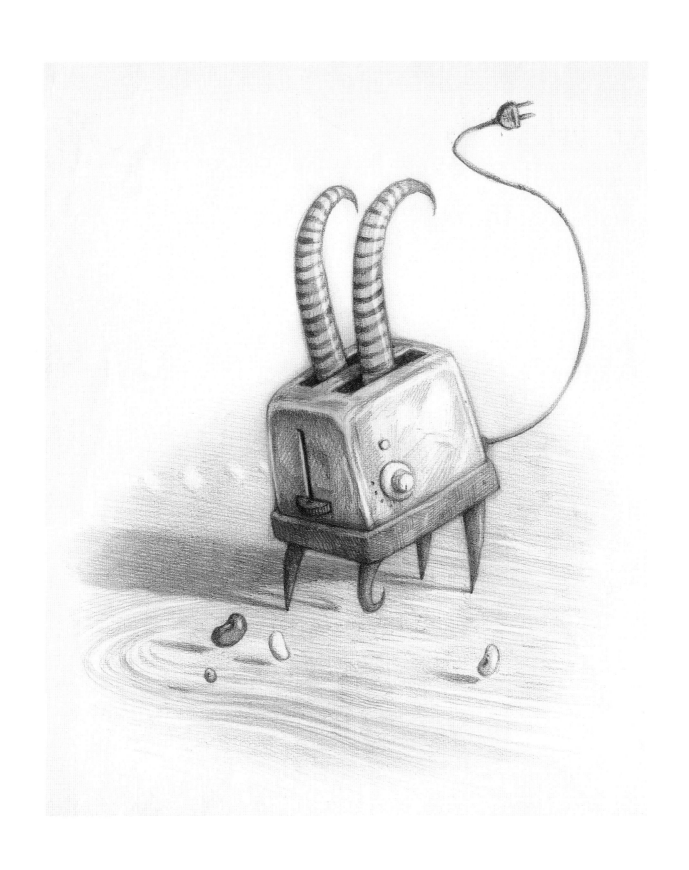

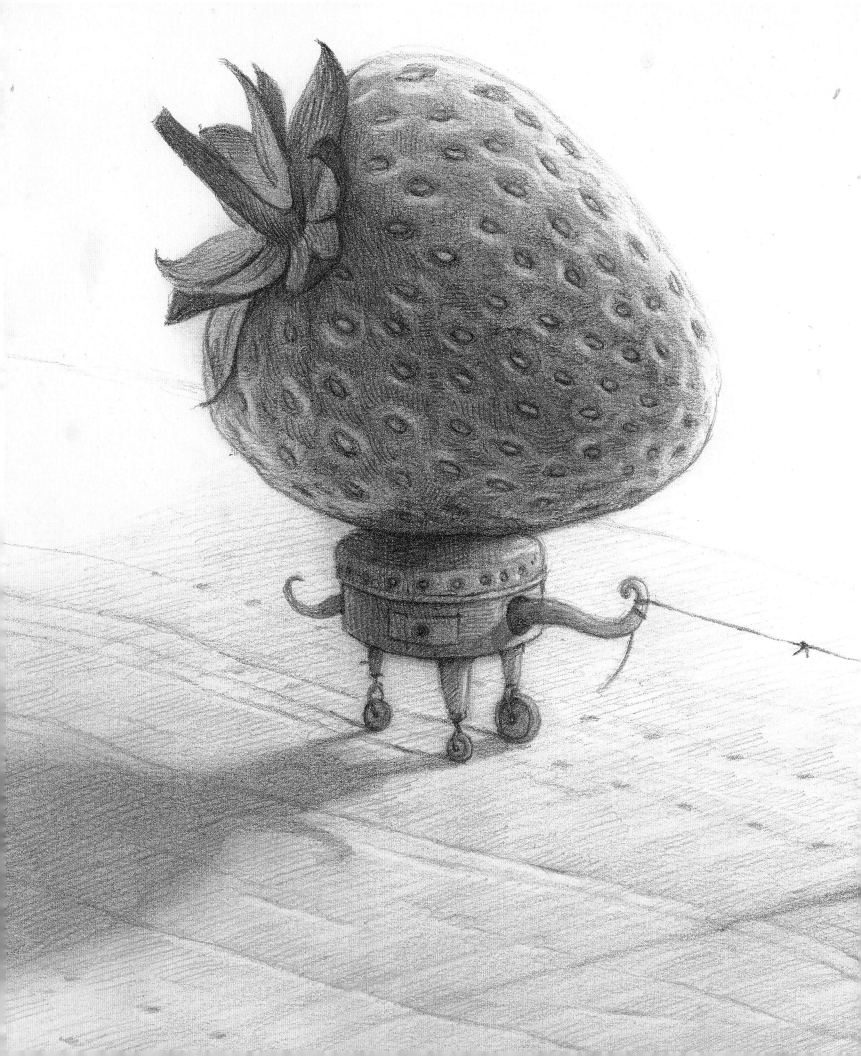

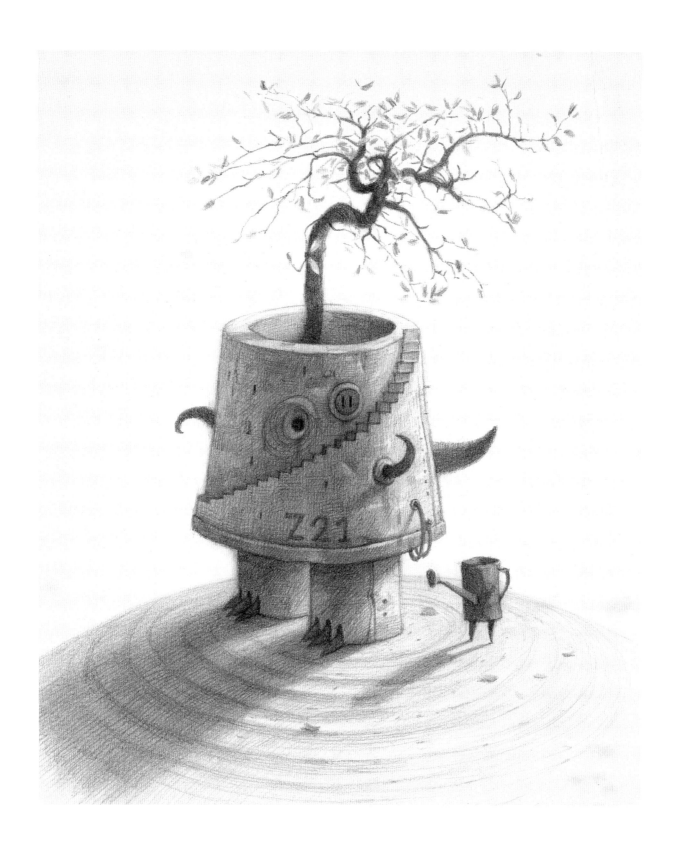

HORTICULTURAL UNIT AND CARETAKER TWIN

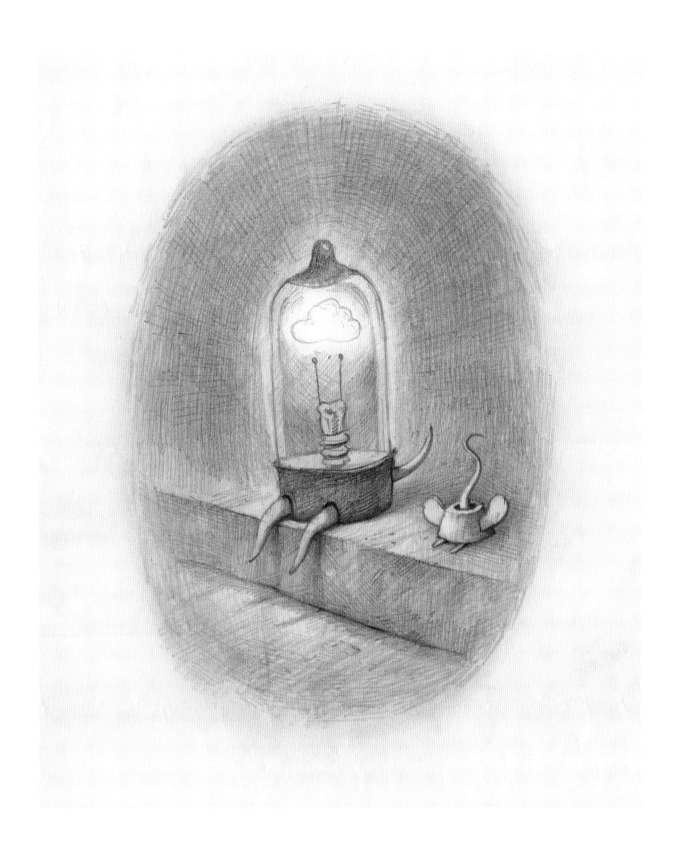

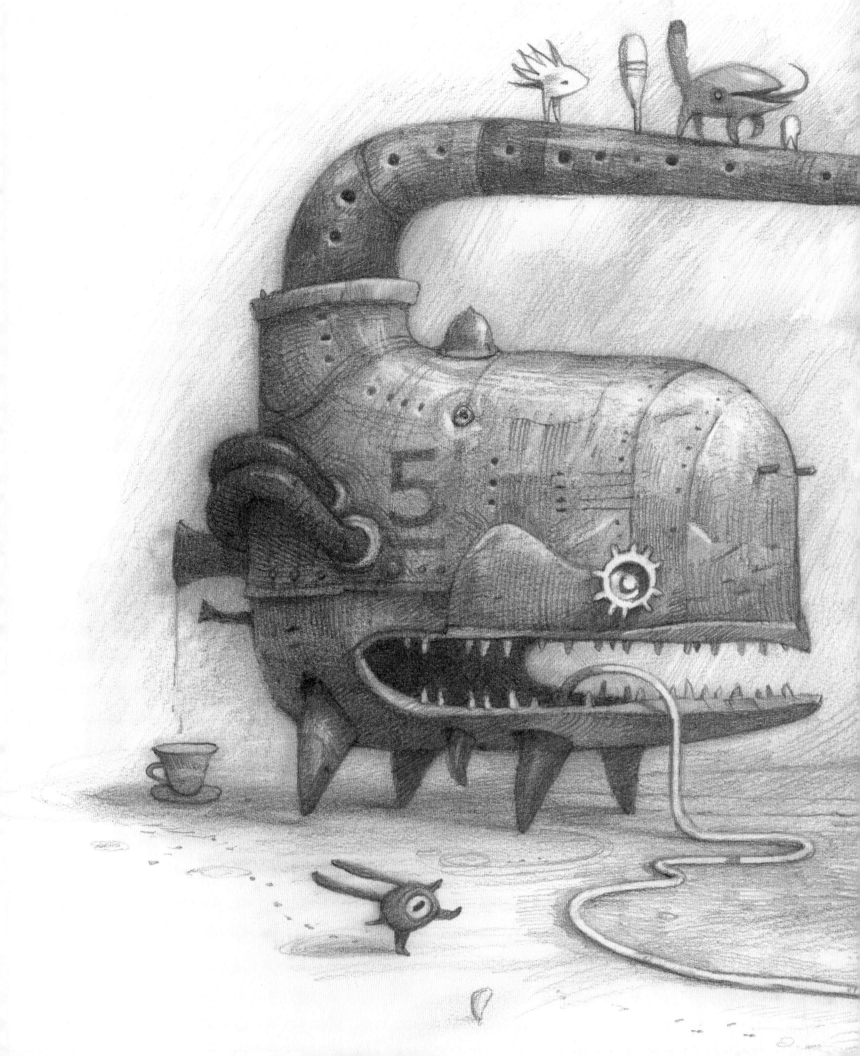

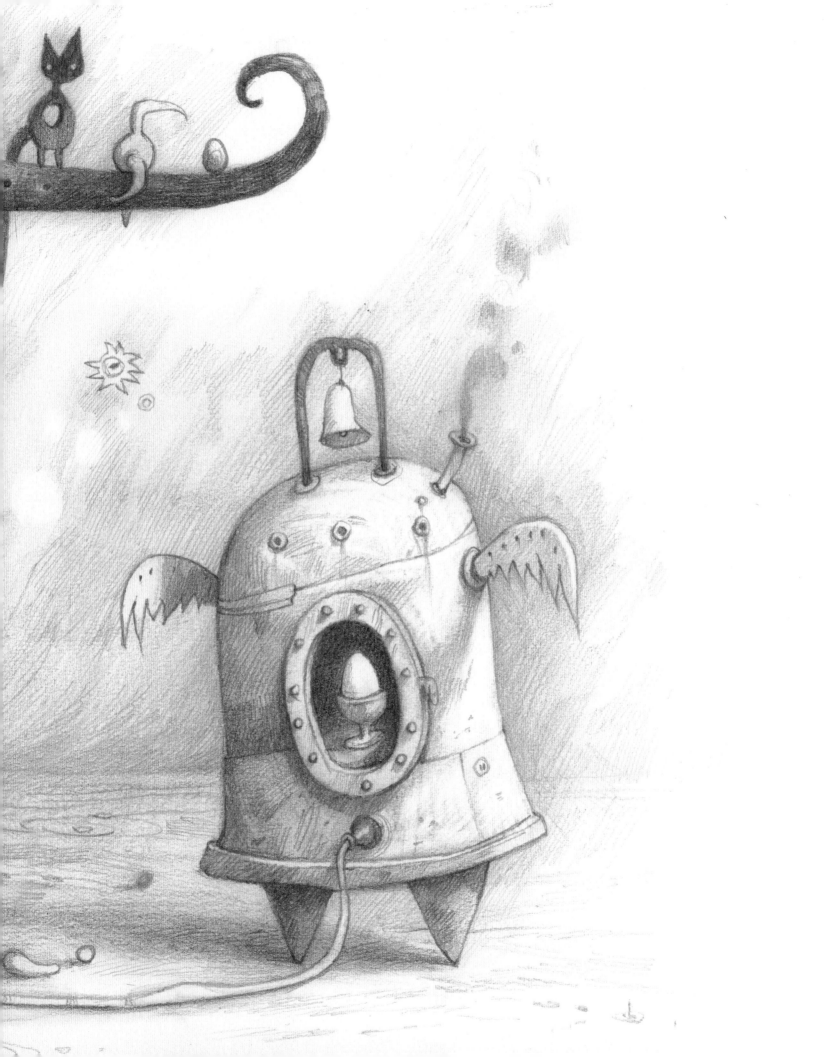

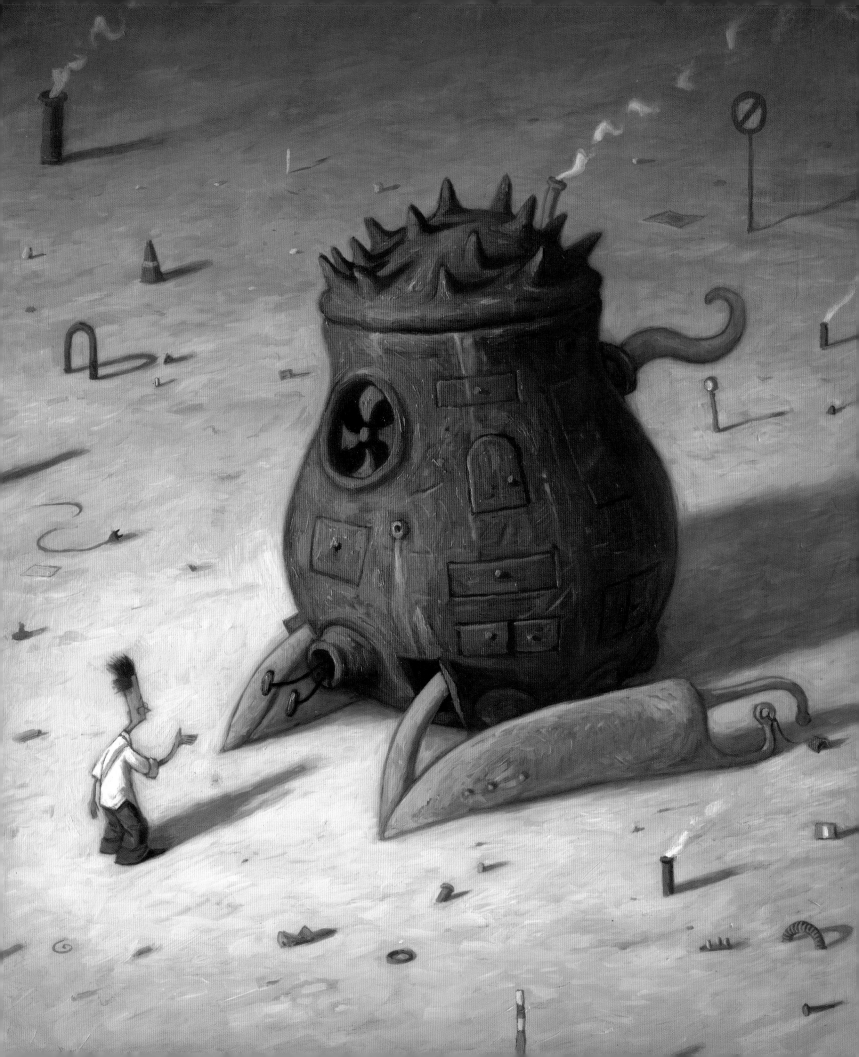

COMPANIONS

Someone to talk to, someone to listen, and someone to just sit with in silence.

When I was around the impressionable age of five or six, my dad let me stay up very late one Friday night to watch the weekly "creature feature" on our old, wood-veneer, black-and-white TV. The movie was *The Beast from 20,000 Fathoms* (1953), concerning a gargantuan prehistoric reptile awoken from slumber by some poorly considered nuclear testing. This absurd idea left quite an atomic shadow on my young mind, as much as monster movies in general, being no less than the inspiration for *Godzilla* (1954). Above all else, it was Ray Harryhausen's wonderfully trembling stop-motion, high-contrast monster that lodged in my own reptilian limbic system as it tromped through New York City, a place that was possibly also fictional as far as I knew, and fun to see pulverized. This was also the first time I recall hearing the word *creature*. That is, a frightening monster from a deep place, best left alone.

Certainly the words *creature* and *monster* are often synonymous in Western culture, as any cursory online search will reveal. This dark, dangerous take on otherness lies heavy in the human mind, if several thousand years of storytelling are anything to go by. Even those creatures not specifically peddling fear or moral caution—the ambiguous, neutral, or even helpful ones—are usually pretty suspect: the trickster, the dealer, the benevolent savior whose help comes with a taxing subclause. I love all these stories but have always been more attracted to an empathetic reading of otherness, quite far from the usual notion of a monster: something more like a companion. Insiders rather than outsiders. Returning to early childhood memories of movies— that principal art gallery of suburbia—my sympathies aligned with such creations as the titular hero of *E.T. the Extra-Terrestrial* (1982), the parental Mystics of *The Dark*

Crystal (1982), and that willful, feisty version of a cylindrical vacuum cleaner, R2-D2 of *Star Wars: A New Hope* (1977), all of whom seemed to me more humane for not being human. I notice that my own stories many years later follow a similar direction. Even when my creatures are ominously large, sharp-toothed, or tentacled, I'm interested in companions rather than antagonists: neighbors, friends, coworkers—even partners, parents, and siblings. Weird beings who might be the perfect sounding board for private thoughts and feelings, especially those we find hard to articulate.

Not to say that this would necessarily be an easy conversation. Other creatures are, like us, complex, largely unknowable, self-possessed, preoccupied with their own problems, and prone to misunderstanding, or no understanding at all. A blank leaf-shaped face, a clockwork eye, a vague silhouette among trees: each may well stare back with reciprocal bewilderment, asking, "What are you?" In that sense we are all mutually strange. Once the foamy hubris is skimmed from our self-important, self-assured thinking, the pool beneath—that basic mystery of animalhood—is deep and abiding.

The central question that intrigues me when drawing a creature alongside a human companion is simply this: what happens when these strangers meet? As in real life, I think that's a good trial of personal character, how we react when we are faced with a genuinely unexpected encounter, a situation so conceptually challenging that we must fall back on less cultured or cognitive instincts, on our basic emotional nature. Are we fearful or curious? Defensive or sympathetic? Do we tighten the armor of our carefully crafted identity or see an opportunity to loosen its seams, even welcome the other as a friend, an equal, a companion and teacher?

Which is not to say that these creatures are all charming and benign. In many of the drawings here, there is something off-kilter about the relationship between human and nonhuman characters. That congenial game of cards played among an amphibious cohort could easily turn nasty once a delicate trust is broken. That strange machine leaning over a suburban fence is not waving hello in order to enter a circle of friendship, but rather to challenge it, to break it. The beautiful apparition summoned by neglected children might be their guardian, but it might also be a vengeful mercenary, a terrible mistake. In each case, I'm not entirely sure what the story is behind each picture, but they do demand some compelling elaboration; at least that's what leads me to the drawing table, easel, or sketchbook—or a published compilation like this—to extend an invitation to others to make their own guess. To tell a story.

This is something children will be naturally compelled to do when looking at an illustration, without needing to be asked. It may be no surprise then to see how often children appear in the paintings and drawings that follow. While this is partly a

nod to the heyday of my own creature-conjuring, mostly between the ages of about seven and twelve, it's also a recognition that around this time our theories about the world are so malleable and open. The underlying meanings and structures of life, the categories of existence, the rights and wrongs of behavior, our very own identity: these things are all up for imaginative grabs. This may be why children are so receptive to weird companions. They are permutations that ring true, that remind us of everyday life. They feel real. After all, aren't many of our closest friends and family a little like strange creatures? And let's not forget the one in the mirror—no less weird for being utterly familiar. I think much of life involves trying to understand this paradox, working out this alien landscape we happen to call home, mostly through the various stories we tell ourselves each day. This puzzle moves well beyond childhood, across stages and seasons, arguably getting more complex, more befuddling, as time goes by, but also pointing to a simple and oddly reassuring observation: a human being is just one more strange creature in a strange world, always looking for the companionship of another. Someone to talk to, someone to listen, and someone to just sit with in silence and ponder how unlikely it is that any of us should even exist in the first place.

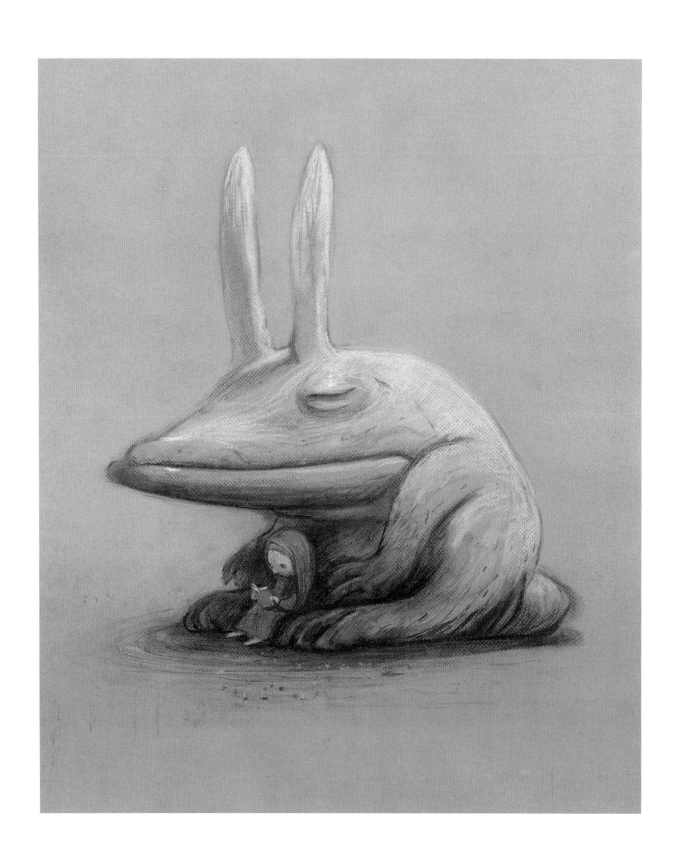

Above: SHADE | *Opposite:* I KNOW

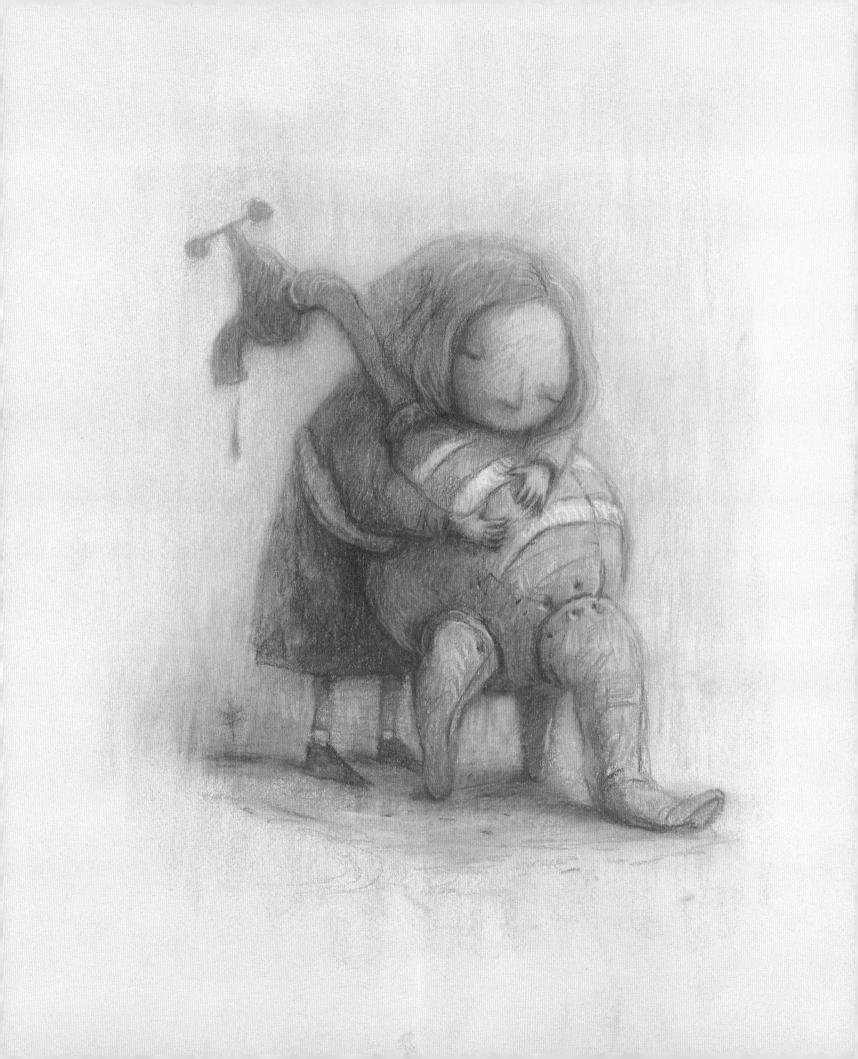

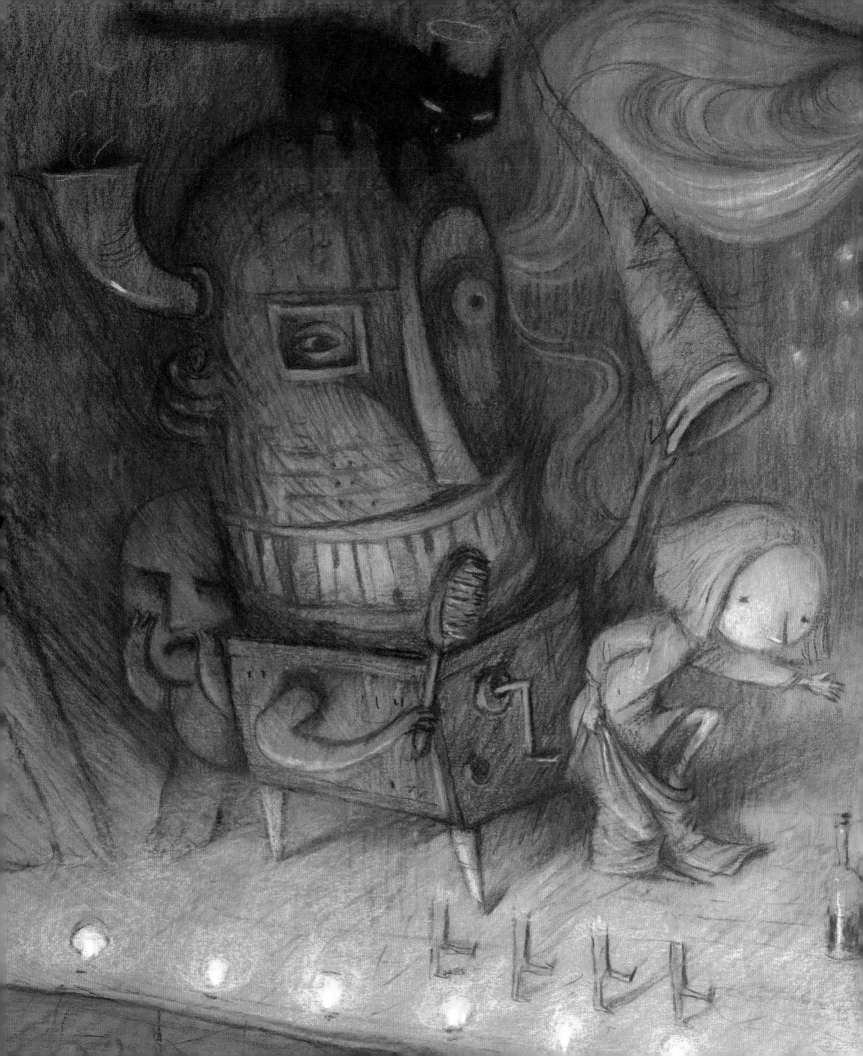

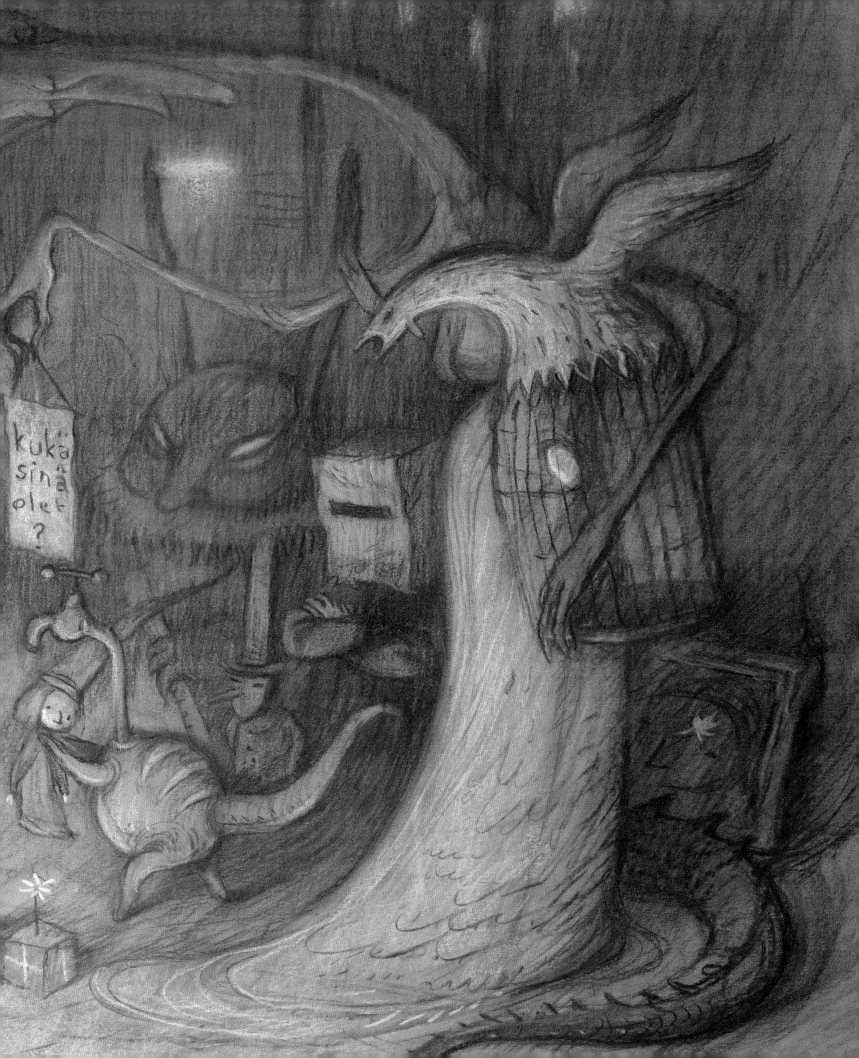

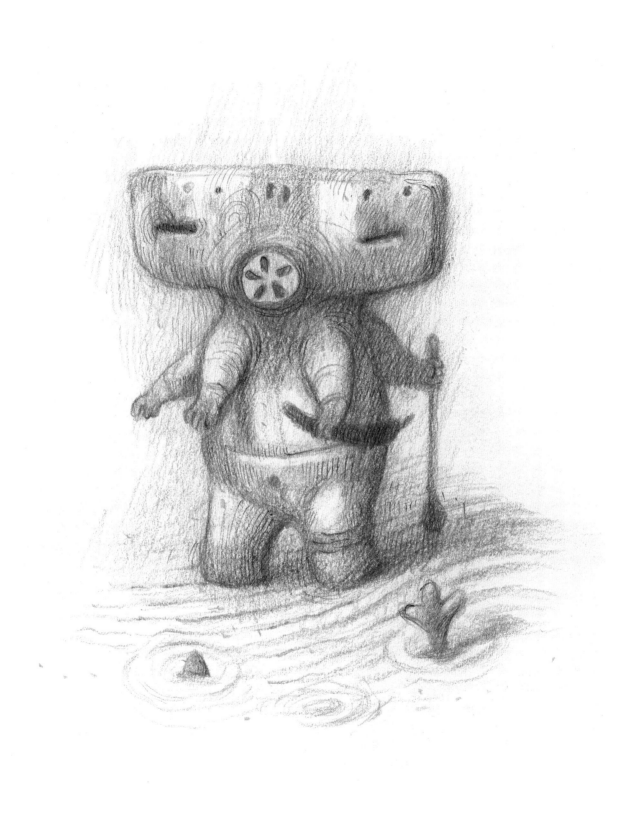

Previous: JUST DO WHAT THEY TELL YOU | *Above:* LITTLE FARMER

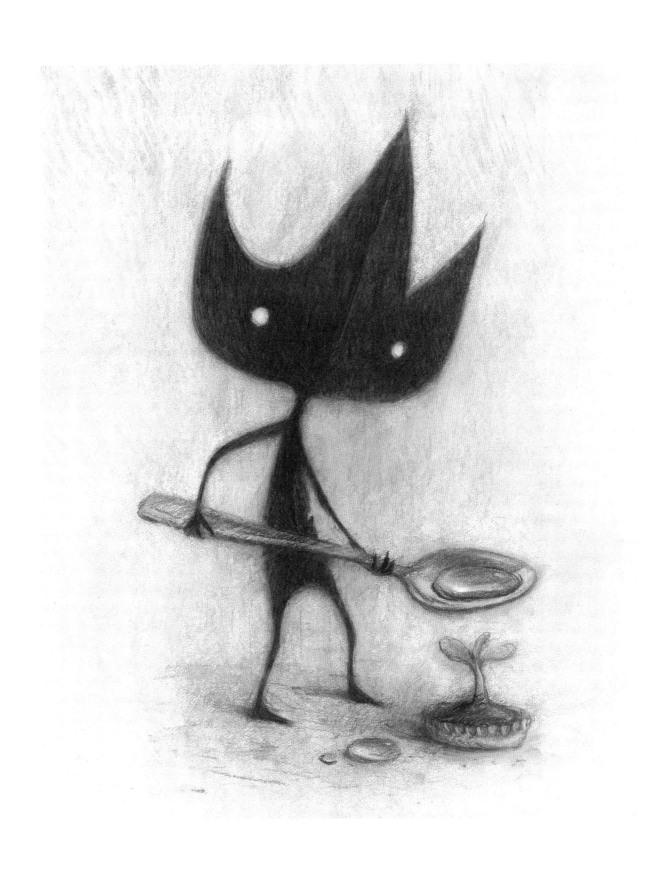

Above: ERIC | *Overleaf:* A DANGEROUS GAME

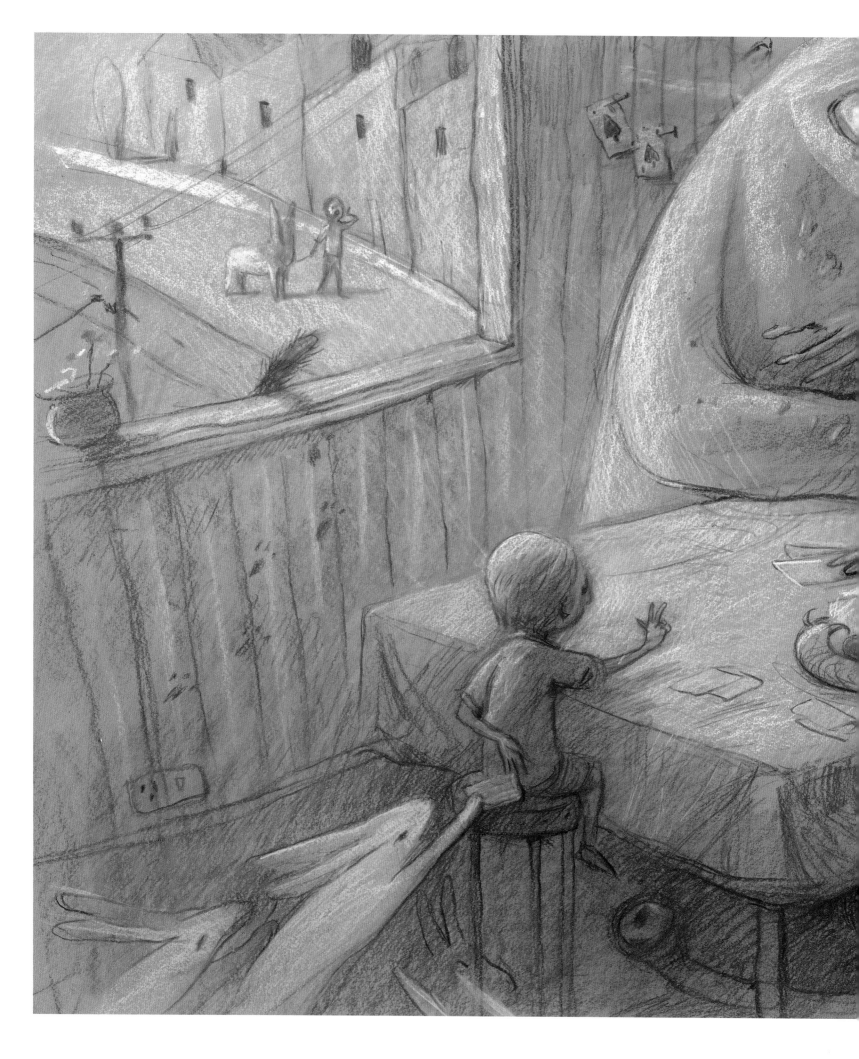

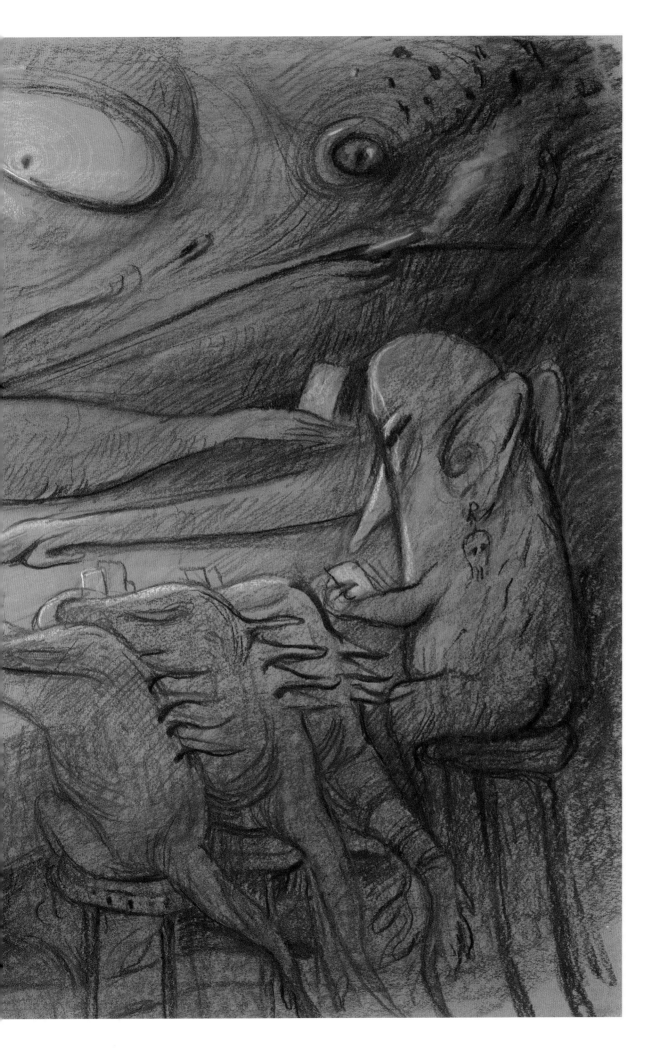

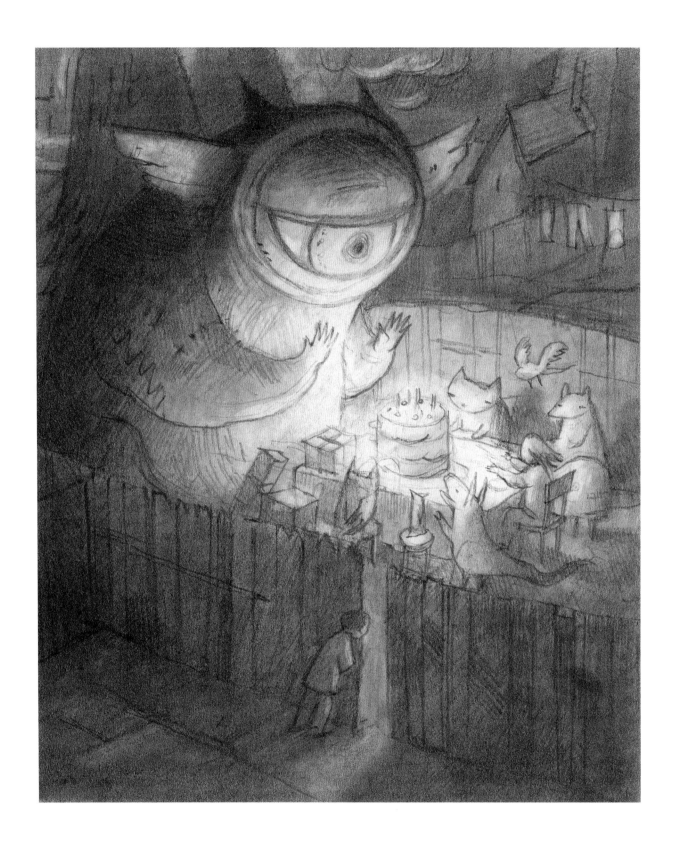

58 *Above:* NEVER FORGET TO BRING A GIFT | *Opposite:* WHY DID YOU MAKE ME THIS WAY?

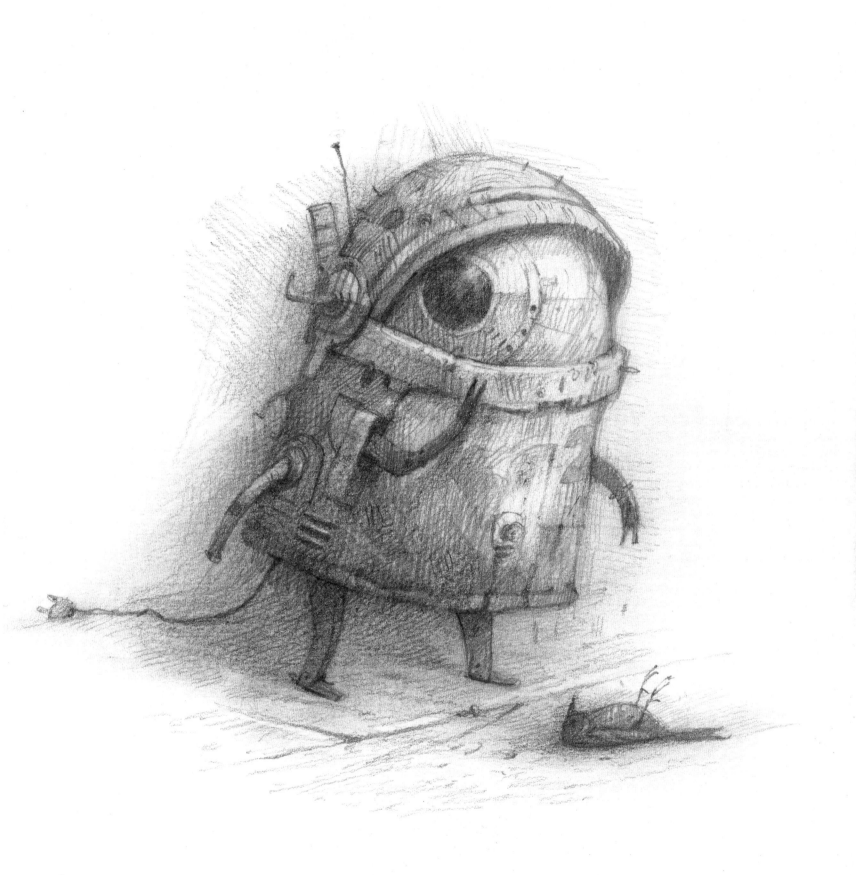

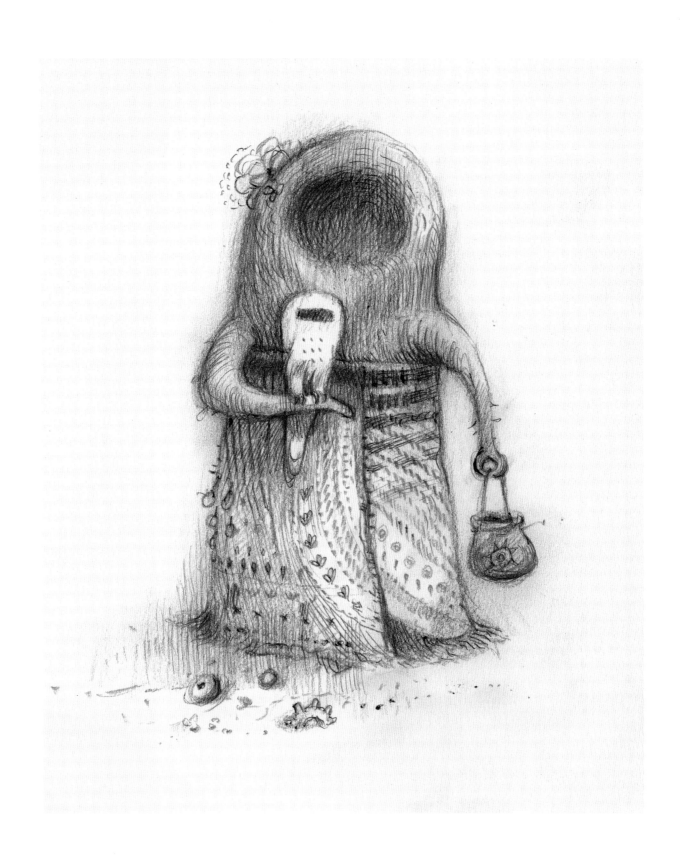

Above: THE FAVOURITE AUNT | *Opposite:* READER

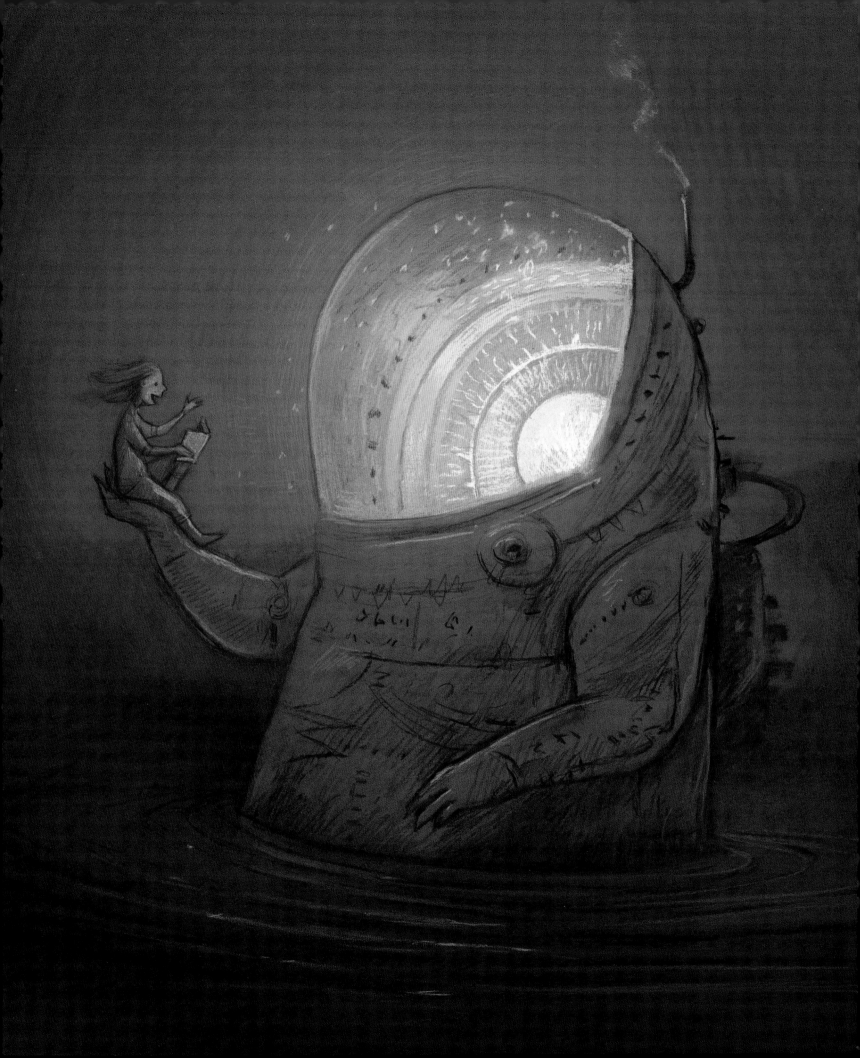

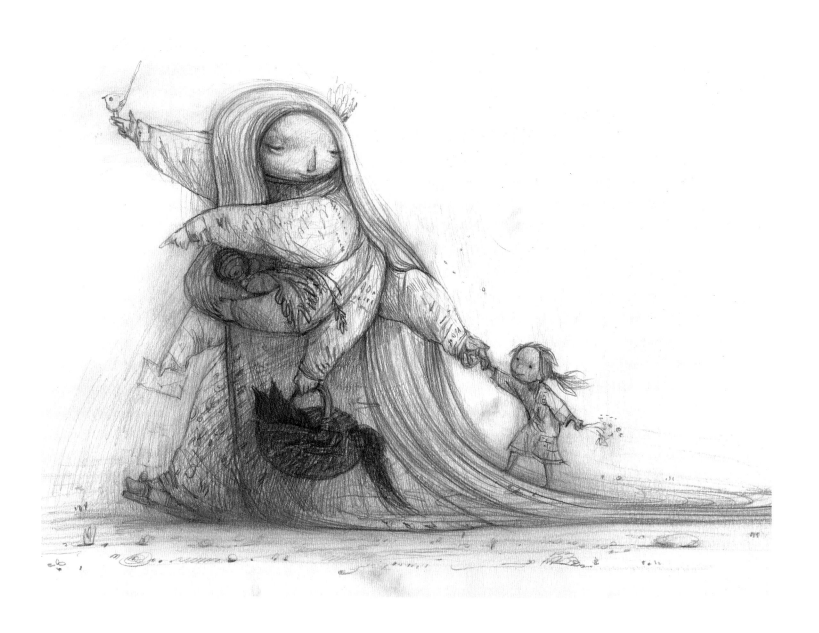

WALKING WITH MOTHER

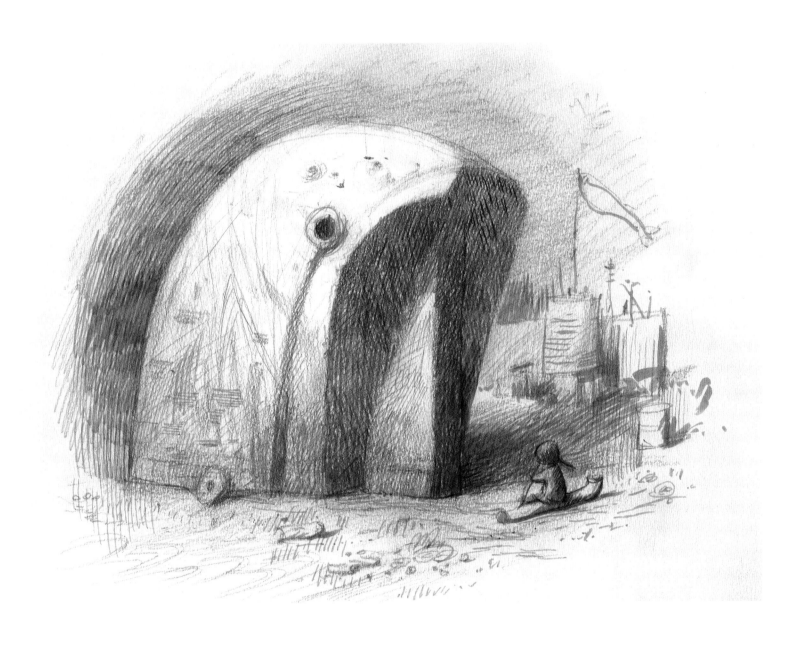

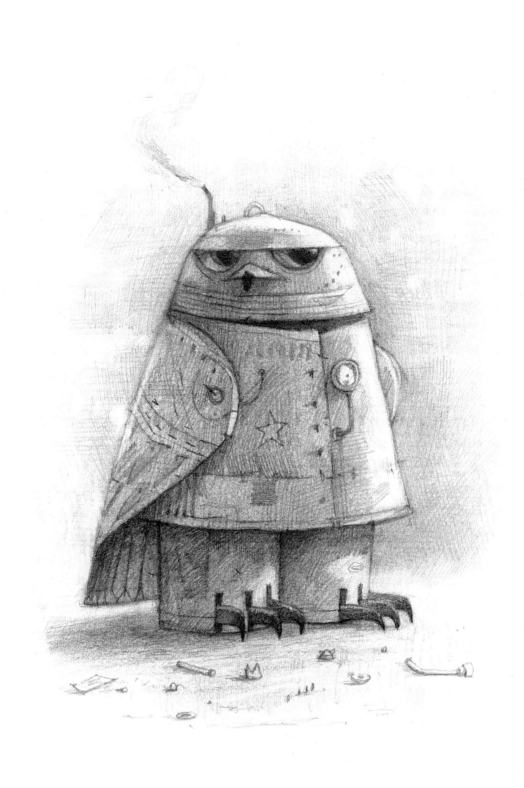

HOME-MADE OWL

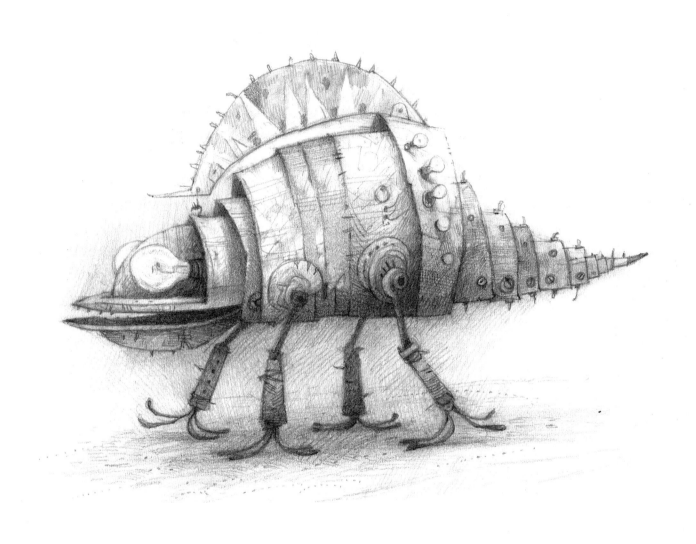

HOME-MADE CHAMELEON

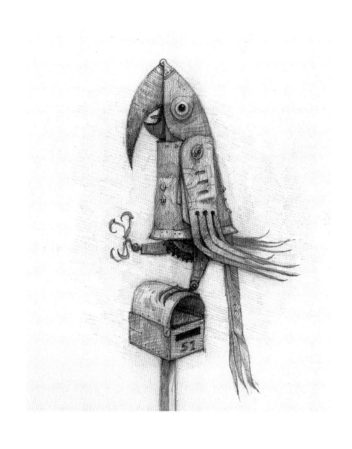

Clockwise from top: MAIL PARROT, TENNIS MOUSE, BEE-EATER, WOMBAT

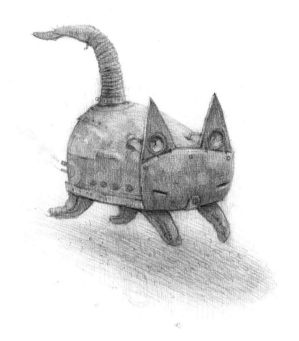

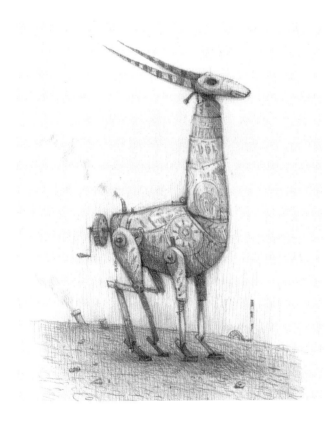

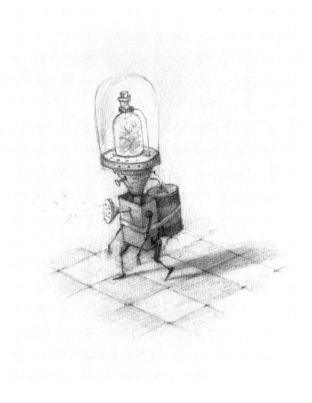

Clockwise from top: CARPET SHARK, HOUSE CAT, MINI HUMAN, COIL SPRINGBOK

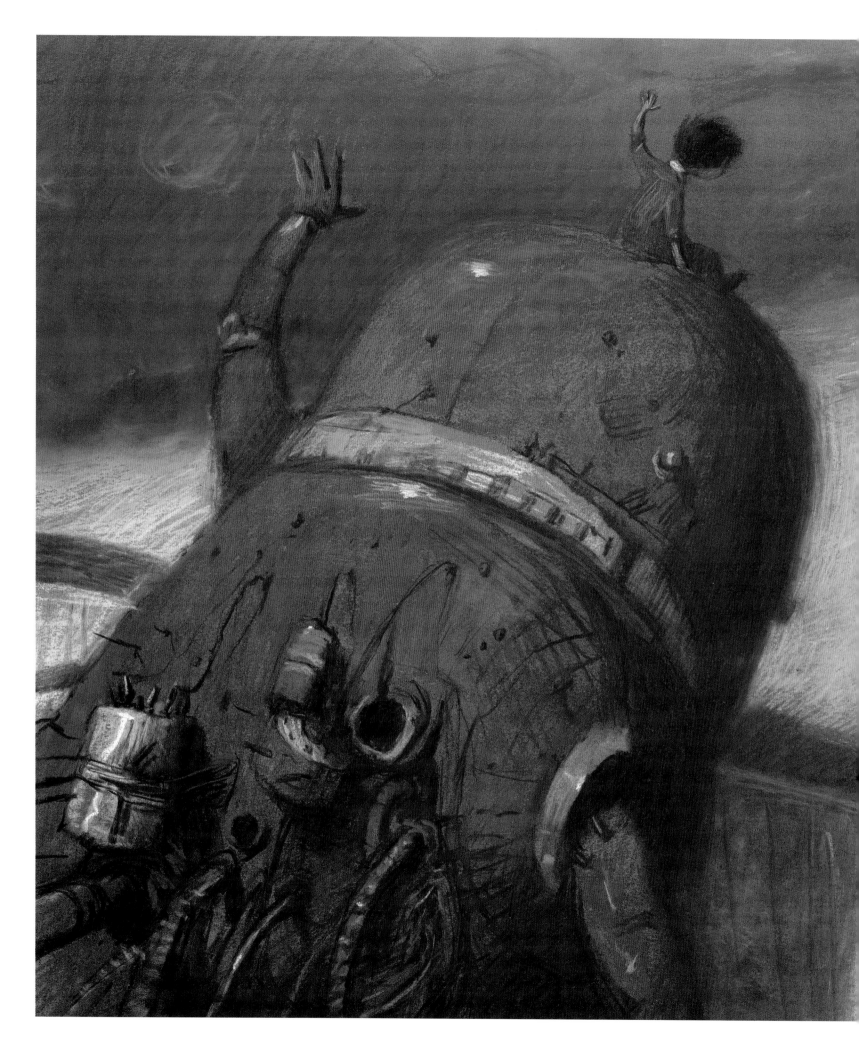

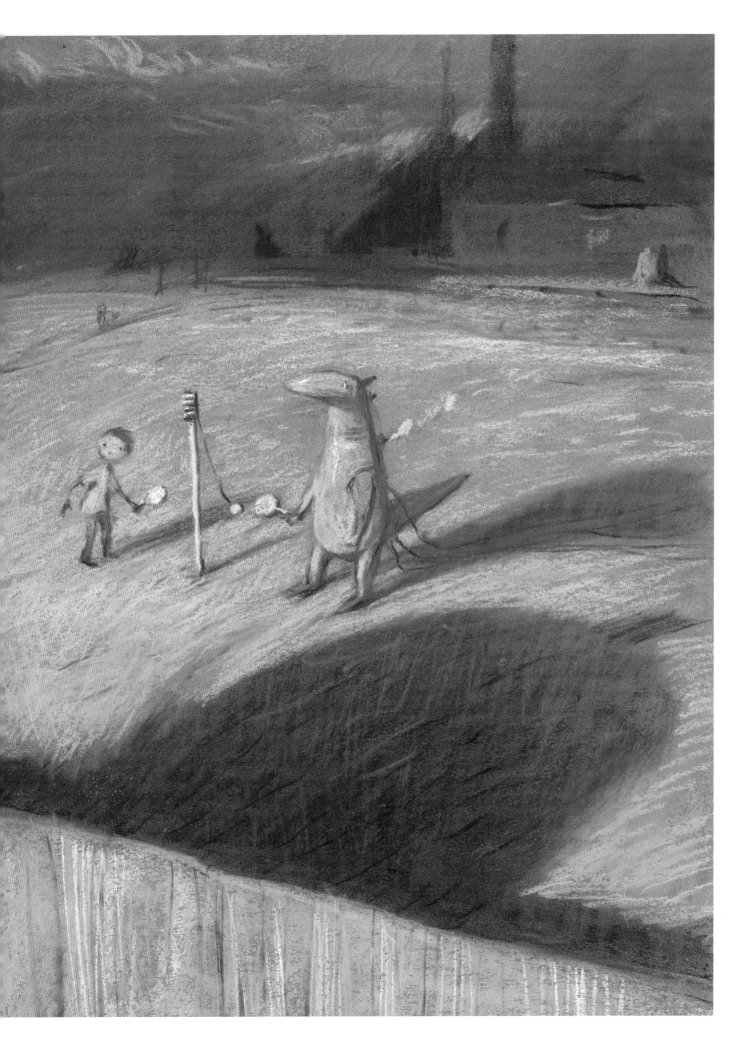

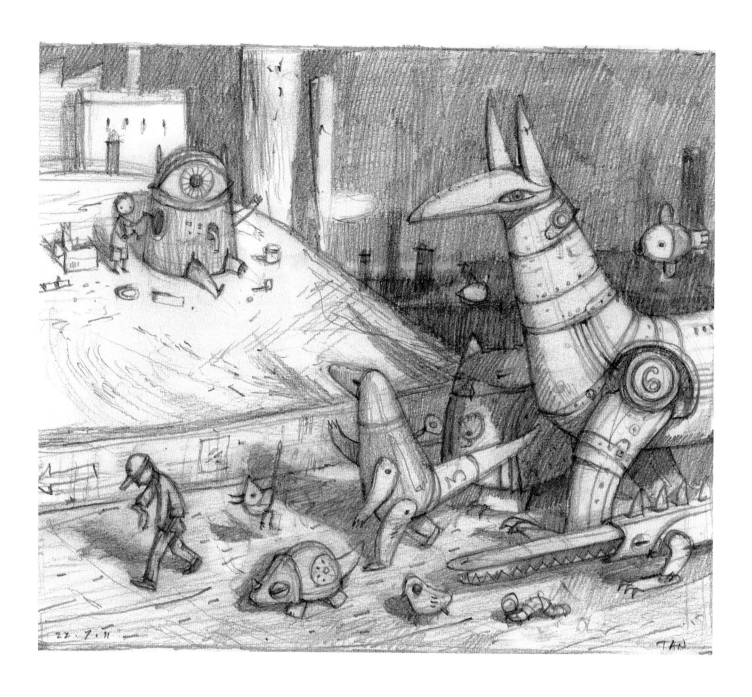

Previous: ANYTHING YOU CAN DO, I CAN DO BETTER | *Above:* NEVER BE LATE FOR A PARADE

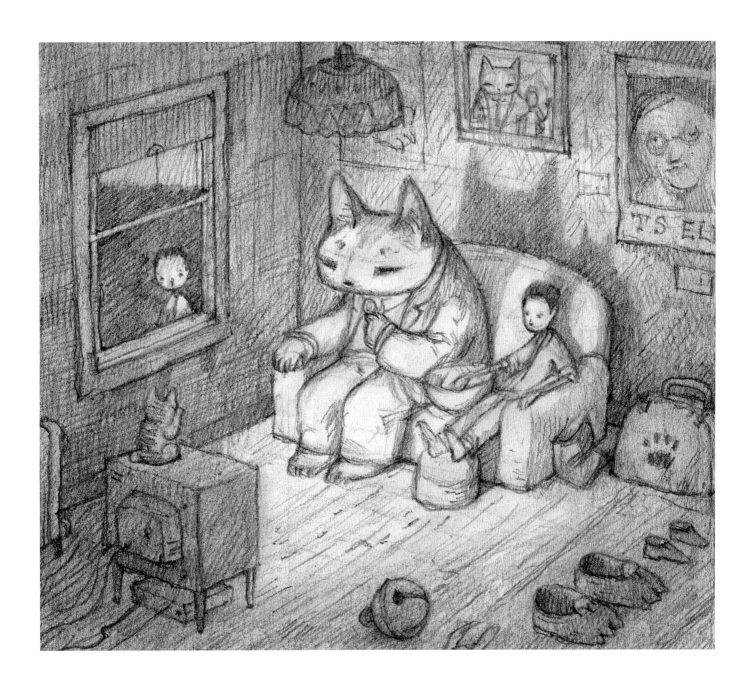

NEVER GIVE YOUR KEYS TO A STRANGER

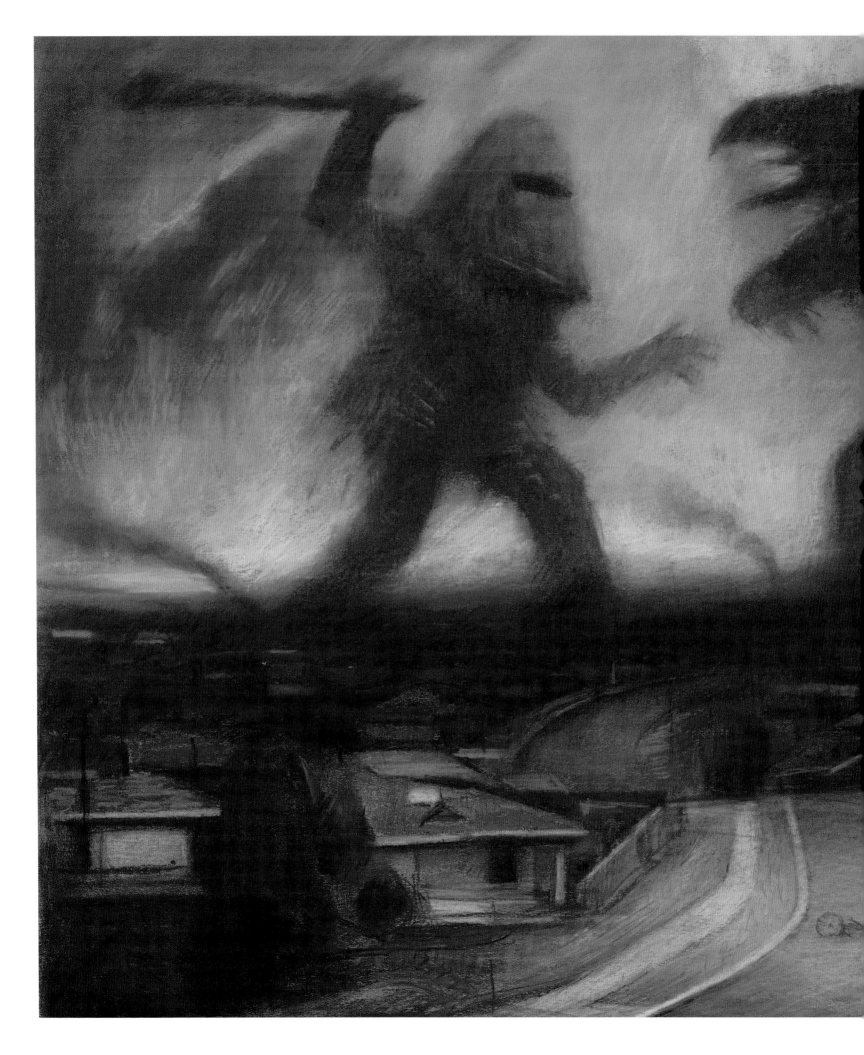

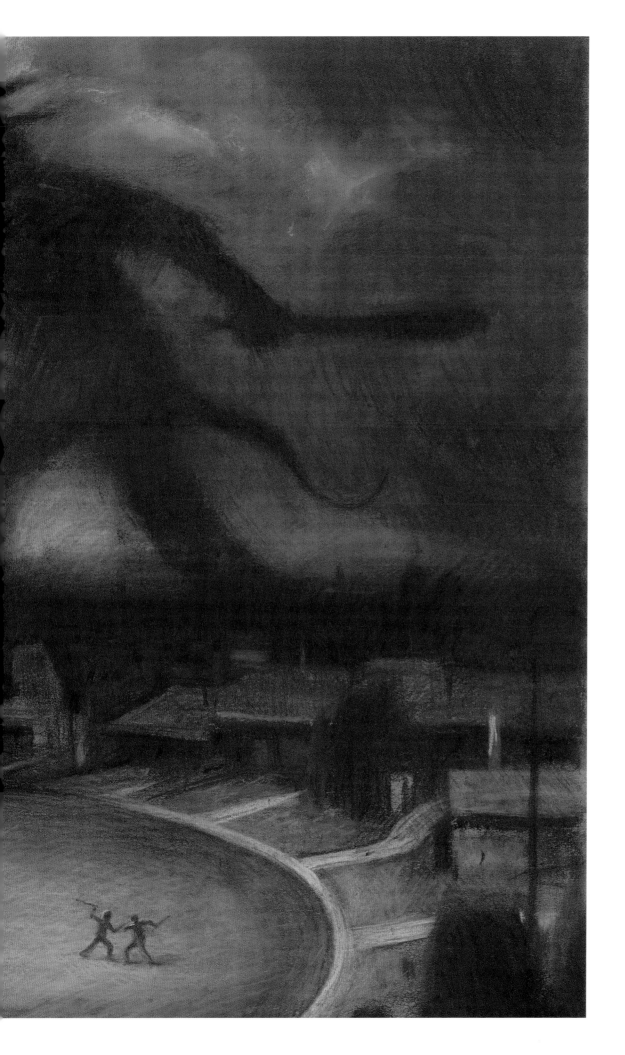

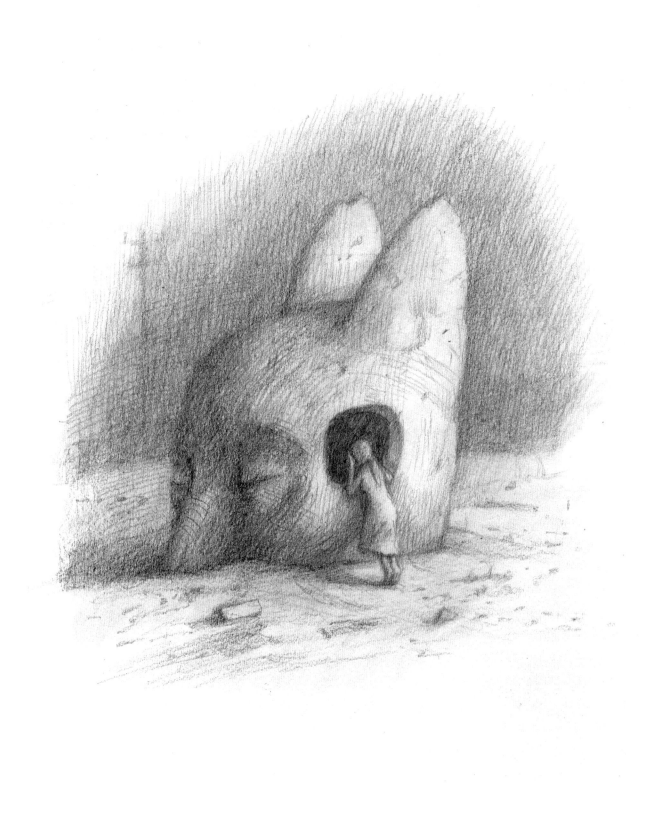

Above: SECRET | *Opposite:* TENDER MORSELS | *Overleaf:* MERCENARY

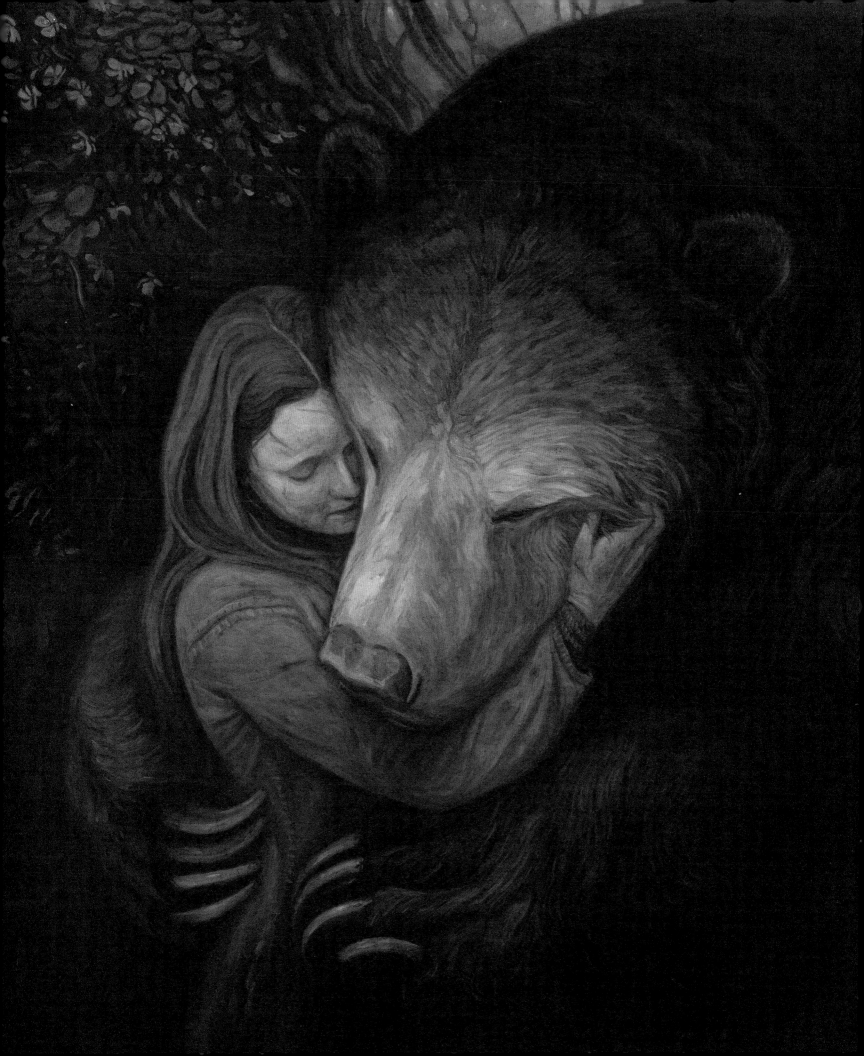

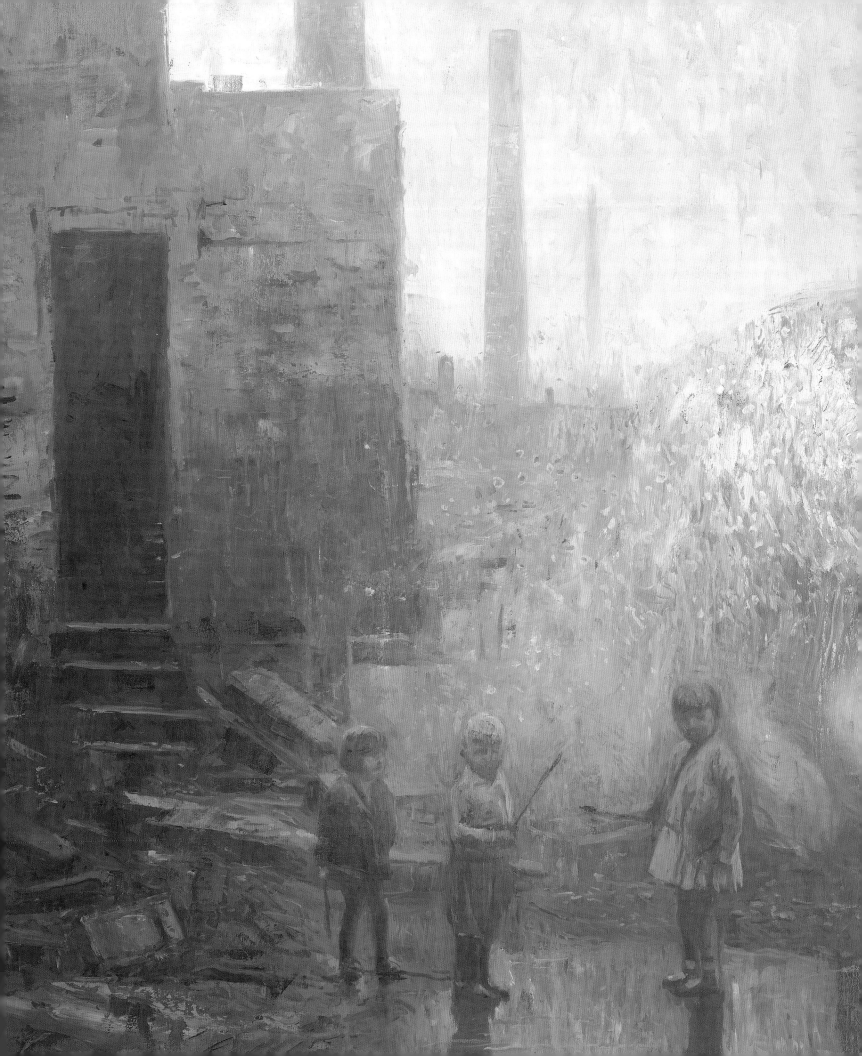

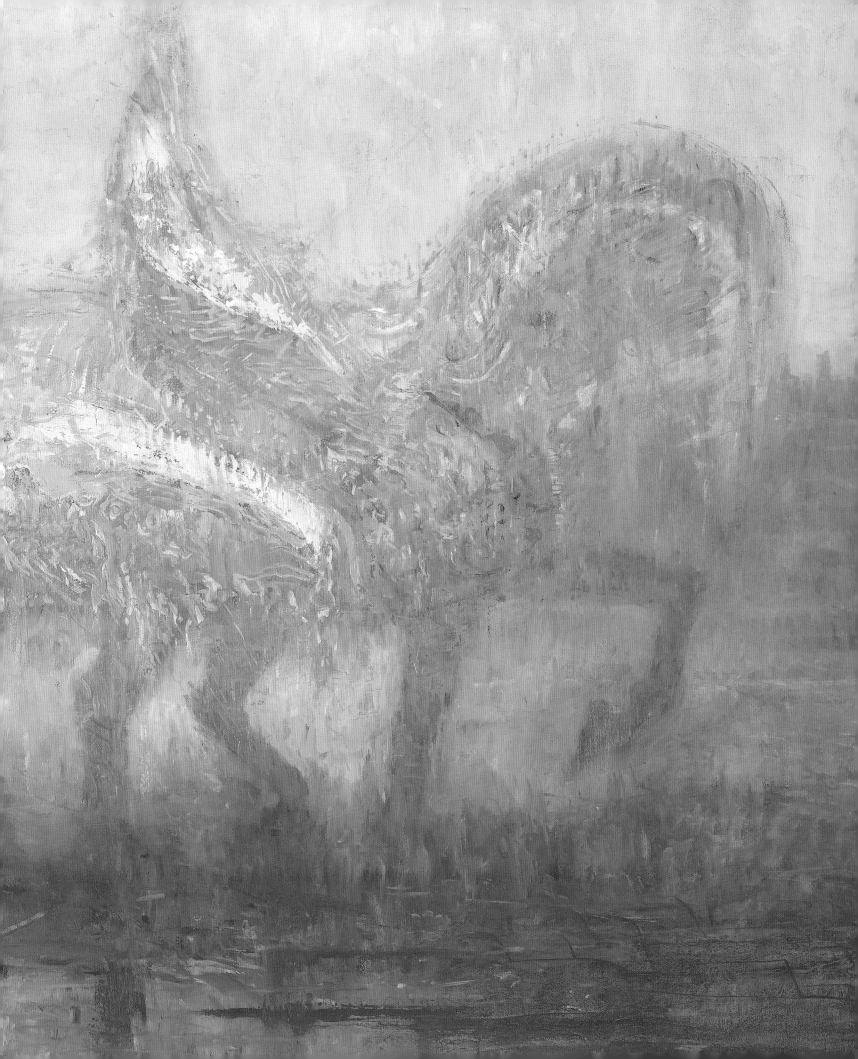

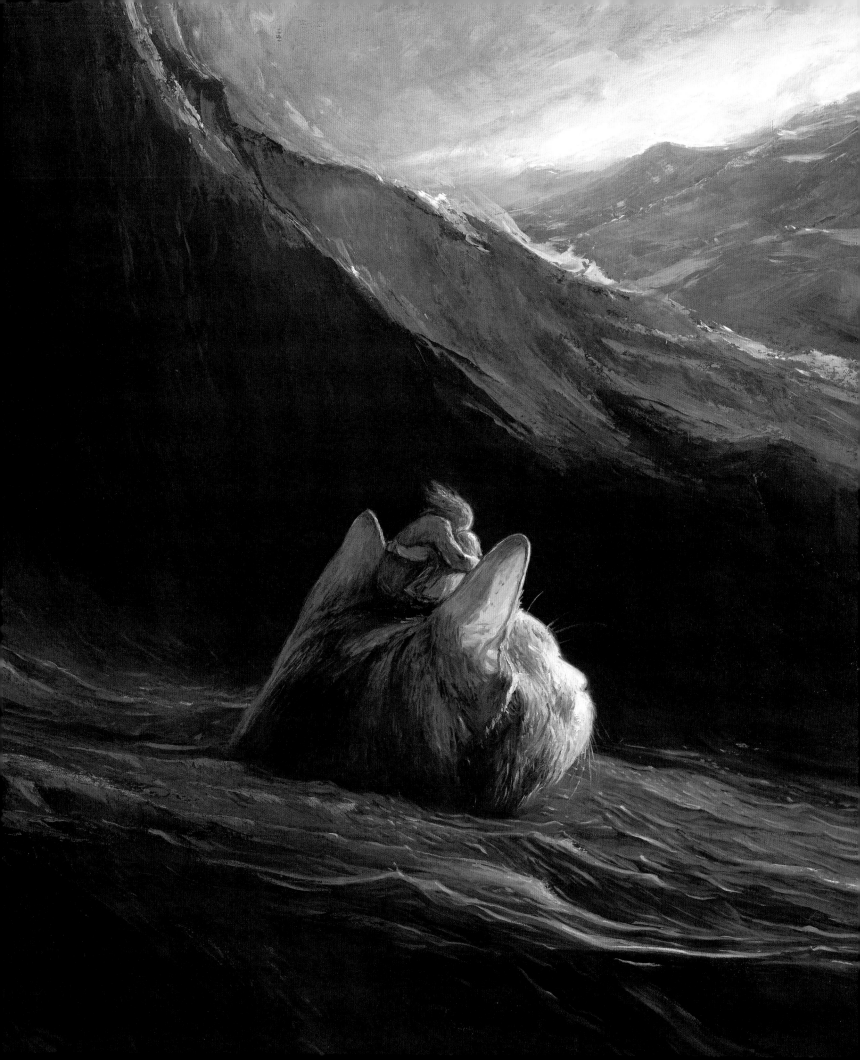

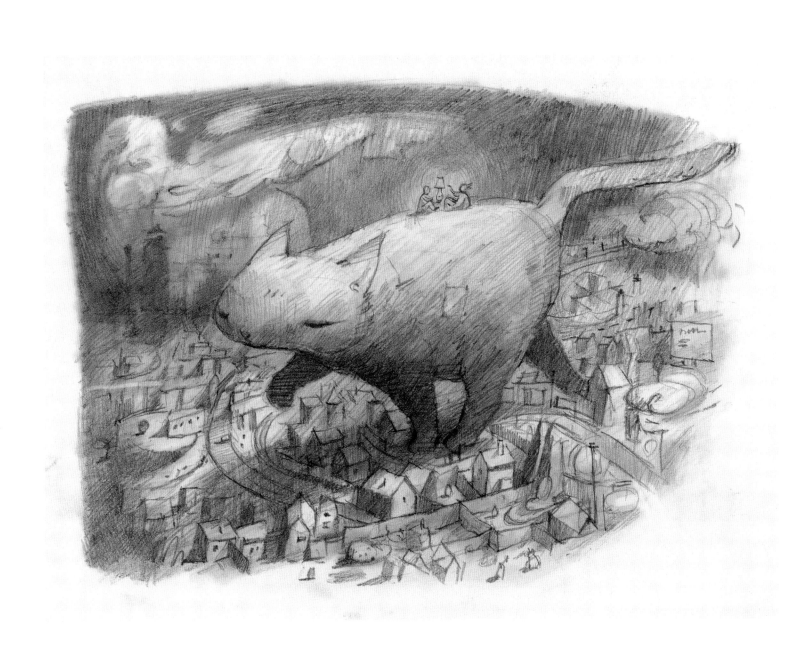

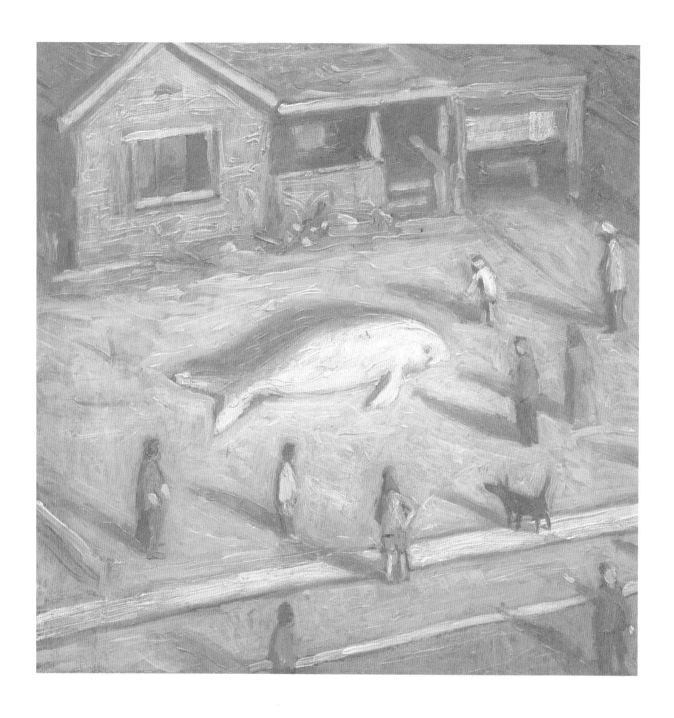

Above: UNDERTOW | *Opposite:* NIGHT OF THE TURTLE RESCUE

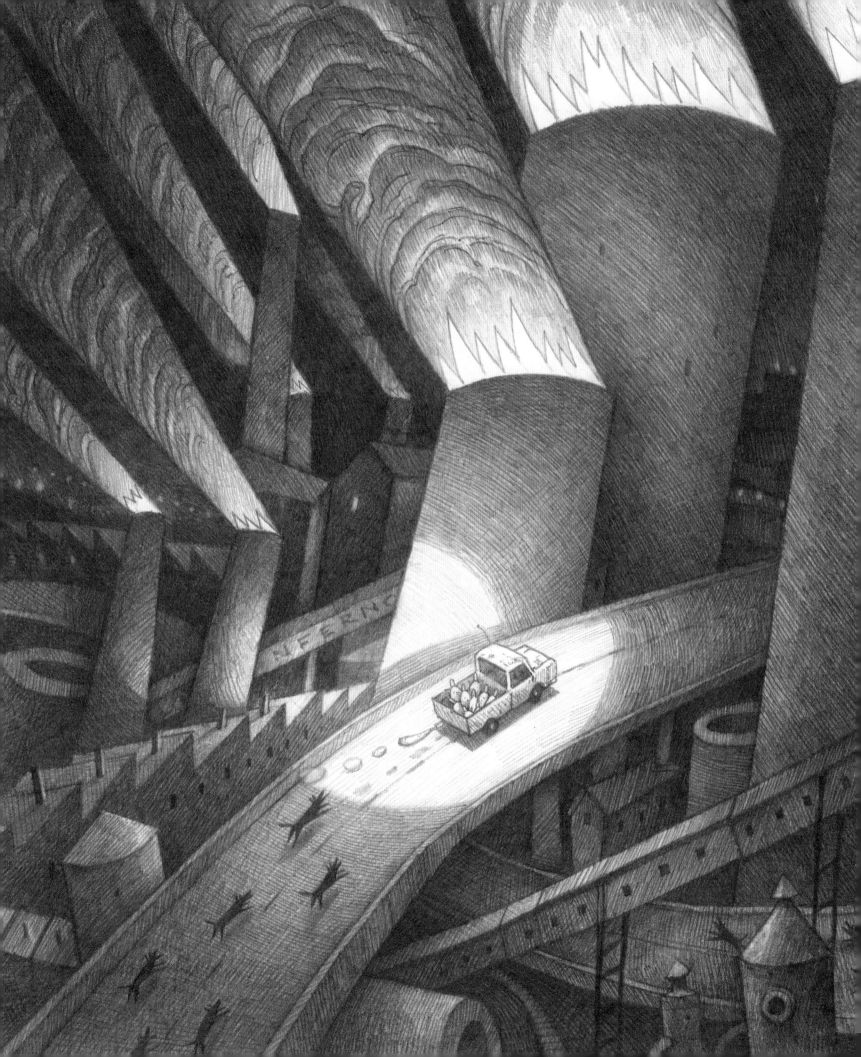

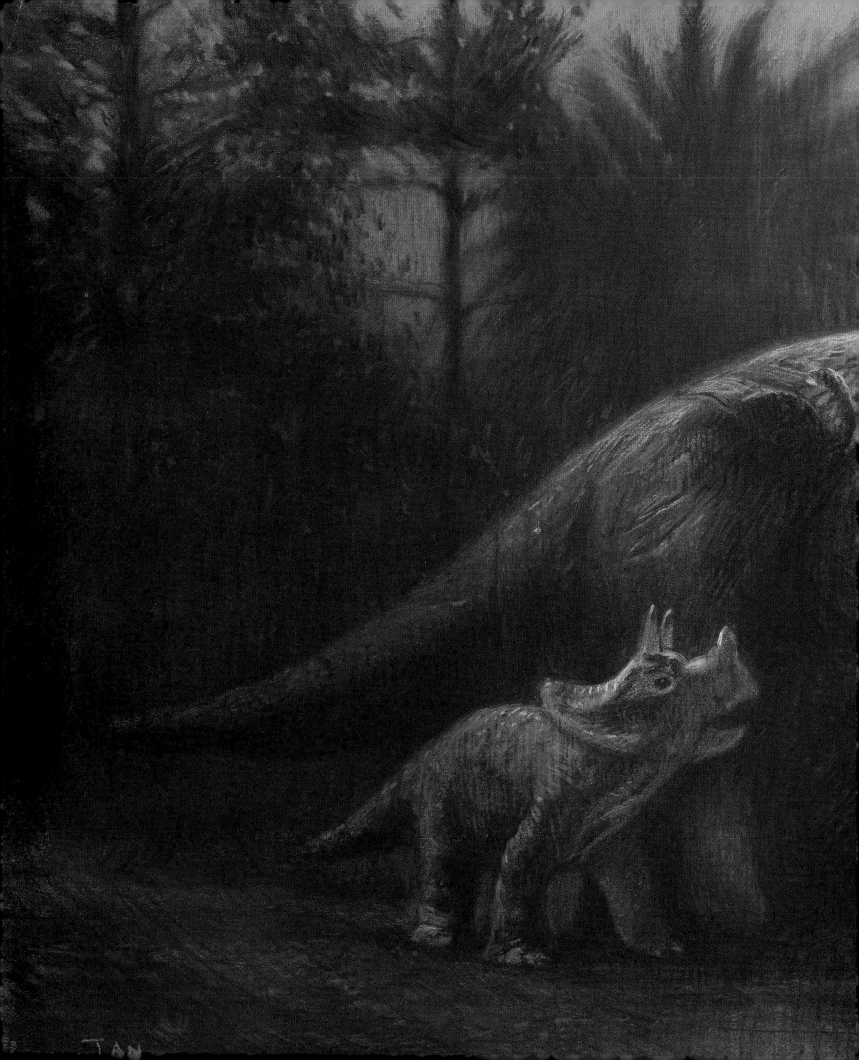

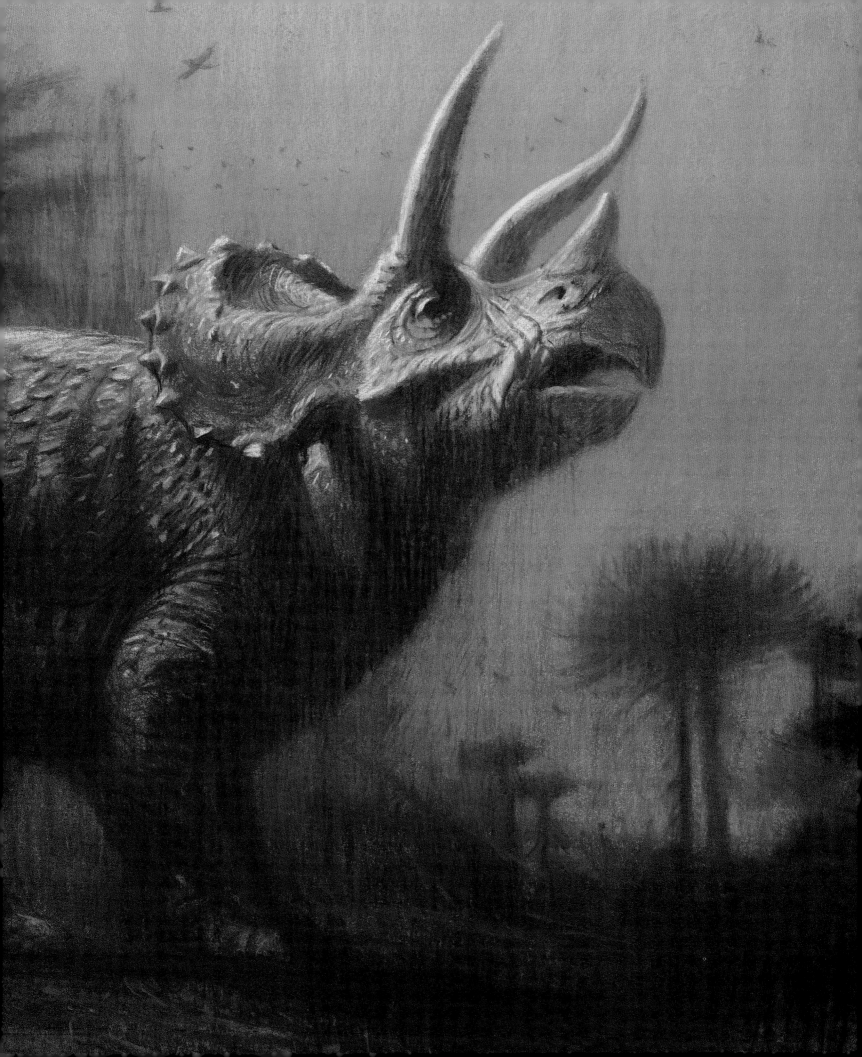

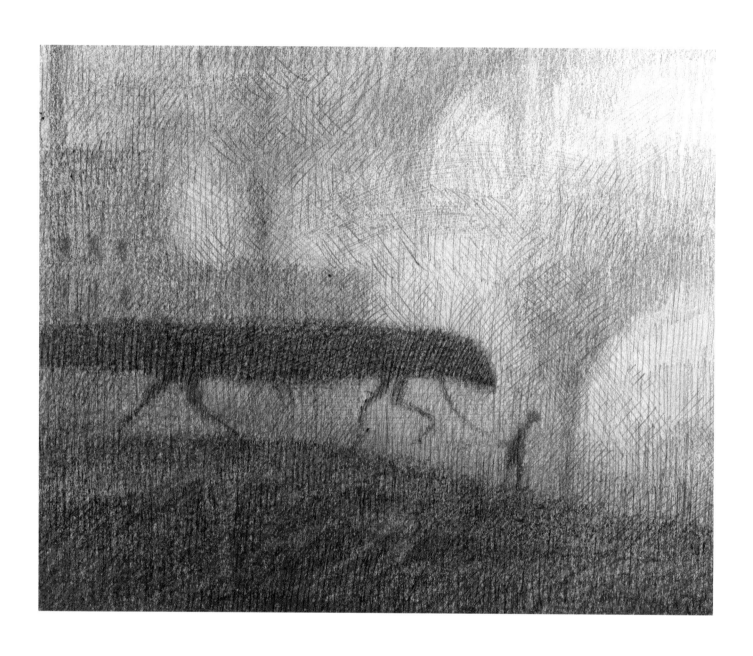

Previous: MOTHER AND CHILD | *Above:* LOCKDOWN

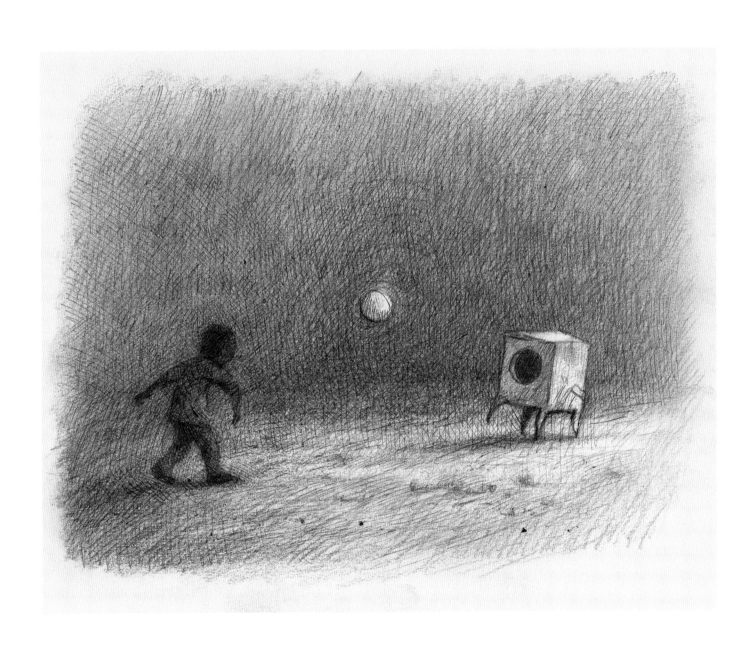

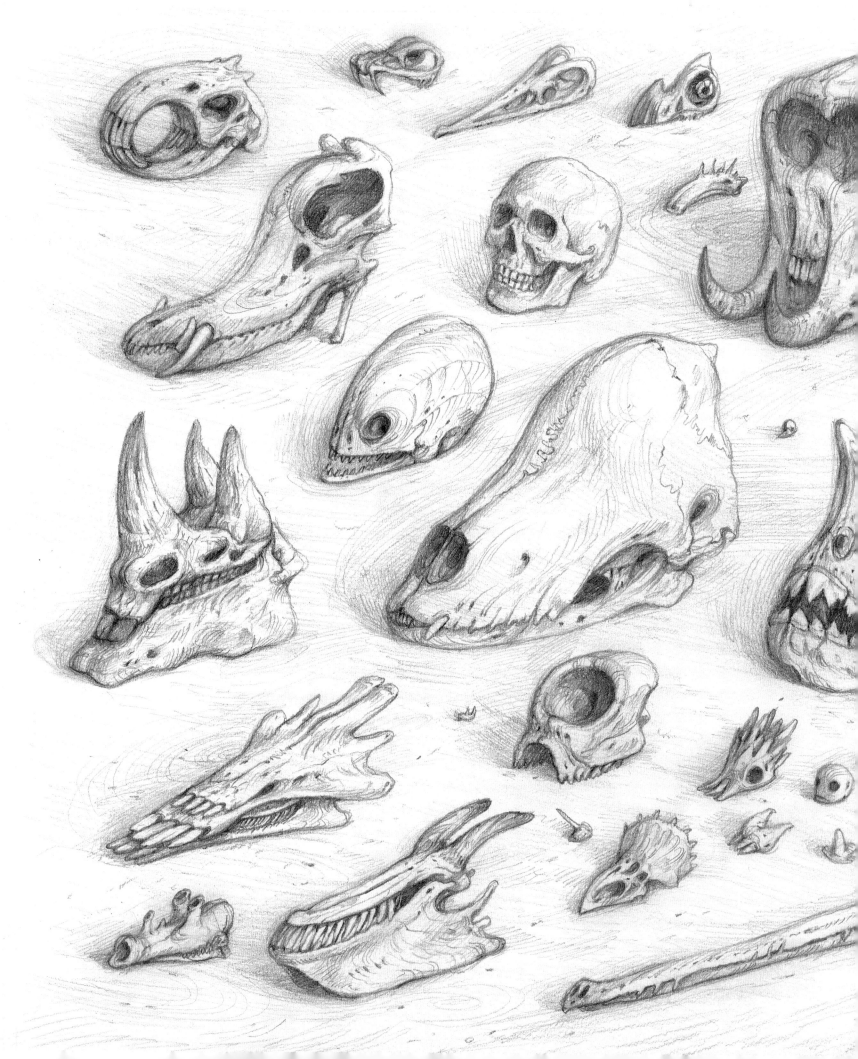

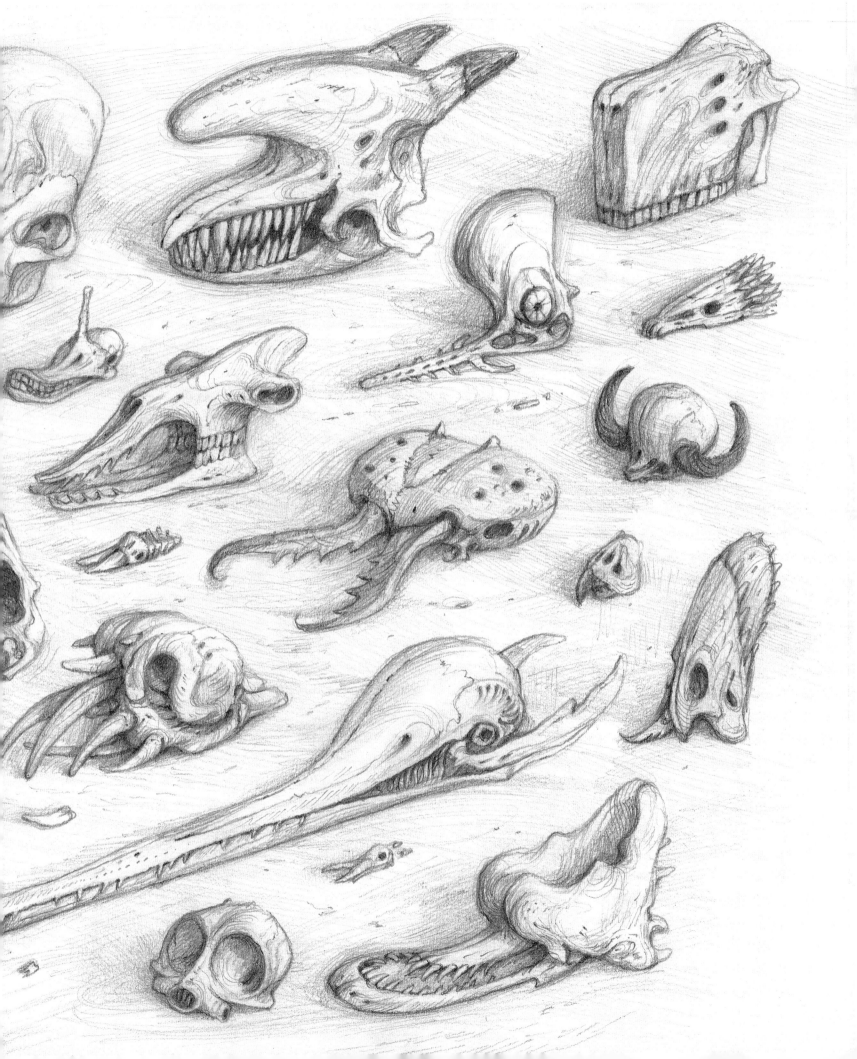

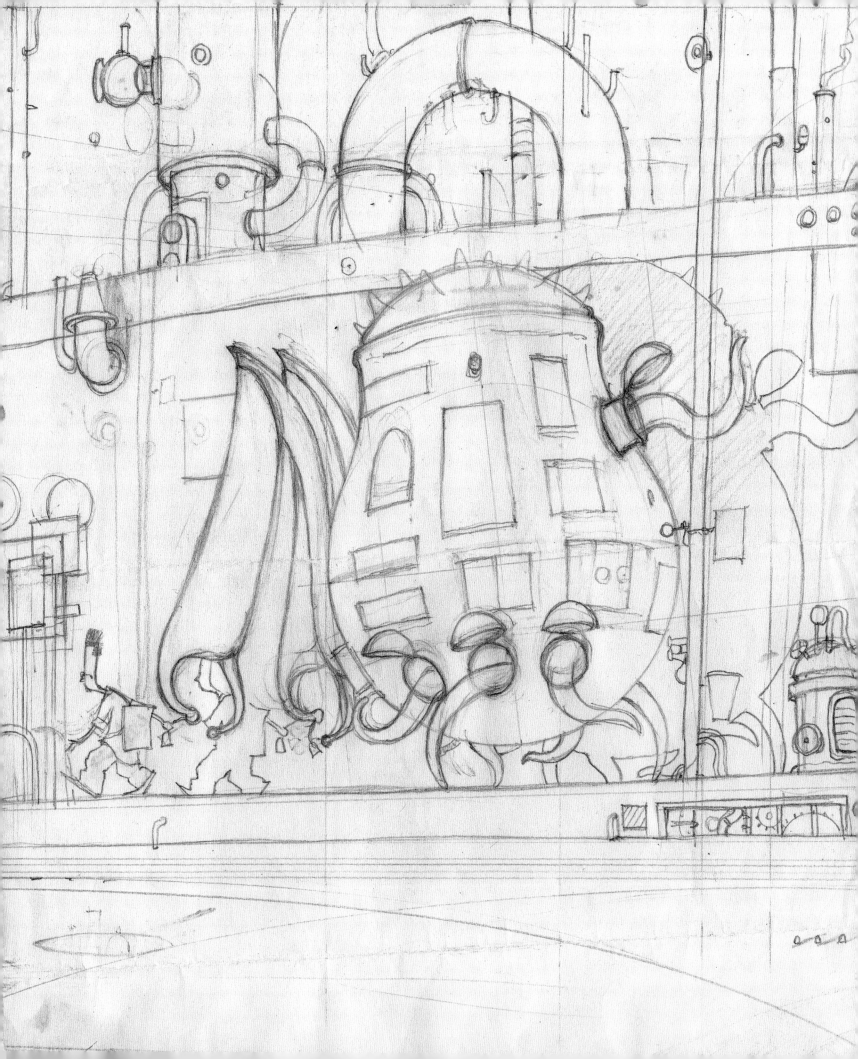

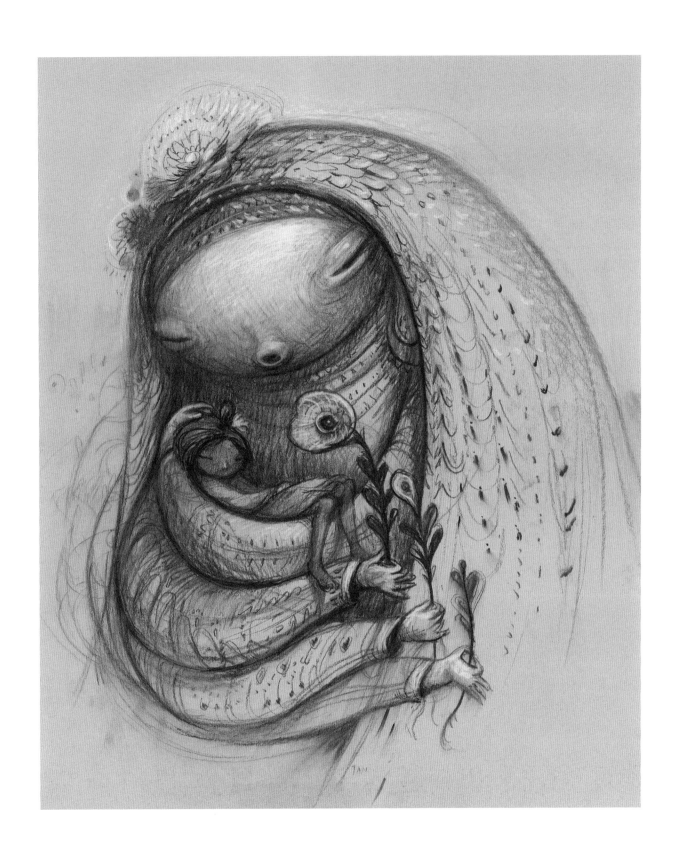

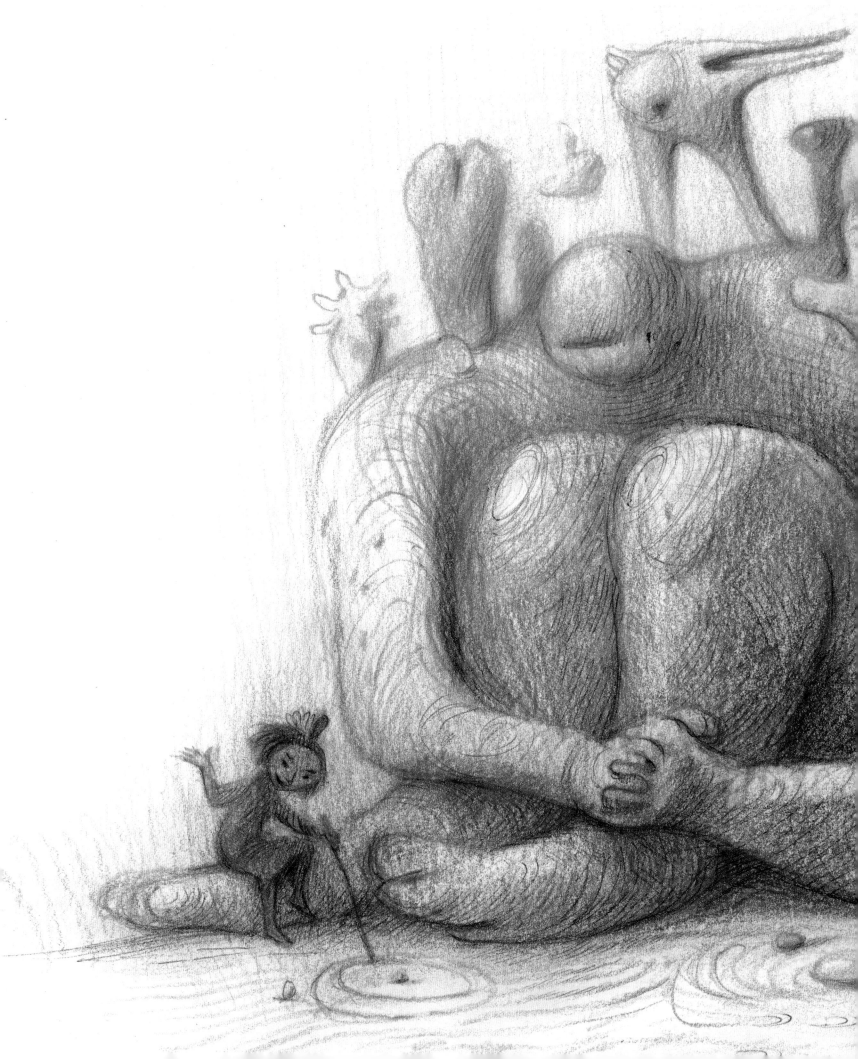

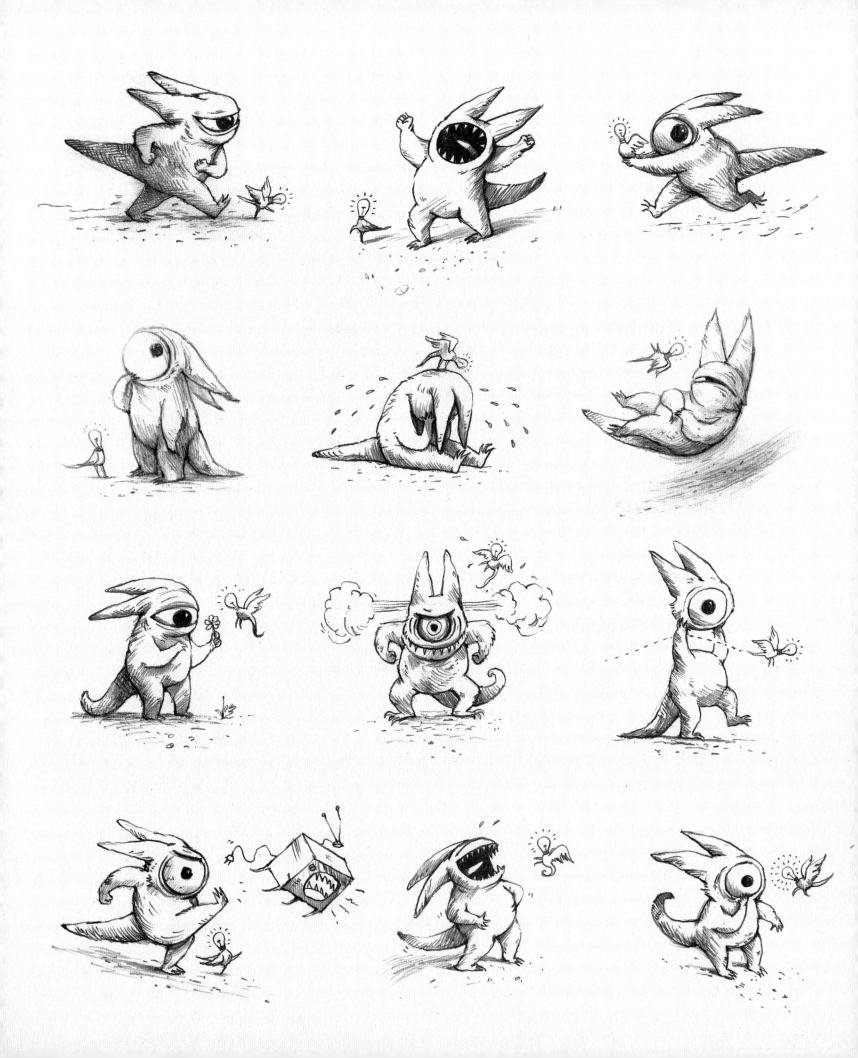

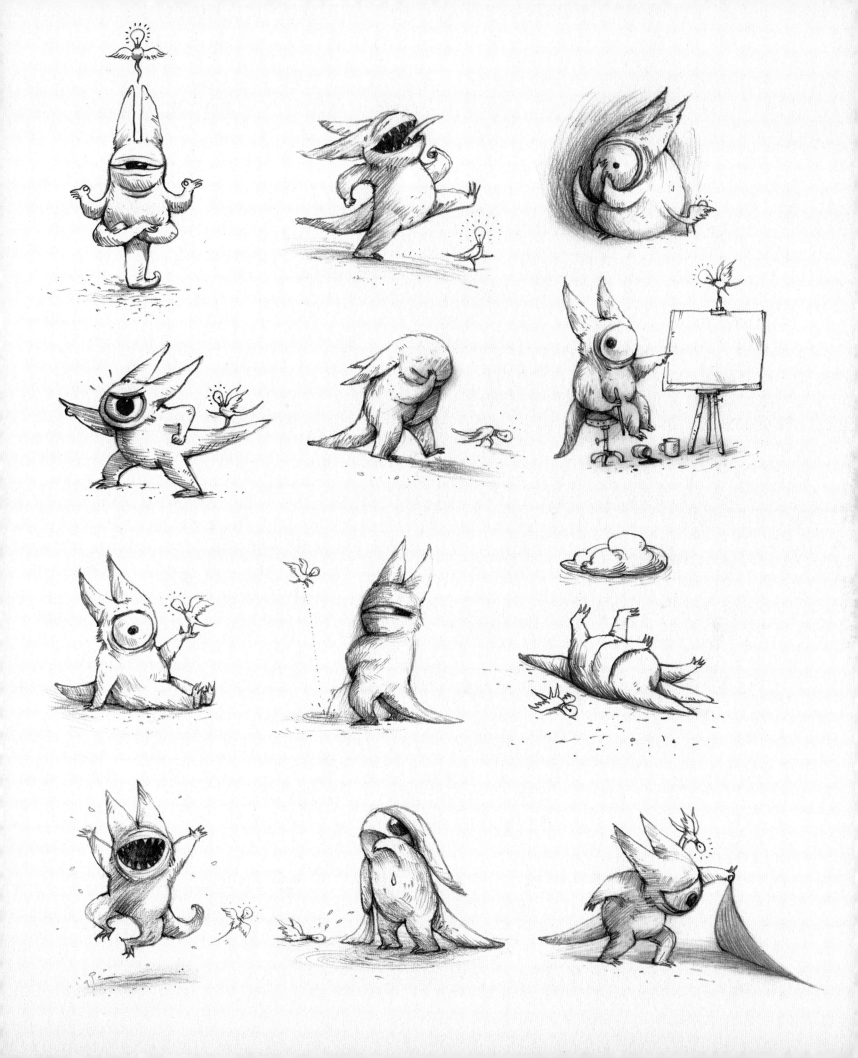

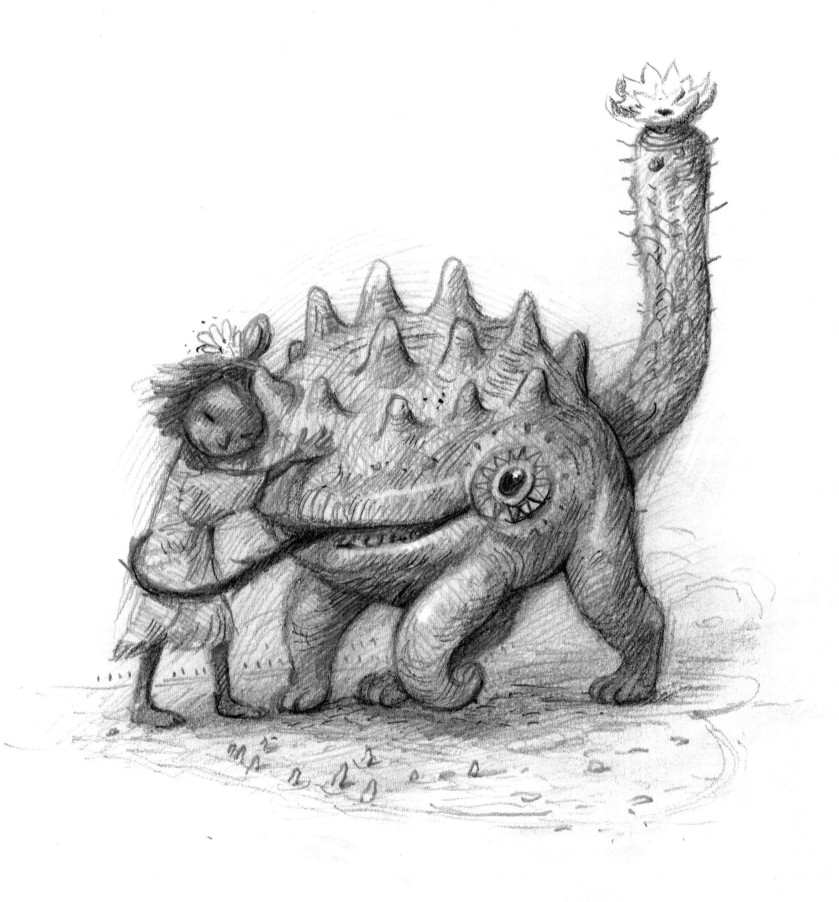

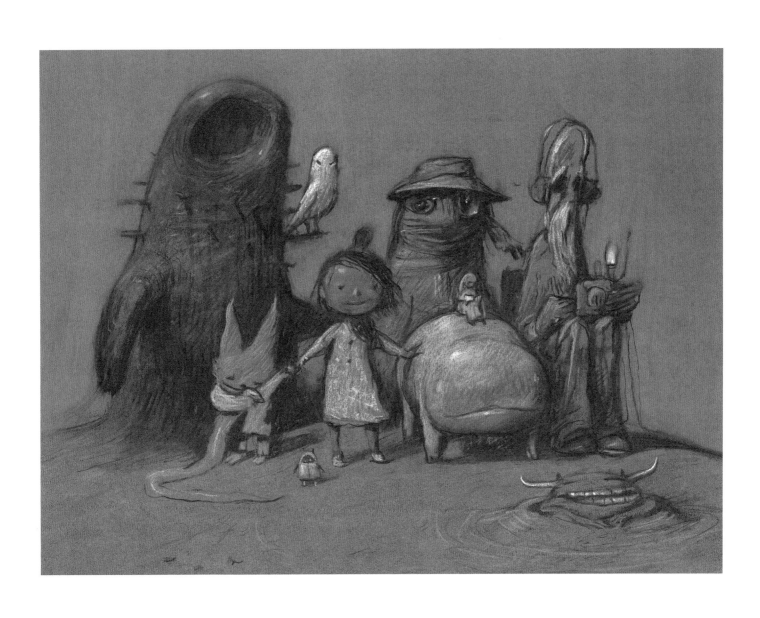

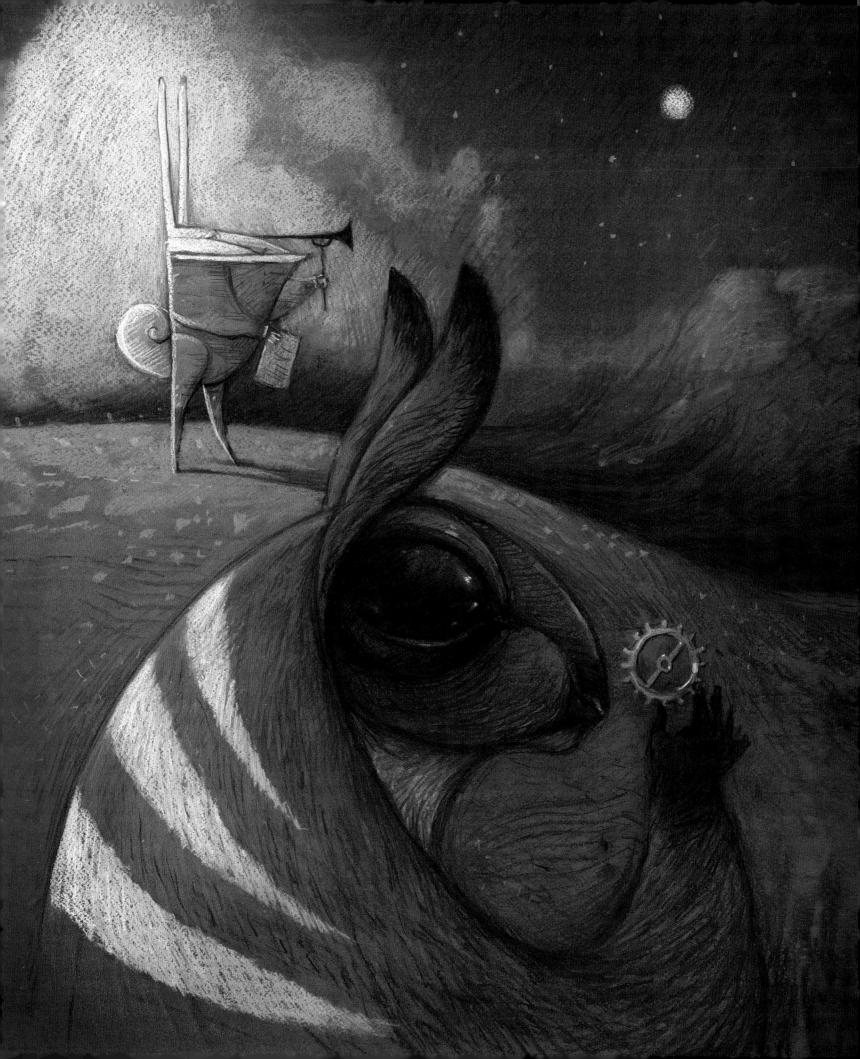

MYTH & METAPHOR

If you can hold this weirdness in your mind, you might just be ready for reality.

One of my favorite picture books as a child was Dick Roughsey's *The Rainbow Serpent* (1975), a retelling of the Aboriginal story of Goorialla, the giant immortal snake that shaped the landscape of Cape York Peninsula in northeastern Australia. In the Dreamtime, the period in which the world and its stories came into being, Goorialla searches the landscape for people of his own language group and upon finding them teaches them how to dress and dance. But he also swallows a couple of young men seeking shelter from a storm, for reasons that are wonderfully unclear. As Goorialla sleeps on a nearby mountain, fellow tribesmen cut their kin free: the boys fly out of the serpent's stomach as colorful rainbow lorikeets. When Goorialla wakes he flies into a rage, smashing the mountain into smaller landforms, killing some of his people with falling rocks while others hide forever by transforming themselves into the plants and animals we see today.

This story made intuitive sense to me, as a child, beyond anything logical, and decades later I'm still struck by Roughsey's hypnotic paintings of the rainbow serpent, especially the vacant red pools of the creature's eyes, such a perfect representation of inscrutable wisdom and passion. The landscapes are equally disquieting, distinctively Australian: plains with low horizons studded with elemental trees and people, stretching to infinite possibility while at the same time flattened to a nearly shadowless frieze, a distant memory, like fossils pressed in time. At the center of it all is the enormous serpent, Goorialla, coiling, dancing, awakening humankind to the elevating force of sacred art, only to crush it all with sudden violence. Which, true to his deeper nature, is yet another act of inexplicable creation.

The word *myth*, originating from *mythos*—speech, narrative, or fiction—has come to refer to any story that seeks to explain a natural or social phenomenon, notably involving at least one supernatural creature, whether a colorful serpent, an angel, a talking fox, or a cyclops. The word *metaphor* comes from a Latin phrase meaning "to carry across," to transfer the qualities of one idea to another. As a storyteller and visual artist, I tend to think of myth and metaphor as more or less the same thing, and a useful way of framing my own attraction to imaginary creatures and the urge to charge them with narrative force, inspired by the very first stories ever told around a fire, or even before any flame was struck.

Opposite: THE COG

As they walk, fly, swim, and crawl, these creatures follow the deep ruts left in our cultural psyche by thousands of years of storytelling, everything from ancient religion to intergalactic space opera. Sphinxes, dragons, golems, and droids: these are things that infuse—and will continue to infuse—our everyday language and dreams, passed on through print, screen, and backyard conversation like hereditary strands. As an artist, I always like to check the "truth" of an image by trying to assess its similarity to those myths that fascinate me the most, like that of the rainbow serpent. Does a drawing or painting feel strange enough, yet also real, like the memory of something that happened a very long time ago? A story I may have seen, read, or heard about elsewhere? An old question in search of a contemporary answer?

Importantly, no good metaphor should be too transparent, too specific in the sense that one thing means or represents something else. I'm not a fan of symbols, signs, allegories, and allusions, where a painting or story requires decoding or special knowledge. Even a five-year-old should get a fair gist of any well-rendered narrative without having to ask for a meaning, hence my attraction to books for young readers as much as books for older ones. The long-eared creatures that colonize an alien landscape in my book with John Marsden, *The Rabbits* (1998), might draw upon Australian history, but they are too strange to properly signify it, nor do they need to be so particular. If anything, it's the overall feeling of weirdness that is being shown, and this is the thing I'm most interested in as an artist—how things feel rather than what they mean, not unlike my first impressions of *The Rainbow Serpent*. The world around us and how it came to be is surely too strange a story to be reduced to clever signs and symbols. The best metaphors are always left open, unwritten, yet still feel true, regardless of who you are or what you know.

Similarly, the most memorable passages of traditional myths—especially my personal favorites, creation myths—defy any learned logic as if that's a necessary condition of engagement. Clouds are made from the brains of a dead giant thrown into the air, the world rests precariously on the back of a tortoise, a creature with an axe emerges inexplicably from a cosmic egg, people and animals swap bodies willy-nilly, skipping barely a heartbeat or mention. There is a deliberate obfuscation of reality, testing the suspension of disbelief, as if to say, "If you can hold this weirdness in your mind, you might just be ready for reality."

The dream-logic of myths is no doubt just that, borrowing from what is arguably the antecedent of all fiction: dreams. You need only recall the visions of last night's sleep to know our brains assemble stories in very strange ways, in myths and metaphors that seem to acknowledge rather more than our conscious selves care to. What I love about drawing, especially loose and unplanned sketching, is that it

approaches a kind of wakeful dreaming. I don't often know exactly what I'm doing, but I let the lines uncover latent forms and intentions, like finding shapes in clouds or characters in ink blots, a flow of associations without too much calculating force. The process suggests some connection with more universal mythology, the tendency to let imagination run amok without relinquishing a safe tether to more familiar reality: masses, edges, textures, colors, and other recognizable elements that can be rendered by the material grit of a brush or pencil. Creatures in particular remain identifiable as beings that are clearly delineated on paper or canvas, stepping into a tangible, matter-of-fact reality of light and shadow, while at the same time drifting beyond description. They have weight and yet they are weightless.

In this way the best myths, fairy tales, and their descendants in satirical fiction—I think of works like *Animal Farm* (1945) and *Gulliver's Travels* (1726), which had a big influence on me as a young illustrator—usually offer very flexible moral instruction. They don't belabor us with didactic lessons, nor do they bless us with allegorical keys. Instead, they ask us to simply pay attention to our own hearts and consider the narrowness of our desires and prejudices, to weigh carefully what is right and wrong, and for what good or bad reasons. Are we a little like Orwell's pigs in believing that some people are more equal than others? Are we more like Swift's calm and rational horses, the noble Houyhnhnms, or the impulsive humanlike Yahoos, obsessed with pretty stones? The answer is never simple.

On one hand, the creatures of fables ask us to measure truth against falsehood, meaning against feeling, responsibility against freedom, and to engage other common dilemmas of human selfhood. On the other, to consider new ways of thinking and behaving altogether, to speculate about other possible selves. Any strange creature, wandering in and out of a myth, has the potential to resonate beyond the clarion call for moral humility, to something even more profound: conceptual humility, to realize that what you know is only what you know, a bunch of human presumptions, and probably not much to boast about in the scheme of things. The most enlightening encounter may well be the one you haven't yet had, a thing that might call your most dependable notions into question, scuttle safe definitions, and stretch your mind just that little bit further. This challenge to complacency isn't necessarily a threat, but rather a welcome relief. A freedom from comprehension, a playful joy. After all, the idea of a novel and nameless living being—as all animals, including us, inherently are—never fails to fascinate, and any brief sighting in a sketchbook always invites a memory, a passing recognition of something we know but find hard to explain. Perhaps the beginning of yet another strange but strangely familiar story . . .

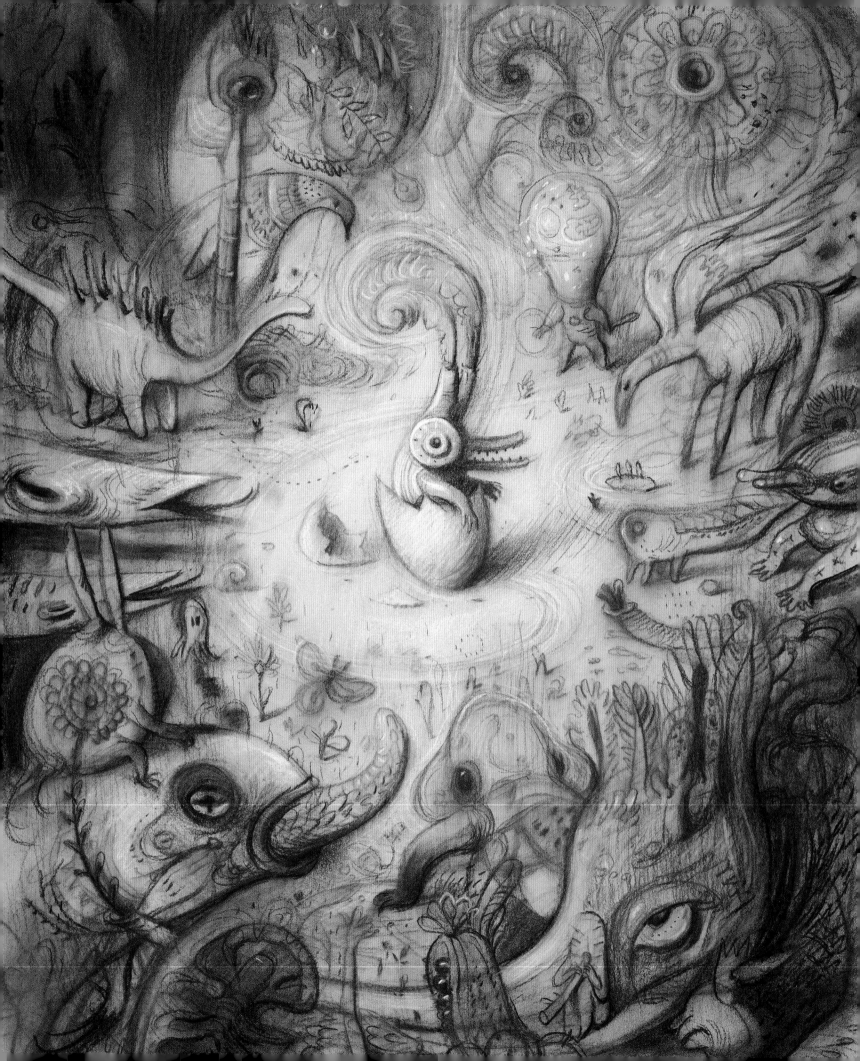

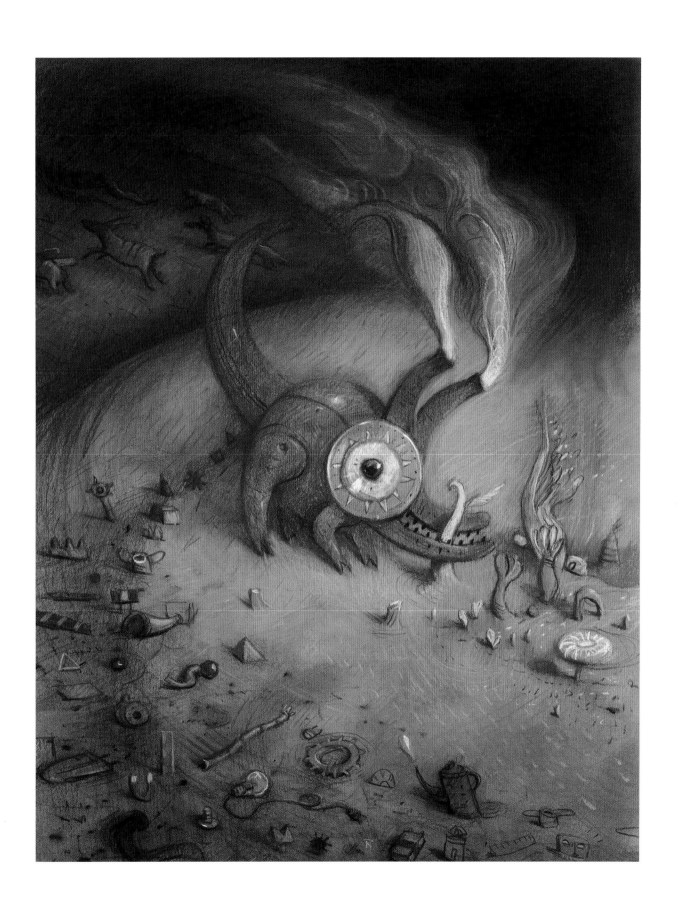

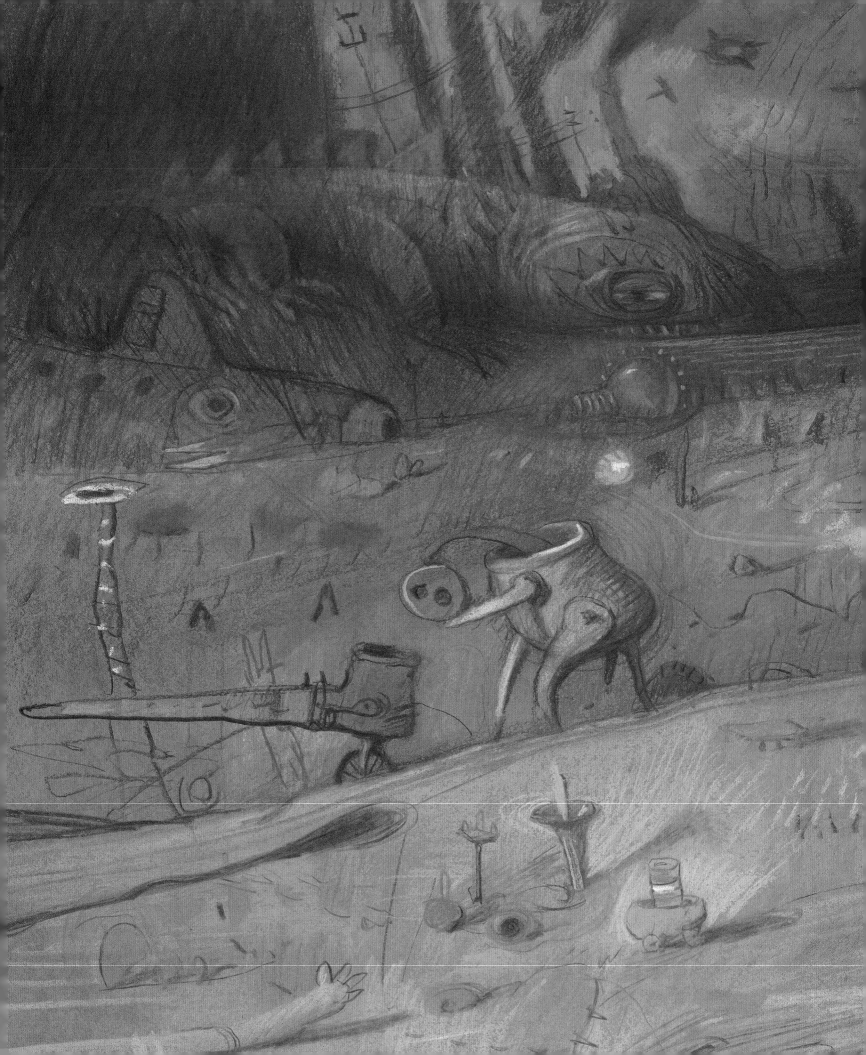

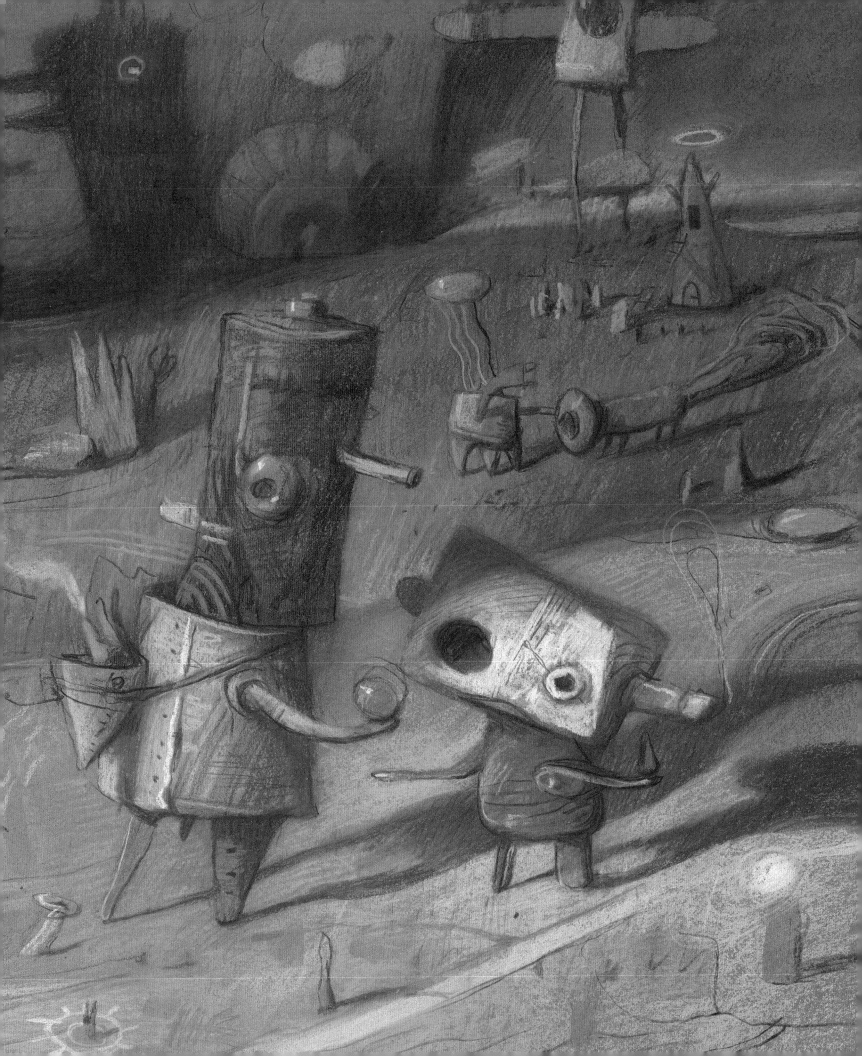

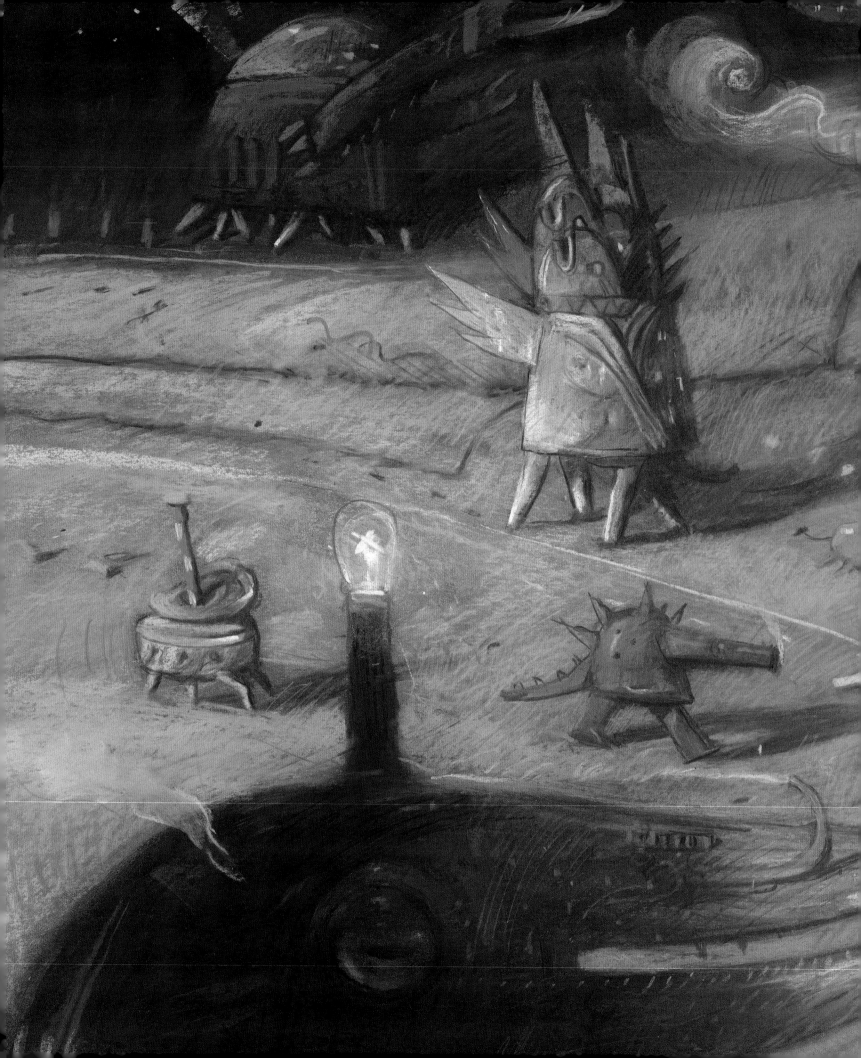

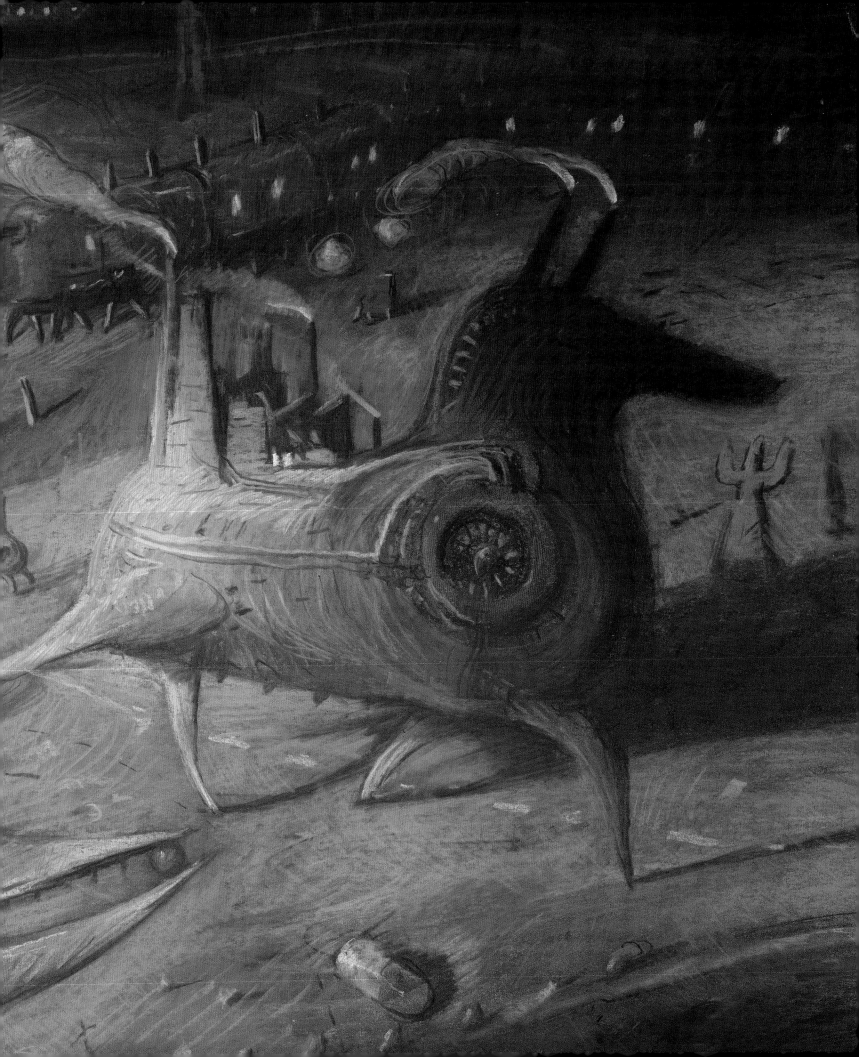

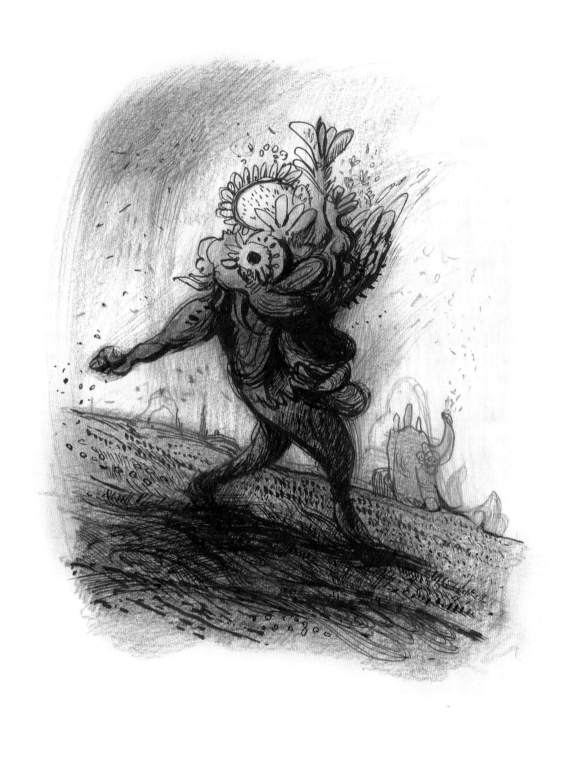

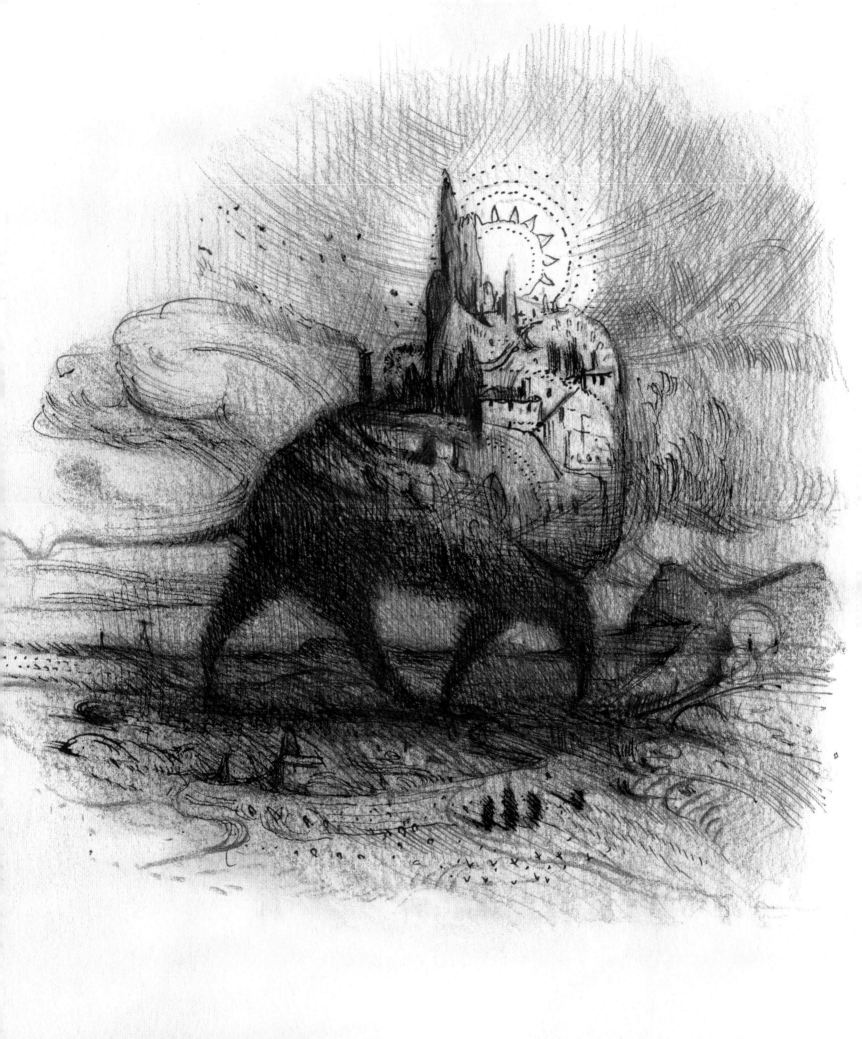

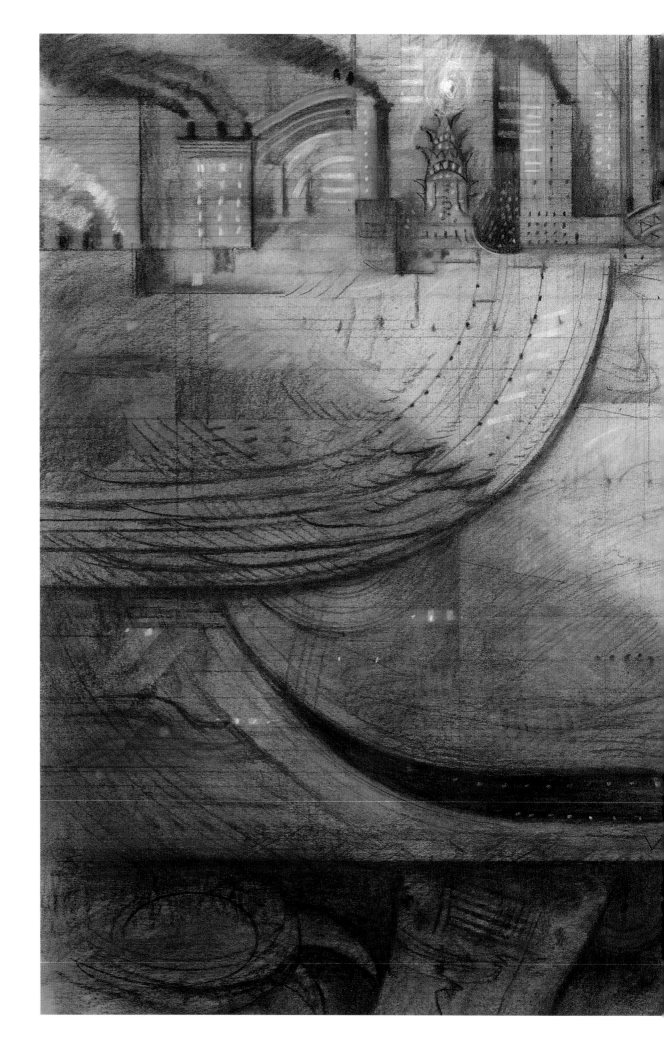

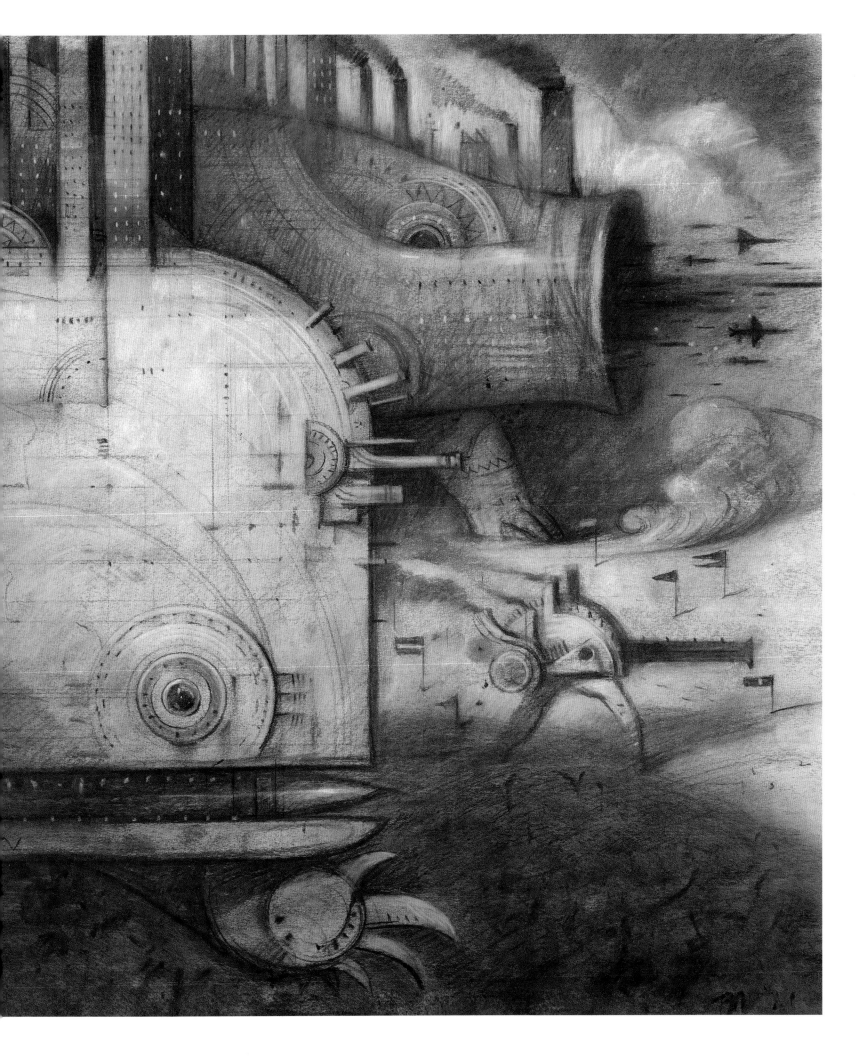

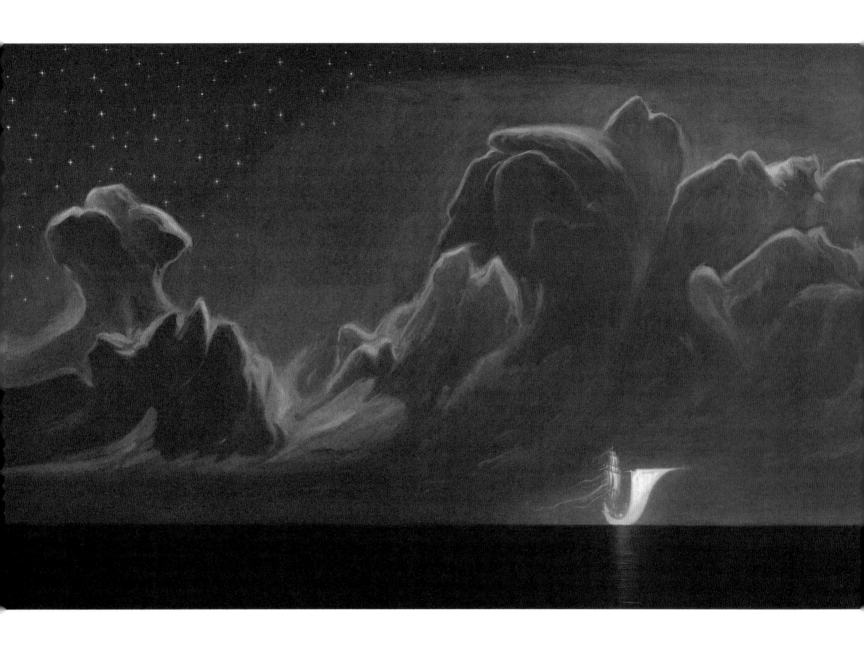

Above: THE SHIP | *Opposite:* THE RABBITS | *Overleaf:* THEY WON'T KNOW THE RIGHT WAYS

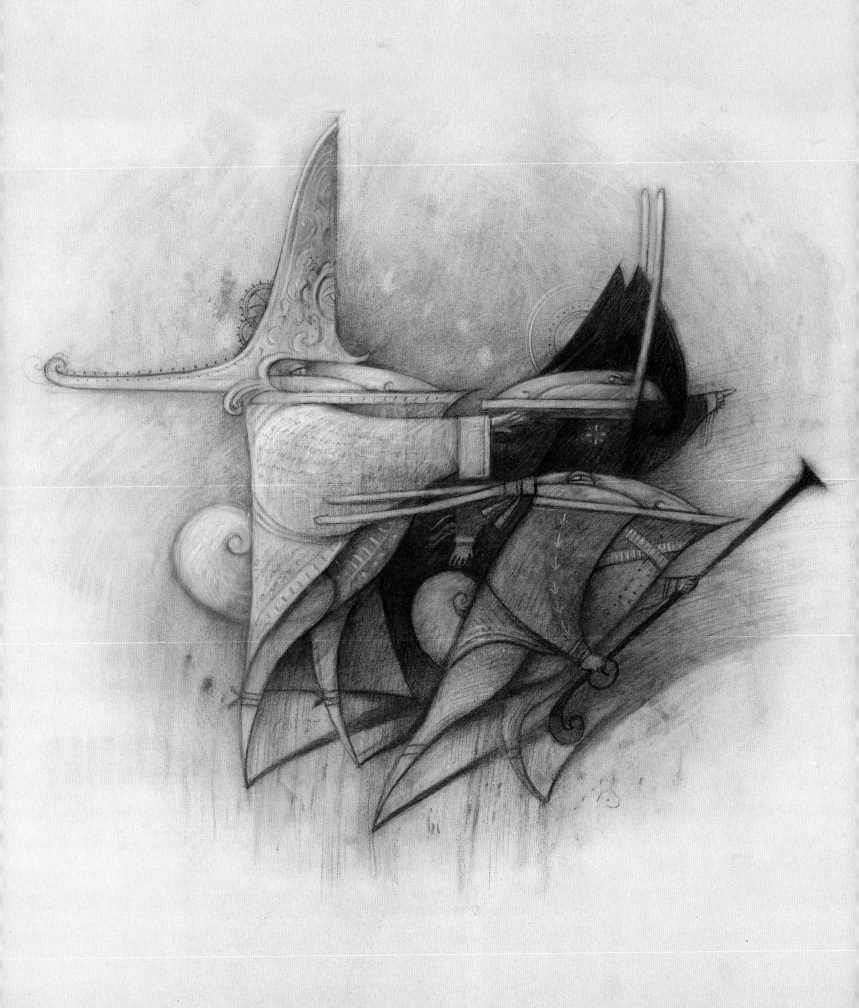

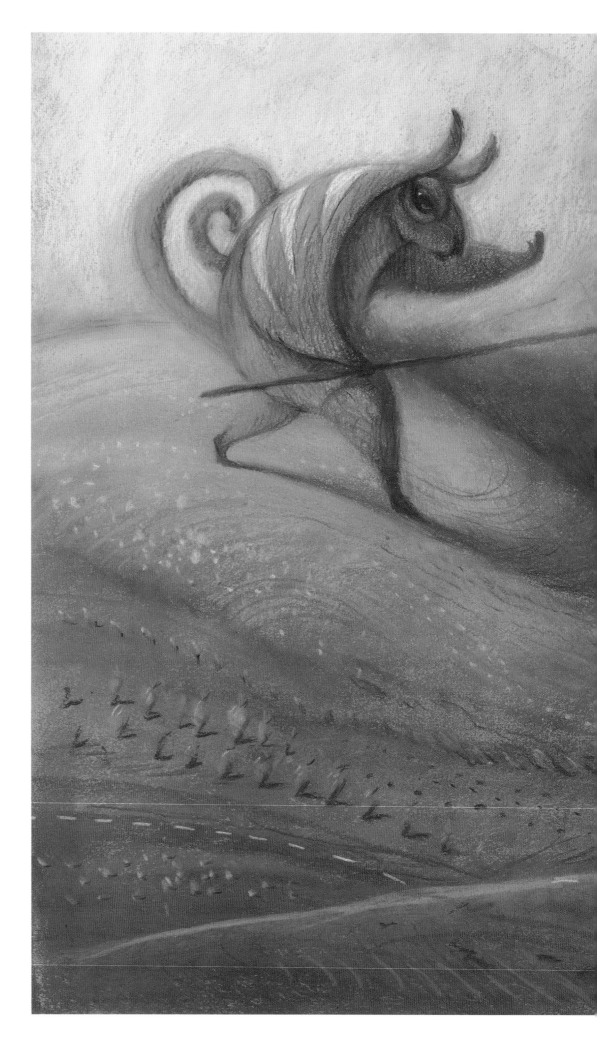

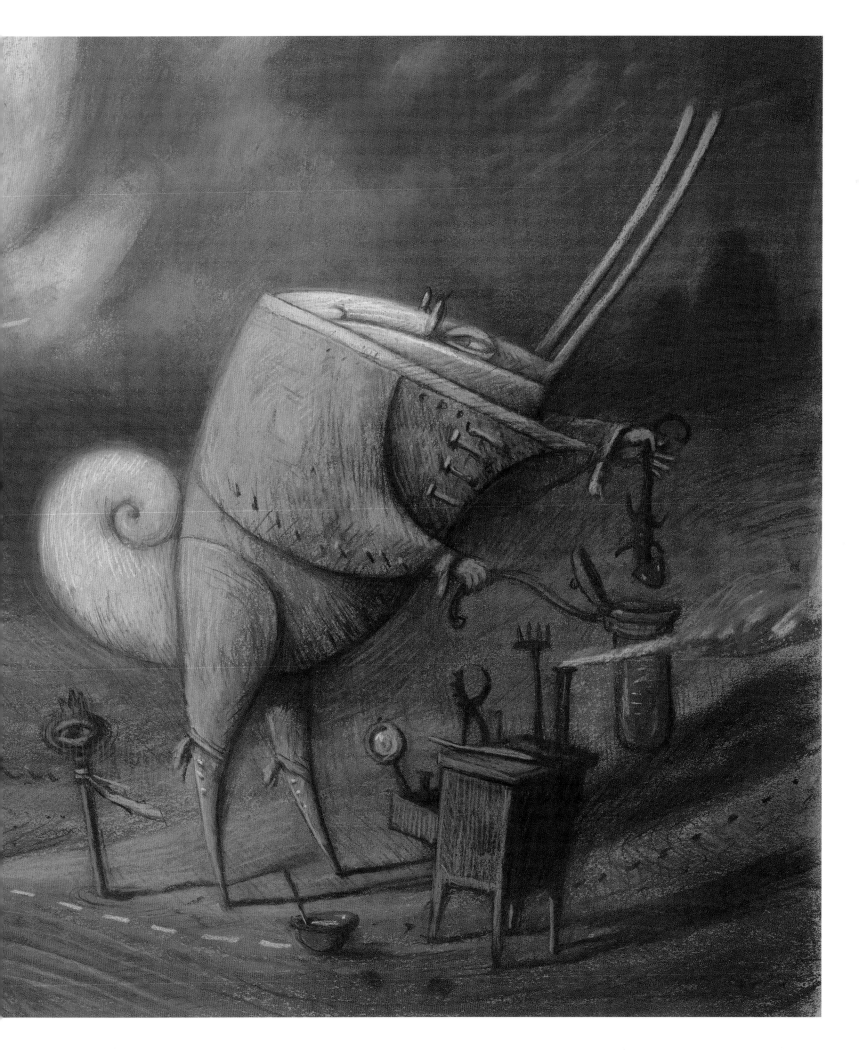

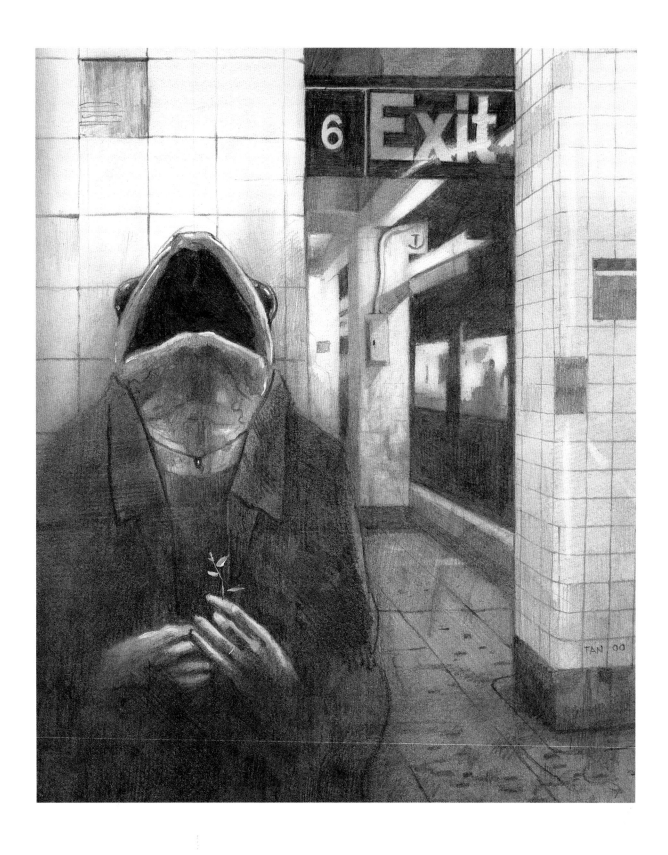

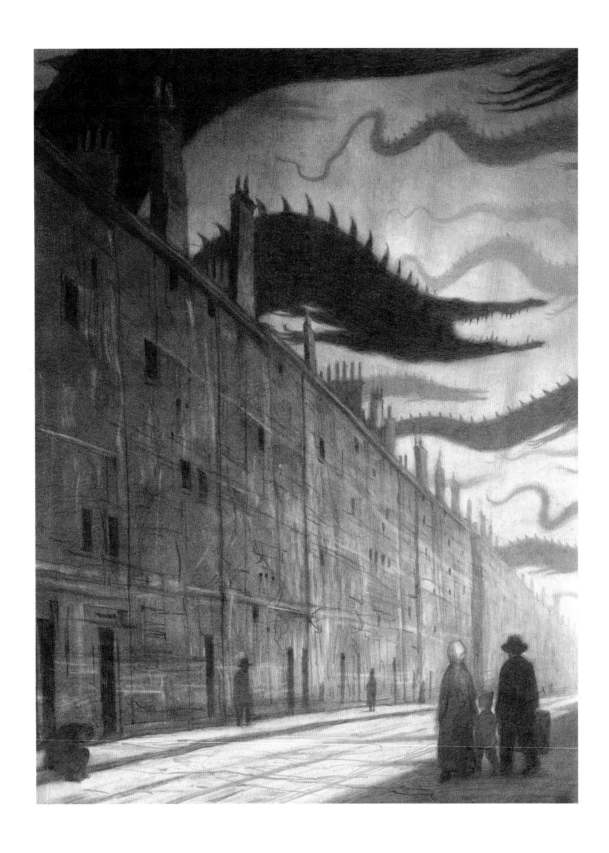

Above: THE OLD COUNTRY | *Opposite:* THE ARRIVAL | *Overleaf:* 1854

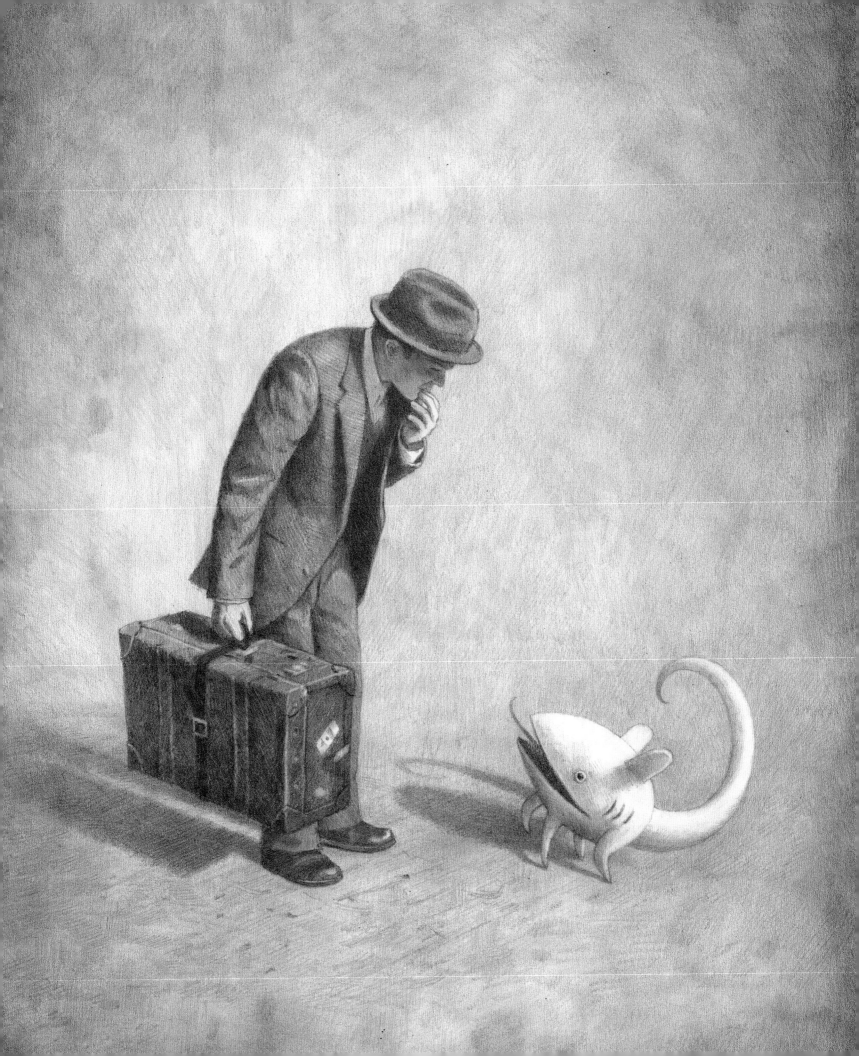

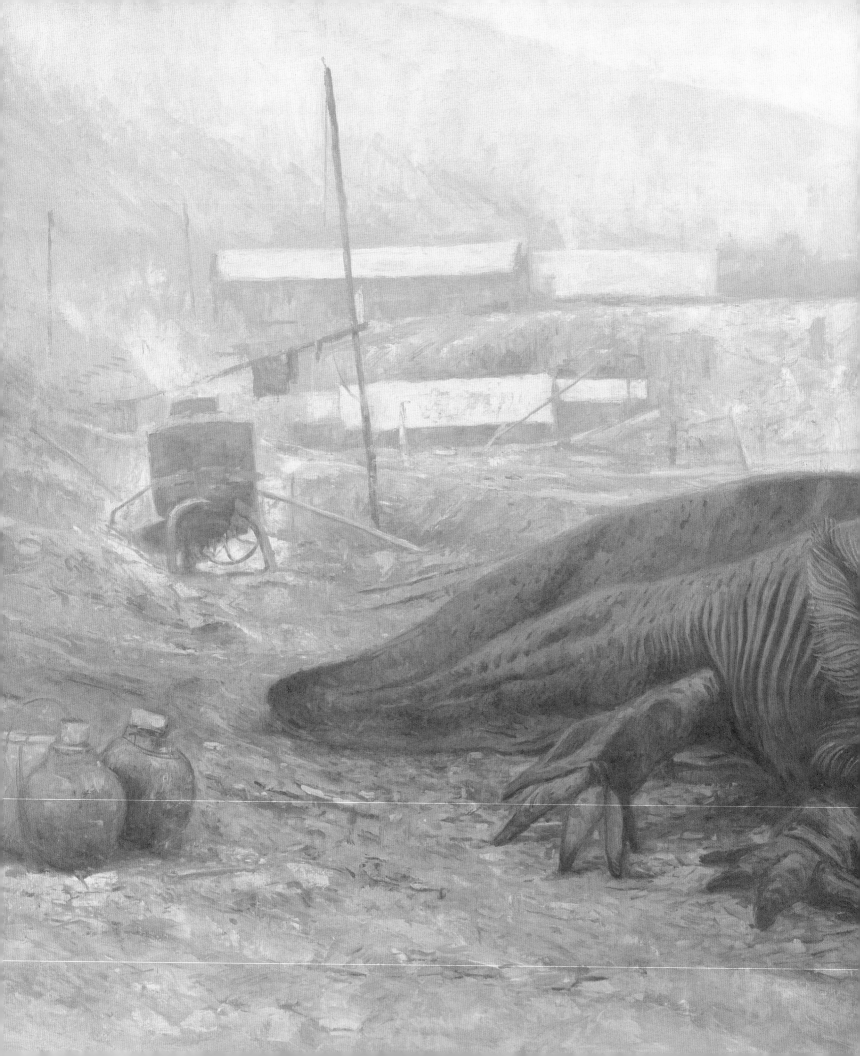

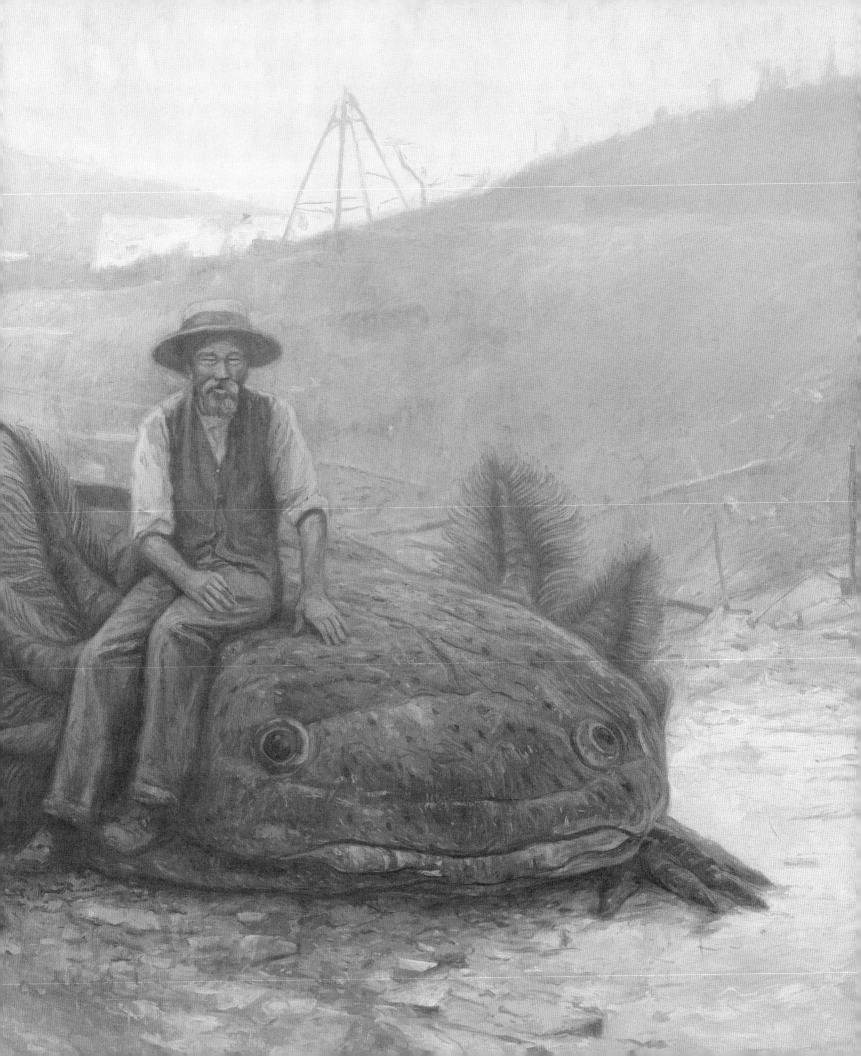

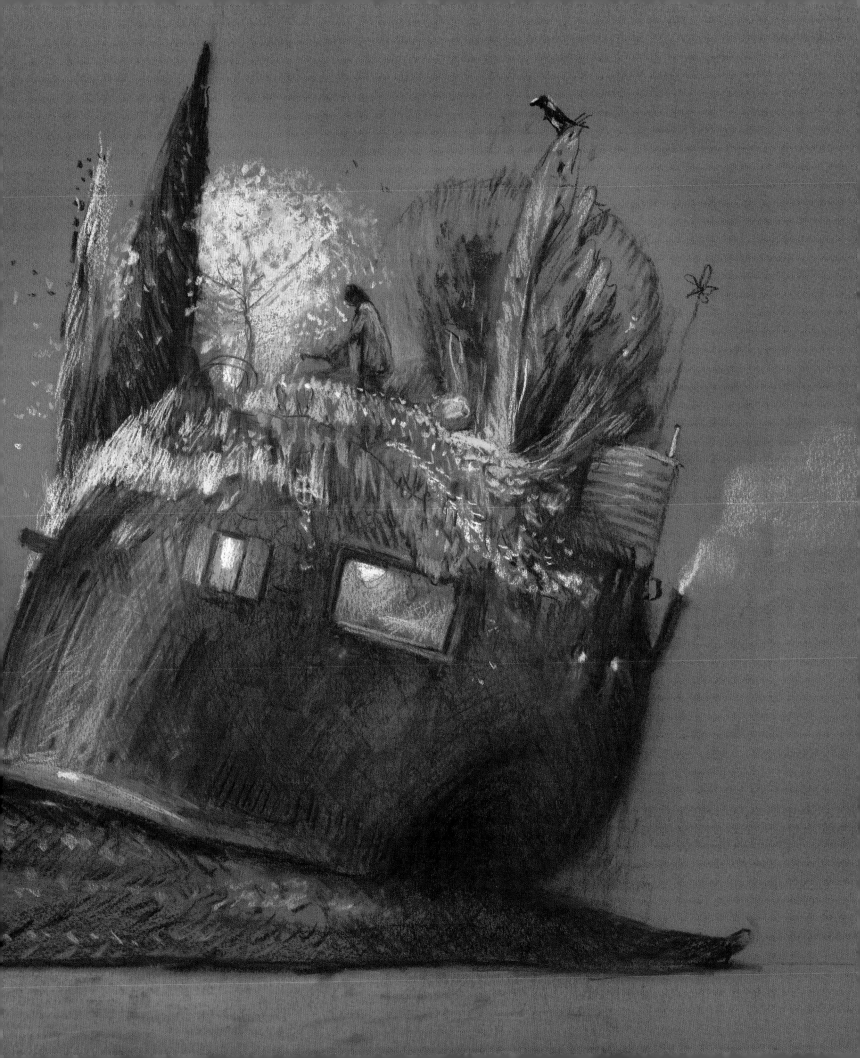

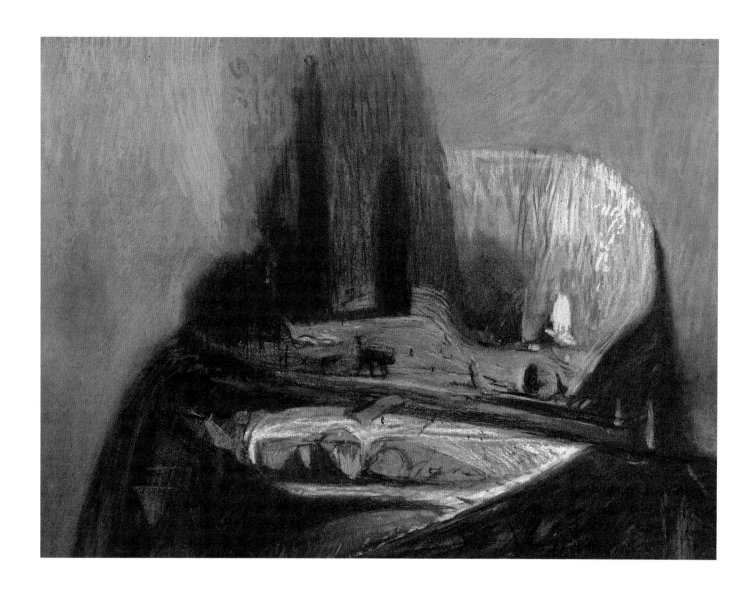

WHERE WE BURY OUR SECRETS

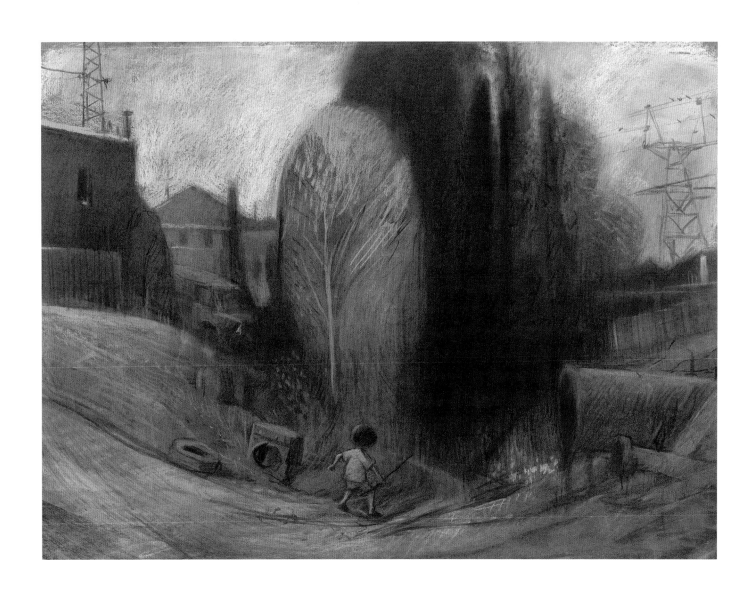

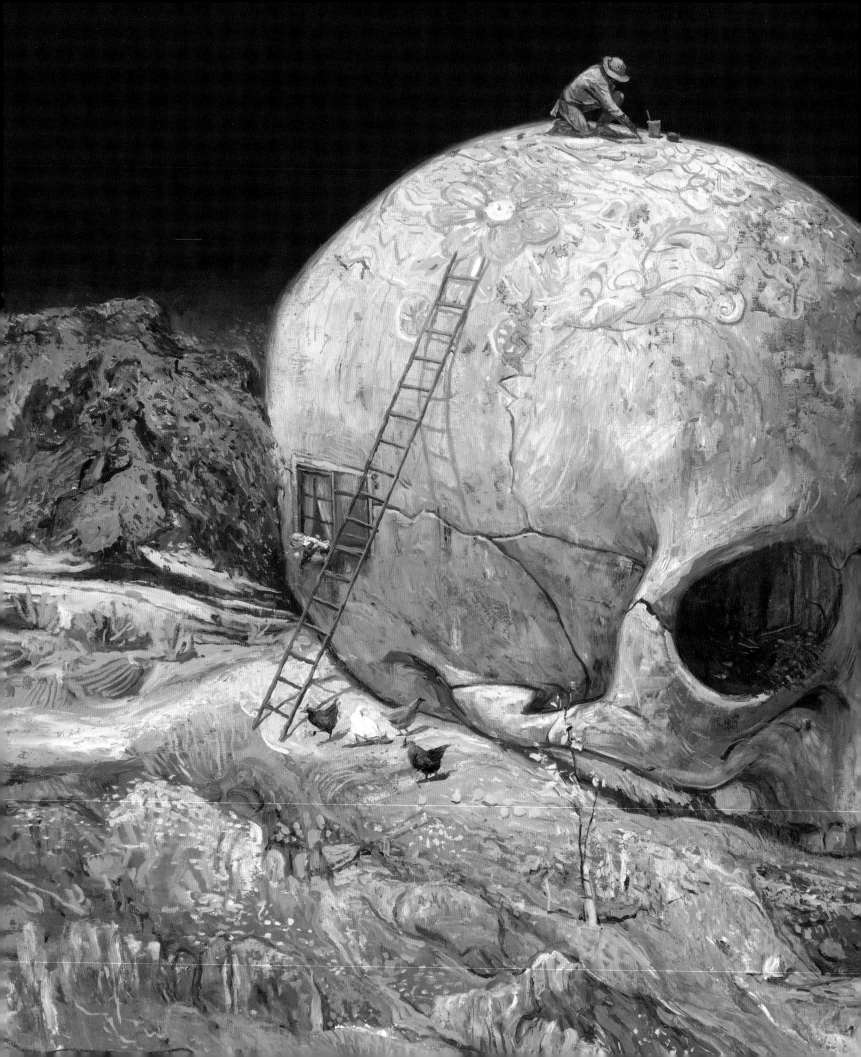

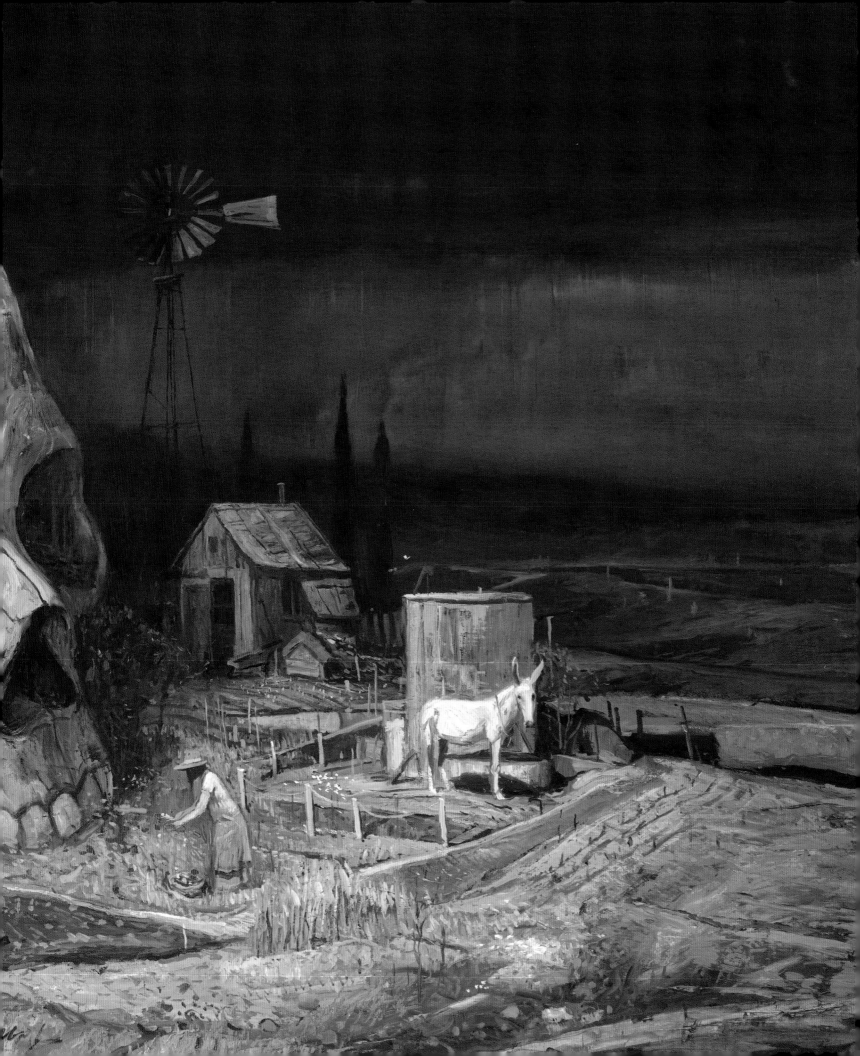

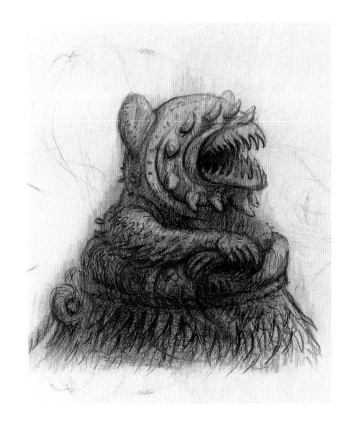

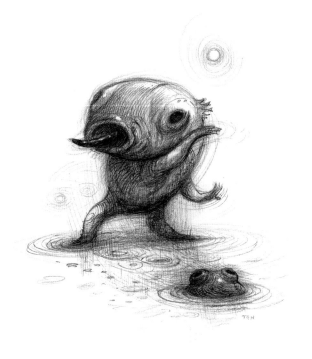

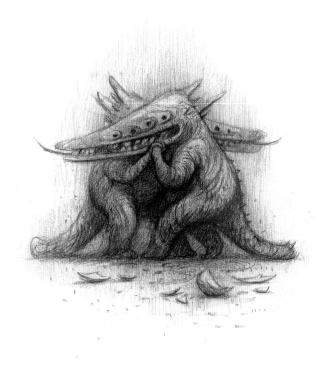

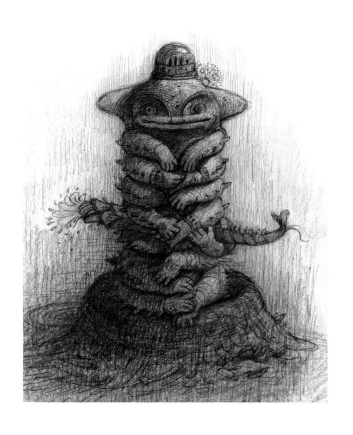
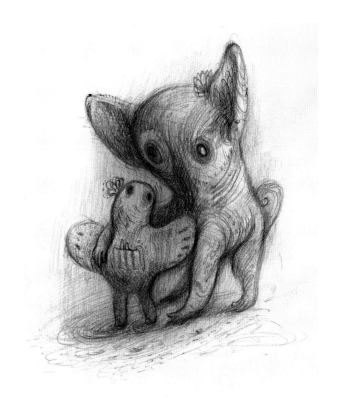
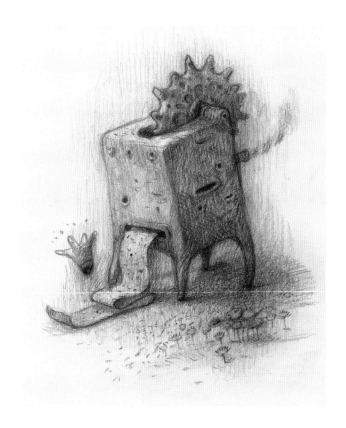

Clockwise from top: BLUE MOTHER, CLAY MOTHER, STONE MOTHER, STORY MOTHER

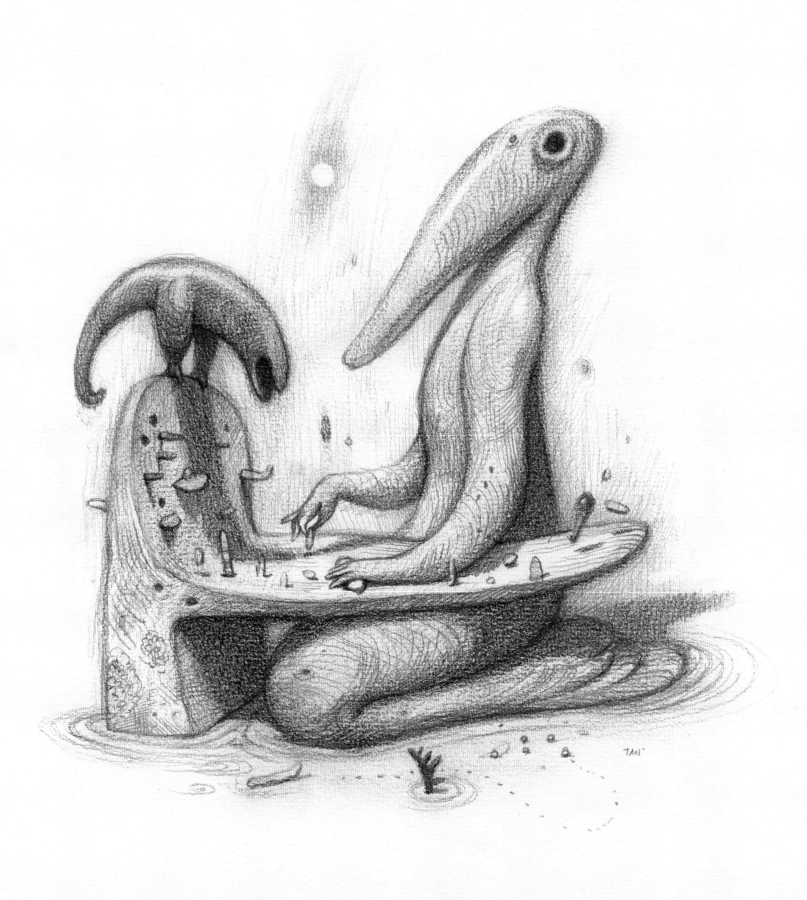

Above: THEORETICAL PHYSICIST | *Overleaf:* ELEMENTAL FORM MOVING TOWARDS A LAGOON TO BE BORN 131

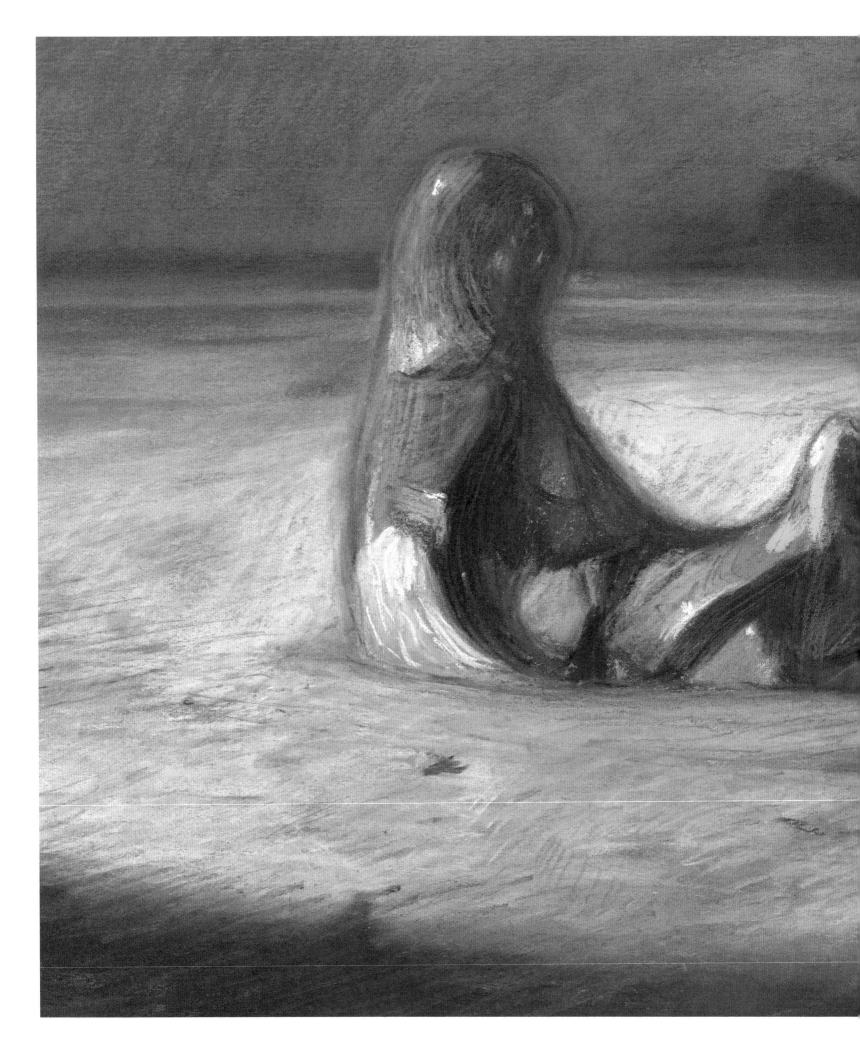

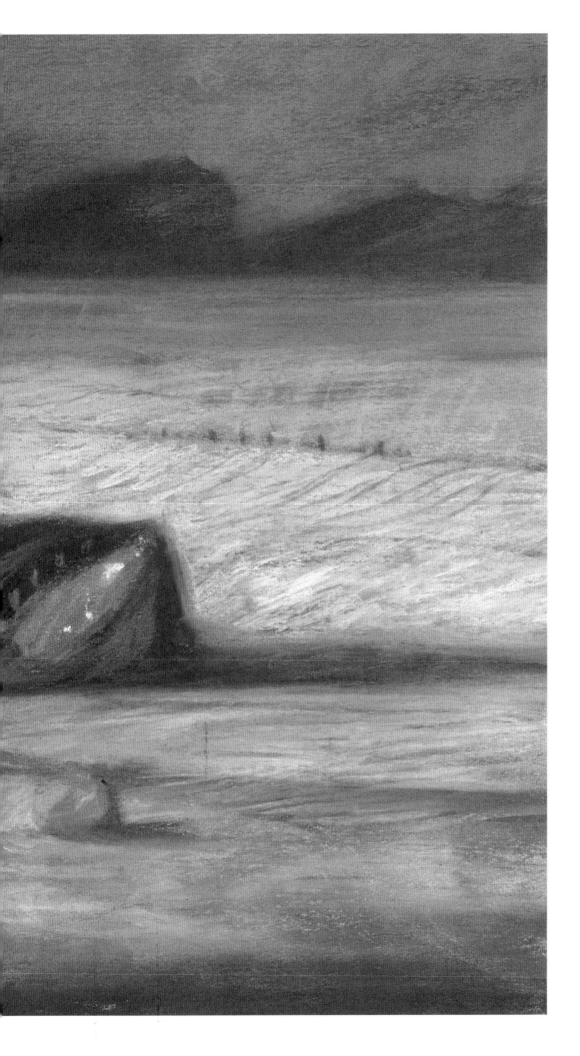

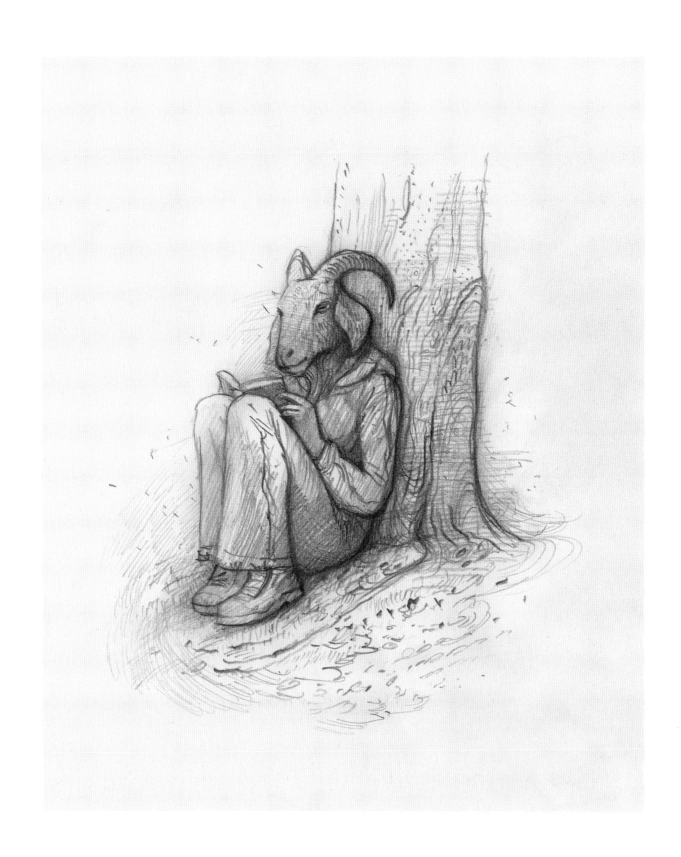

Above: KITE BOY | *Opposite:* THE GIFT | *Overleaf:* OLD SCHOOL

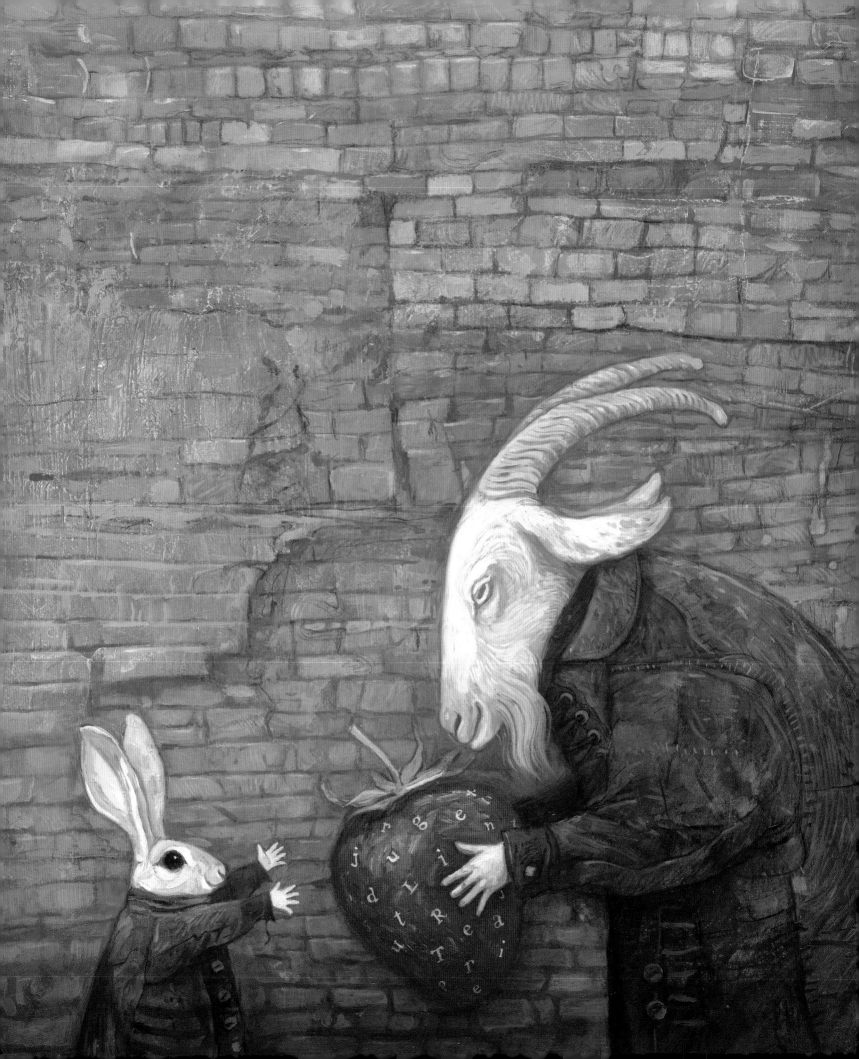

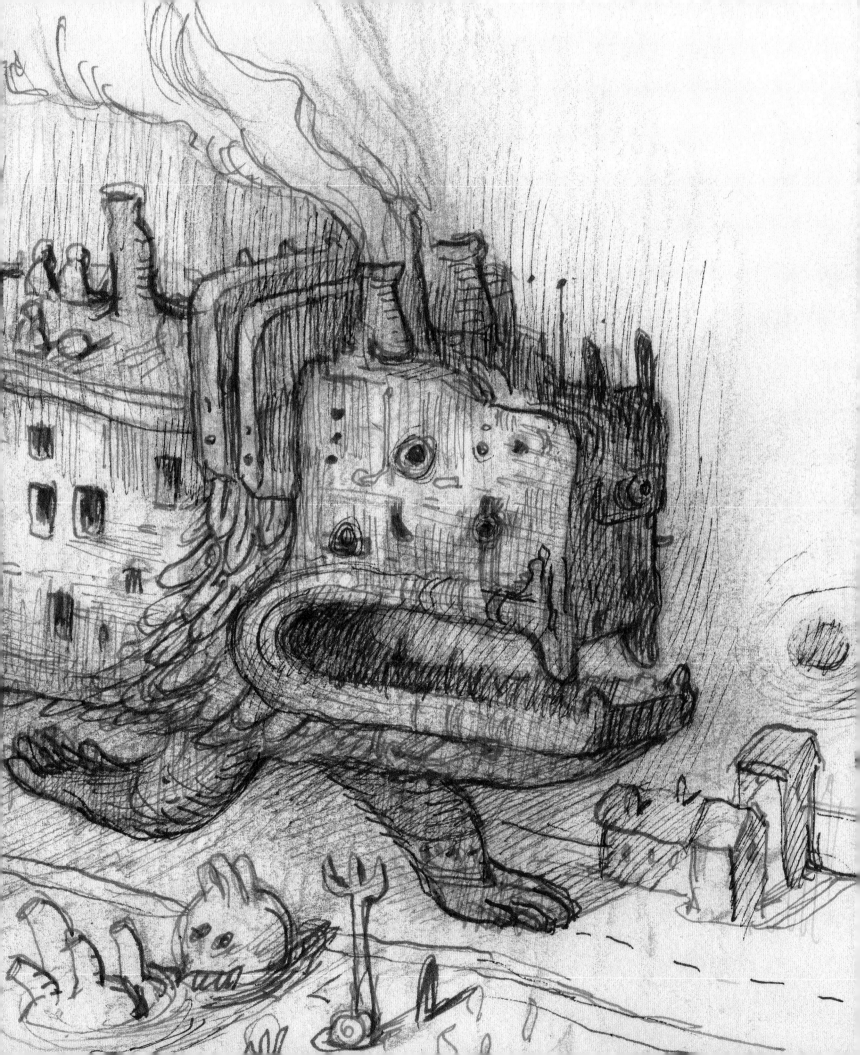

Above: PREPARATIONS | *Opposite:* AWAY WE GO

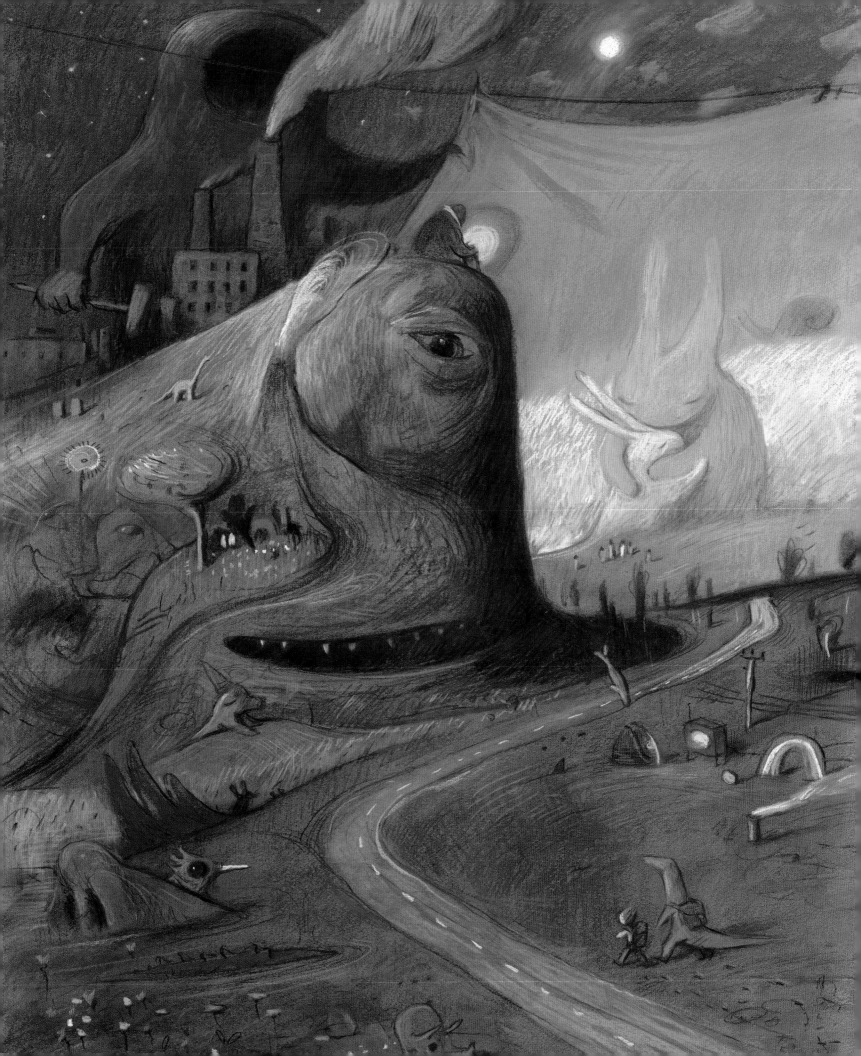

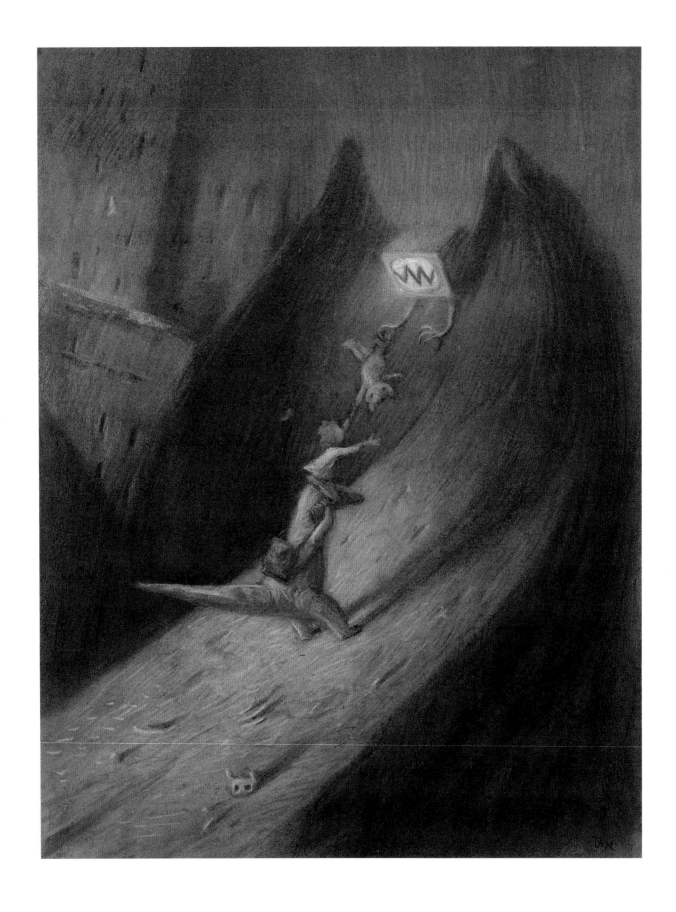

THE HARPY

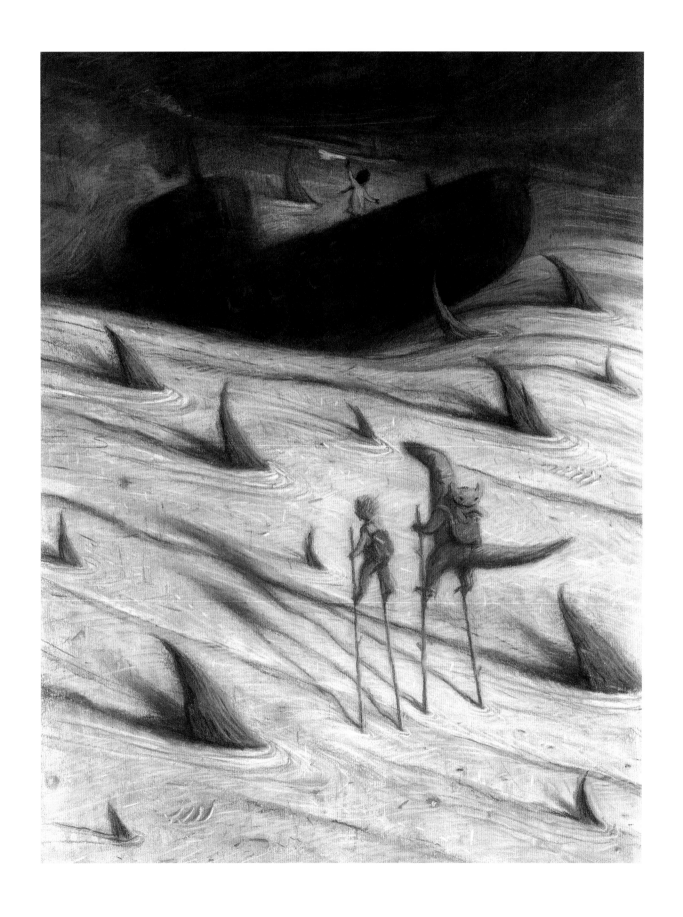

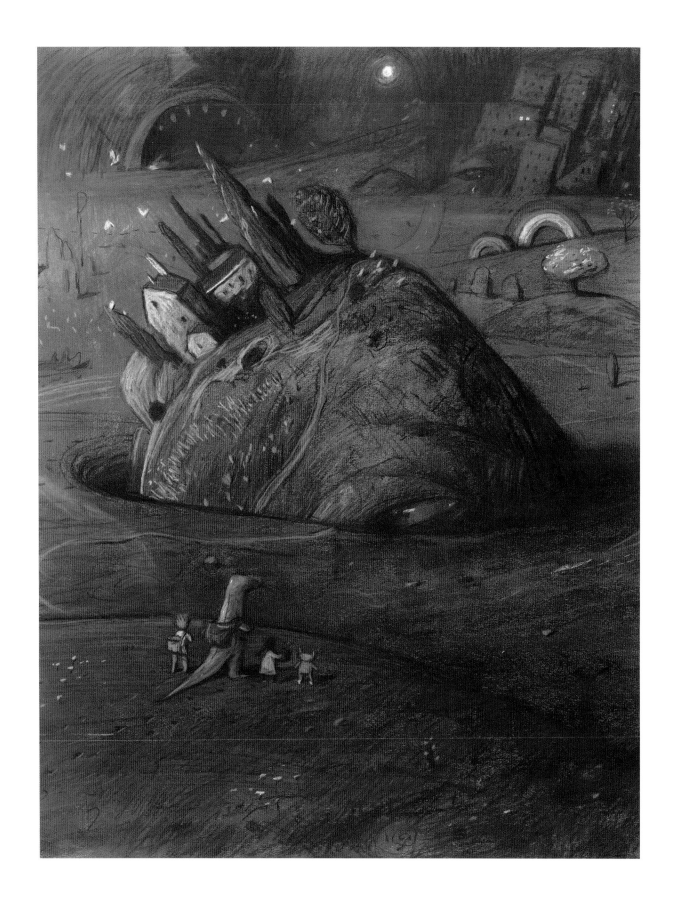

THE RIDDLE

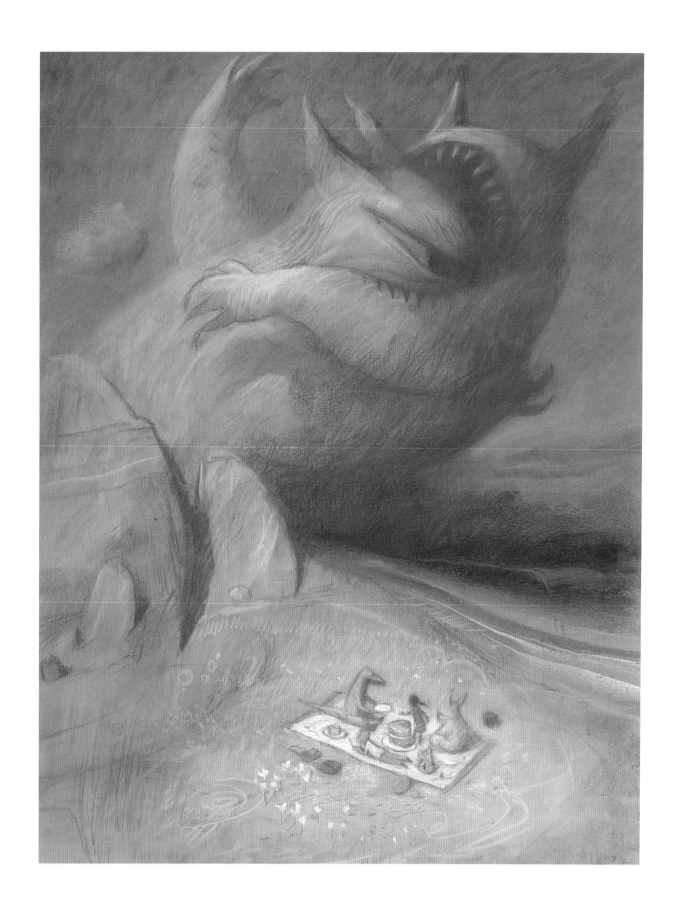

THE PACIFIST

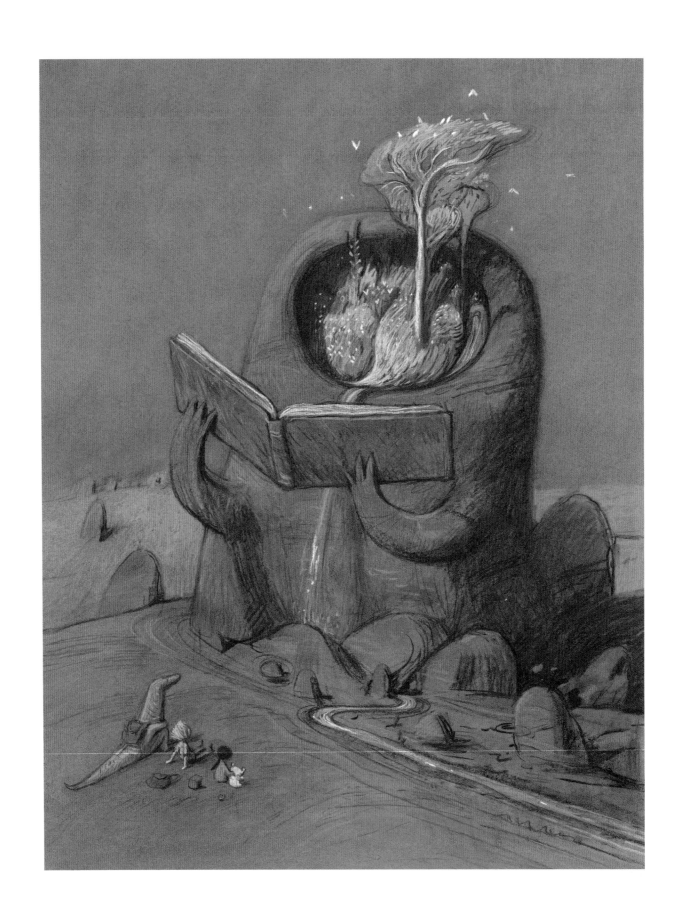

Above: THE SOURCE OF ALL THINGS | *Opposite:* HOMEWARD

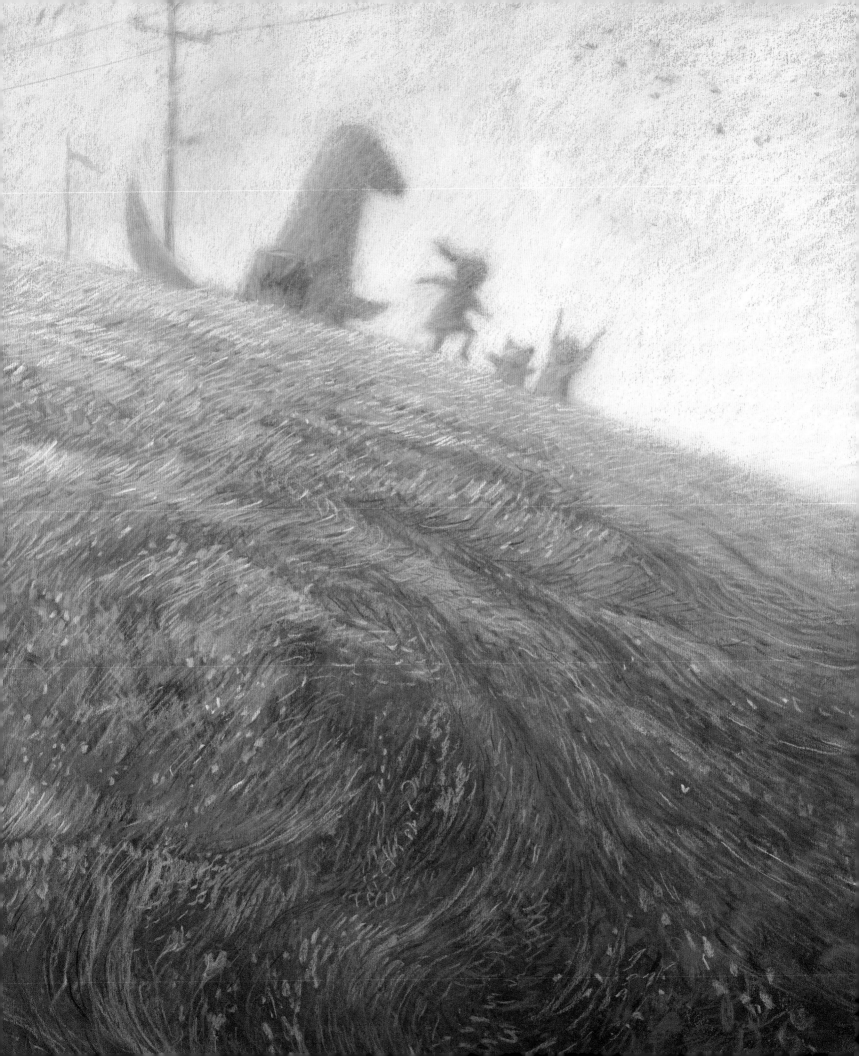

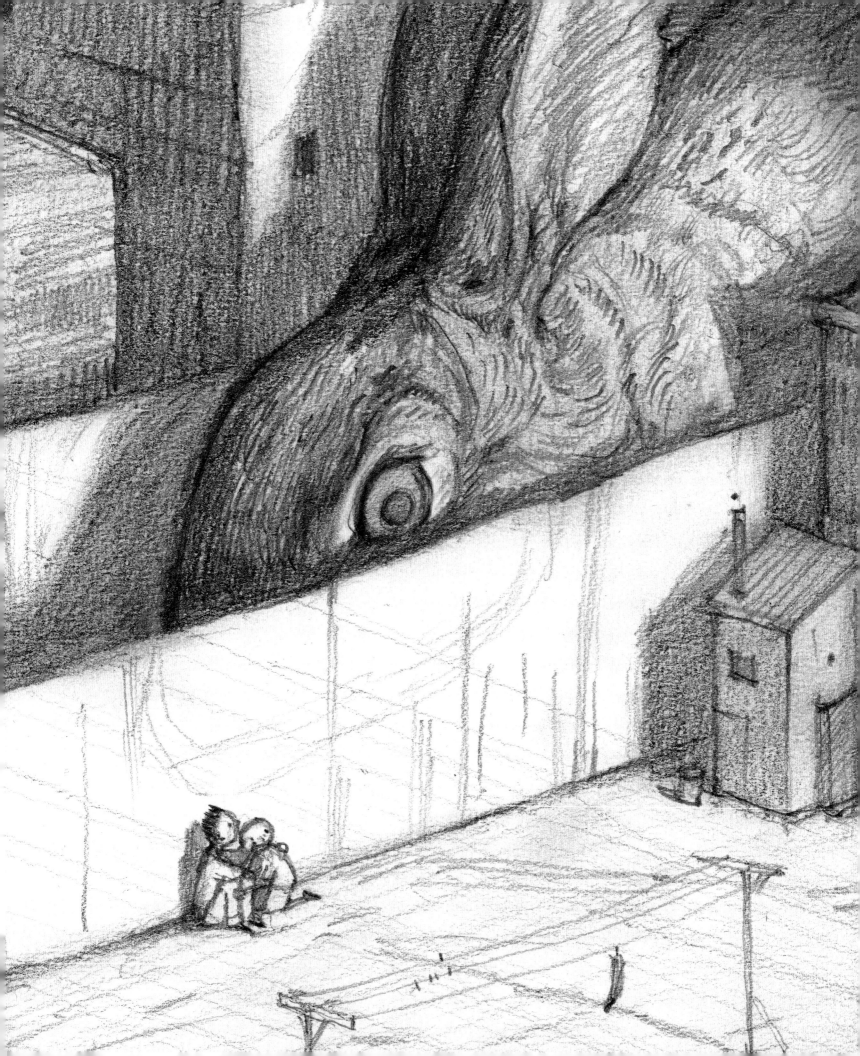

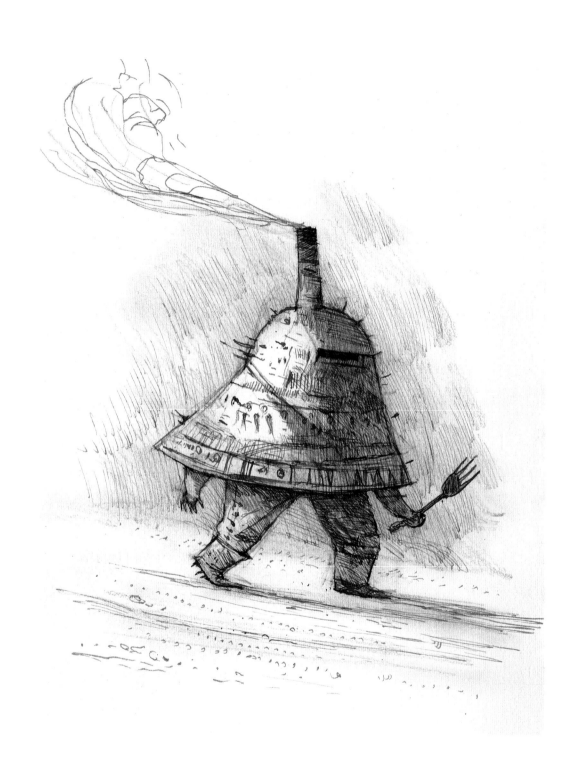

CLOUD

CYPRESS

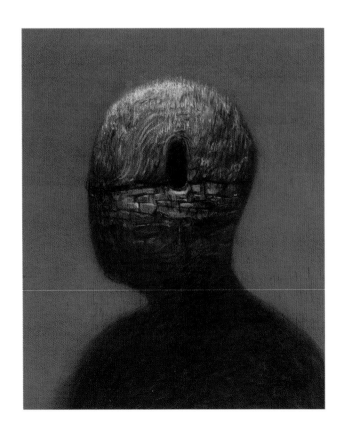
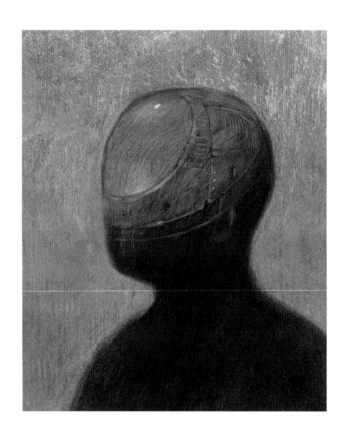

Clockwise from top: BELIEF, LOCK, LENS, TOMB

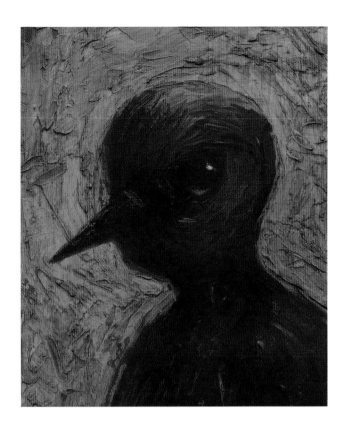
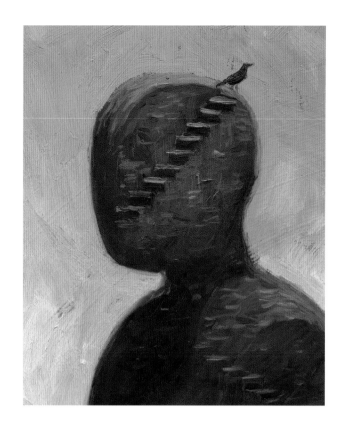
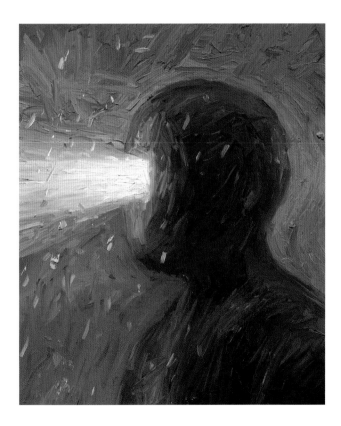
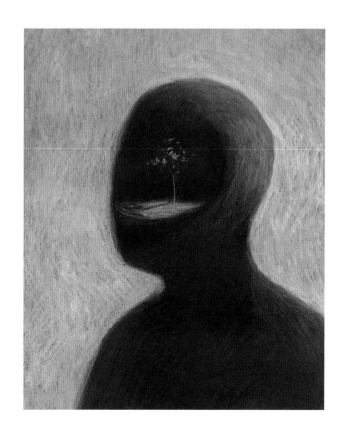

Clockwise from top: FLEDGLING, EYRIE, CAVE, LIGHT

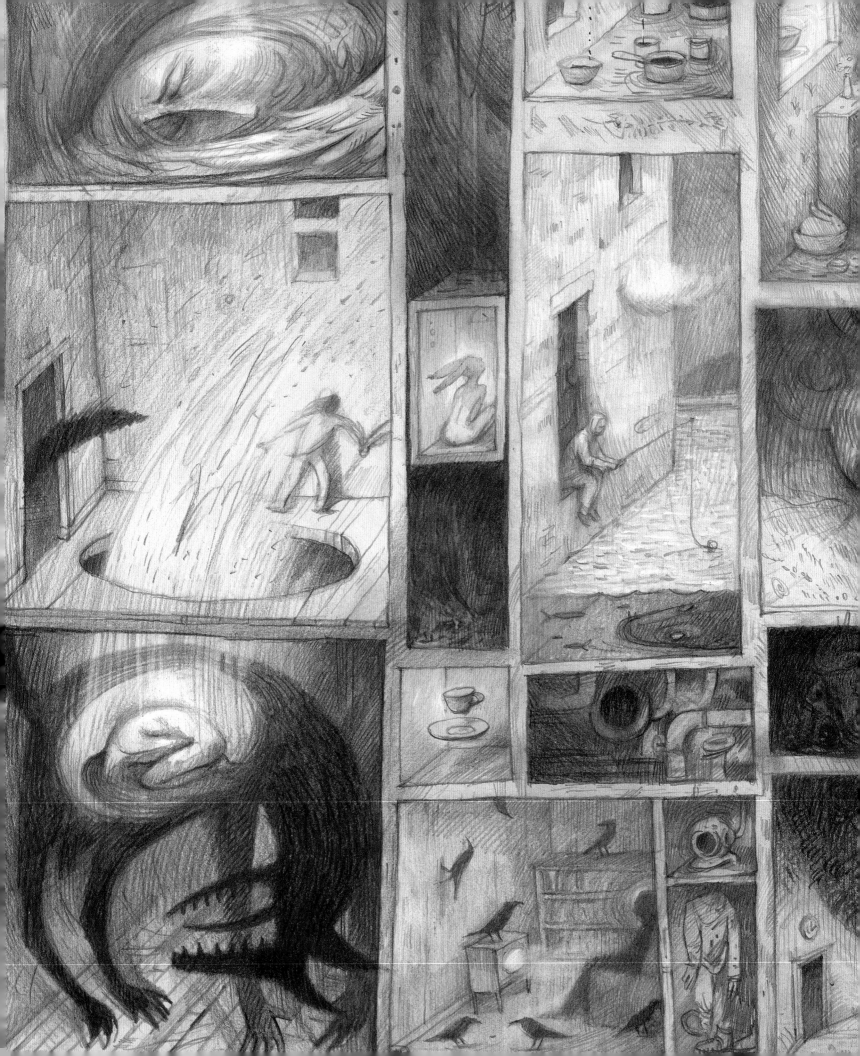

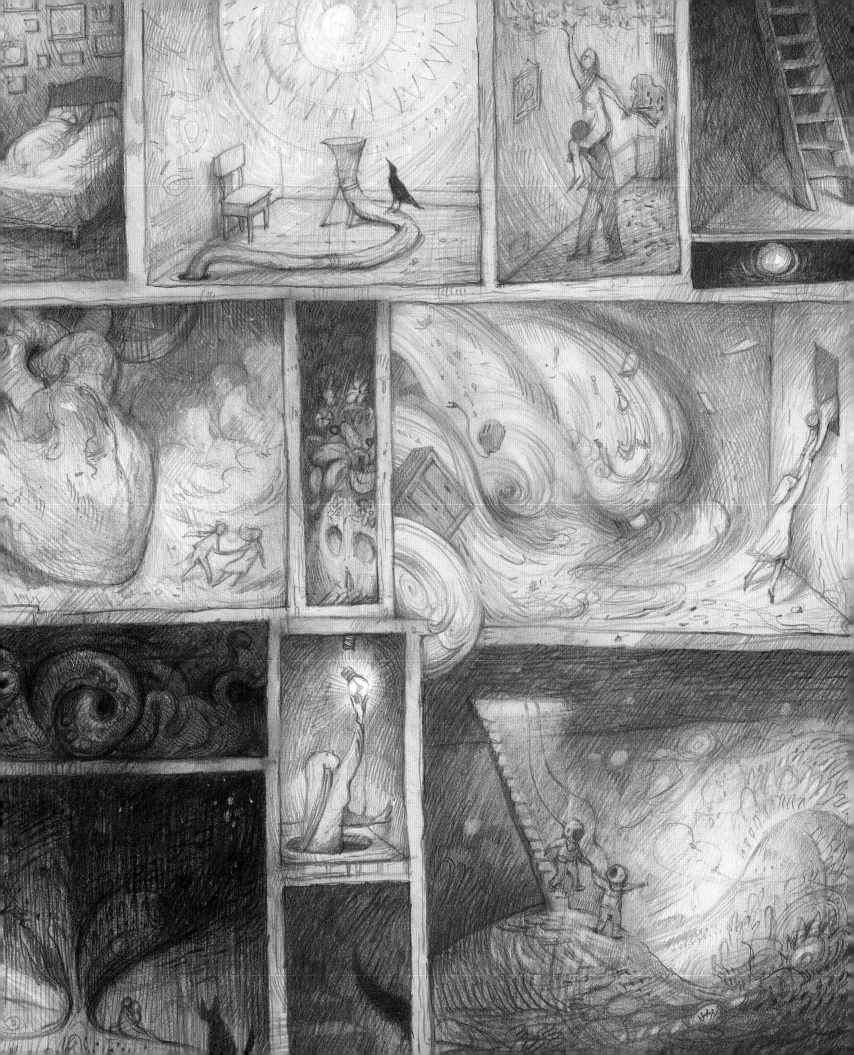

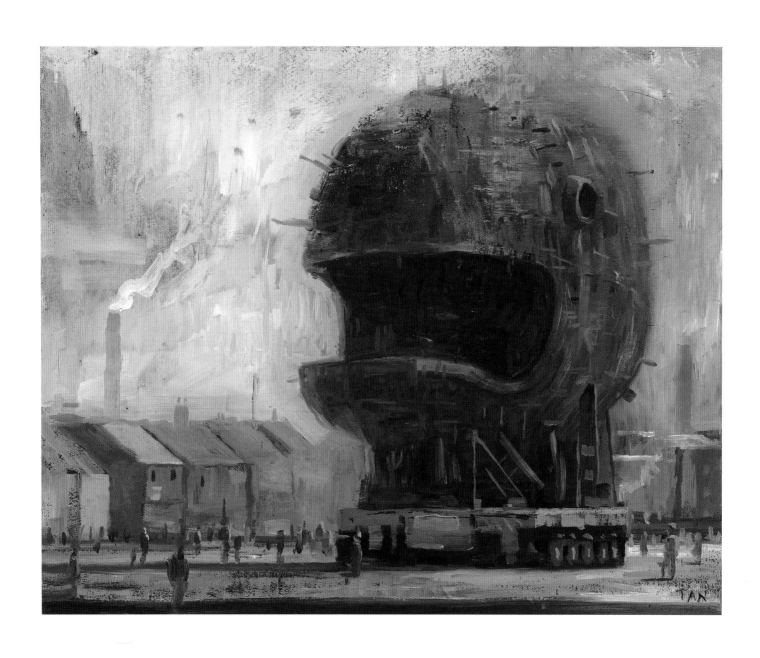

Previous: THE ROOMS | *Above:* THE VILLAGE WEAPON

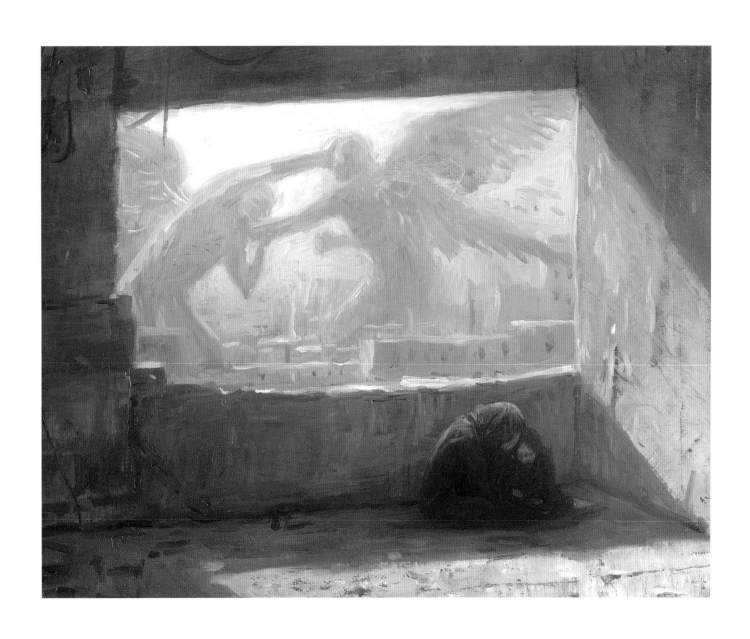

Above: ANOTHER WAR ALREADY LOST | Overleaf: THE LAST DEMON 155

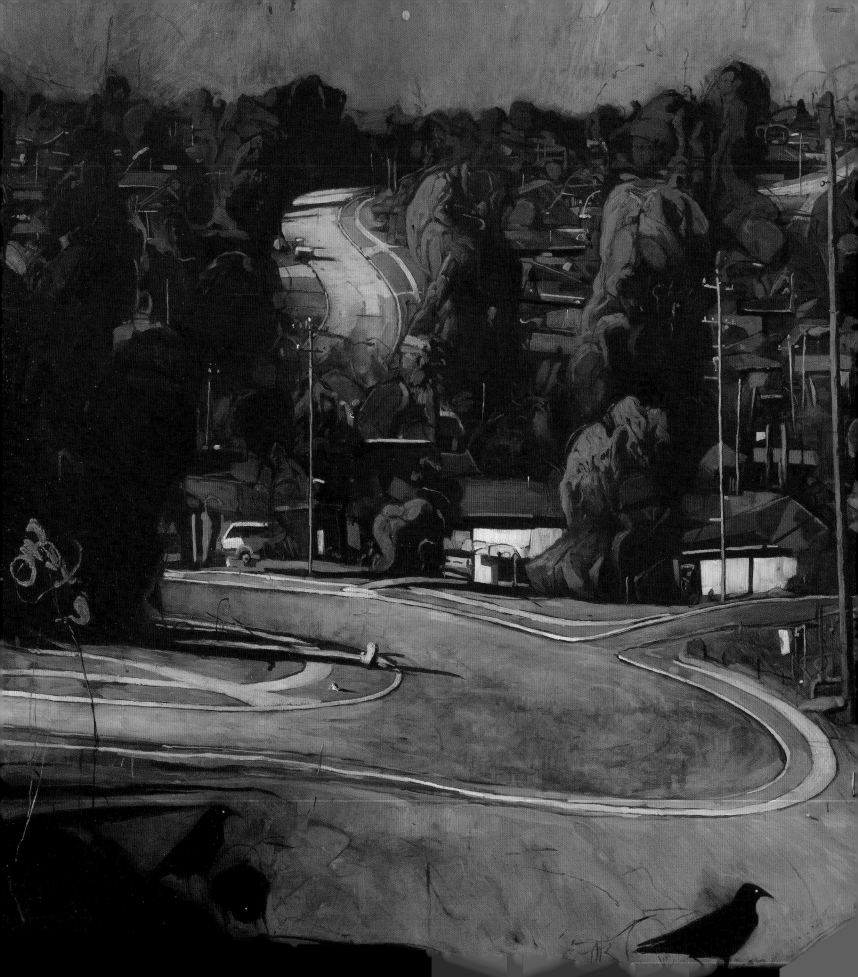

BIRDS

Something about the very existence of birds seems impossible.

Around the age of eleven, I took a shortcut through the dark neck of a local park on my way to a friend's birthday party, glittery card and hastily wrapped gift in hand. A scrum of squawks and feathers passed overhead, one of numerous bird wars that seemed so elemental to the canopies of Perth's northern suburbs, filled as they were in those days with twisting, shaggy masses of tuart trees, alive with raucous life. Back then those trees were so ugly to me, so irregular and graceless. Unclimbable, rough, infested with spiders and other insects for which phobias are just waiting to be invented. The cursed home of broody, attacking magpies (the great dread of spring) and all those other volatile birds.

But much later, when I started painting my local landscape as an art student (too lazy to seek out more exotic subjects), I came to know these trees quite differently. I studied their bent masses of foliage, rising and hanging, forming caves or mouths, arcades and towers marking specific districts, thoroughfares, places to meet, hide, and nest, all shifting with the rake of a golden westerly breeze in the afternoon. Taking time to look—the true purpose of drawing and painting—I saw another neighborhood above my own, another country, a vast empire of birds. Compared with the structurally flimsy pretensions of human suburbia—a flat sprawl that survived only by the good grace of plumbing, petrol, and electrical wires strung everywhere like confessions of a conceptual weakness—these tree worlds were old. They were all that remained of the original coastal plain, but remain they certainly did. When painting them from the roof of my parents' house, I came to realize how old this land really was. And also how interrupted it was by humans.

As a child, though, I probably more often felt the opposite. That humans were interrupted by nature. All this scrubby bush, well, if a bulldozer happened to come along (which they did seem to do, every other week), then good riddance. Too many bugs, too much sand, too many wasps, flies, and bees; gum leaves so stiff and flat on a driveway that no broom could move them; and an army of ants just waiting to rise up and overthrow us. Postcolonial hubris runs very deep and is so quietly transgenerational that you can't even see it if you're always busy sweeping and complaining, retreating indoors to read books about English gardens, Germanic fairy-tale forests, and white swans (not the black ones down the road). Too busy trying to get to a birthday party, worried about missing a piñata or some other fun cultural confusion.

When a small wattlebird fell from a tuart tree in front of me, a deeper empathy snapped to attention, a deeper reality. A compassion that bypassed all other thinking with a sense of kinship and purpose. The ruckus of birds ripping into each other moved on to another canopy, and I dutifully waited near this crashed aviator to see what would happen. It floundered about, a fluffy, dull-colored heap on the quiet grass. Clearly just a fledgling, perhaps it had strayed into the wrong territory or escaped a crow. I knew enough to diagnose a broken wing in what was now a nice snack for local cats and dogs. I bundled the bird carefully in my cap, mindful that you weren't supposed to touch a bird with your hands (I couldn't remember why), and ran all the way home, quietly pleased. The dark and ugly tuart trees had chosen me to save it. The birthday party could wait.

This small wattlebird became a family companion for many months after we nursed it back to health, taught it how to fly and feed itself from native flowers, even how to extract caterpillars from cocoons. It was not a pet so much as a neighbor, coming to live independently in the suburban wild, holding its own among other fierce birds and wily cats (including our own, which succeeded only in catching the bird's detachable tail feathers), roosting in a tree by our window every night as if to maintain a polite orbit. Like an old friend it would occasionally land on our heads, hands, or shoulders when we ventured outside, poking its beak earnestly into our mouths or, with a noisy thrumming sound, our ears. It was never clear if this was a gesture of affection. It may have been that the bird was simply hardwired to check anything remotely floral for water and calories, things of some scarcity in the semiarid forests of its ancestry. Up close, you could feel the complex unity of an animal with its environment, a physical poetry. The way its clean feathers smelled faintly of sea breeze and herring, just like the wild, windy beaches down the road. How the tiny red ear-wattles had the vermilion wrinkles of a red-cap gum pod just before the flower burst out, the faint dusting of yellow pollen above its eucalyptus-twig legs, its eyes gleaming like hard resin. Every time, it felt like a tangible privilege to have such a creature perch on my finger as if I were just another tree branch, as if the vast spaces between us could so easily collapse, and I too could become part of an older landscape.

My fascination with birds grows with each new encounter, and I tend to paint them more than any other creature. I could offer an easy artist statement about why that's so, about grand metaphors of flight and migration, themes which also interest me, and for which birds are especially useful imagery. But the attraction is much simpler than that. Something about the very existence of birds seems impossible. They are ethereal creatures of the earth and air, unimaginably refined and complex, yet so

common as to be the first animal we usually see when looking through a window, or hear when stepping through a door. They are a perfect example of something simultaneously ordinary and miraculous just beyond our walls, both physical and mental.

My early pretensions towards being a "serious" painter, which I understood as something to do with a kind of deep looking at my local environment, began with large paintings of Australian ravens in my early twenties. These ubiquitous charcoal-black birds haunted the landscape surrounding my suburban home, congregating around electrical wires, fighting noisily in supermarket carparks, and strutting casually along concrete footpaths that human pedestrians, overcome by the vastness of suburban sprawl, rarely used. I liked the way they seemed to emerge from deep afternoon shadows as if made of the same dark substance, their long, plaintive cries a eulogy describing tragic events that we, the non-Indigenous interlopers, may have conveniently forgotten. Or worse, can't see coming. The ravens seemed to live in a liminal zone, as perhaps all animals do, a different span of time and place. A world likely to outlast any electrical wire, supermarket, and human footpath. That long and forlorn cry seems to presage many things.

I've since worked on a number of narrative paintings over the years in which birds are a key—if mysterious—protagonist, especially within urban environments that I know well. One series reproduced in the latter part of this section features the birds I see every day around Melbourne, a mix of native and invasive species that have made their home in the strange cities and suburbs constructed by humans within a blink of natural history: magpies, willy wagtails, gulls, pigeons, sparrows, mynas and, of course, those ever-present ravens. We all live in the same place, but not the same universe. Like the birds of my childhood, these creatures represent some kind of reality check, a reminder that there are as many experiences of the world as there are living things within it. Compared to our own narrow perception, life must feel fantastically different to a bird, expansive in unique ways, governed by conceptions of life and death, of the past, present, and future, that we can only imagine. Every time a bird flies overhead, I wonder about the maps and memories, the necessary imagination that guides this magical, commonplace trajectory and somehow keeps things moving along. About how different we all are and, within that diverse family of unlikely creatures, how much the same.

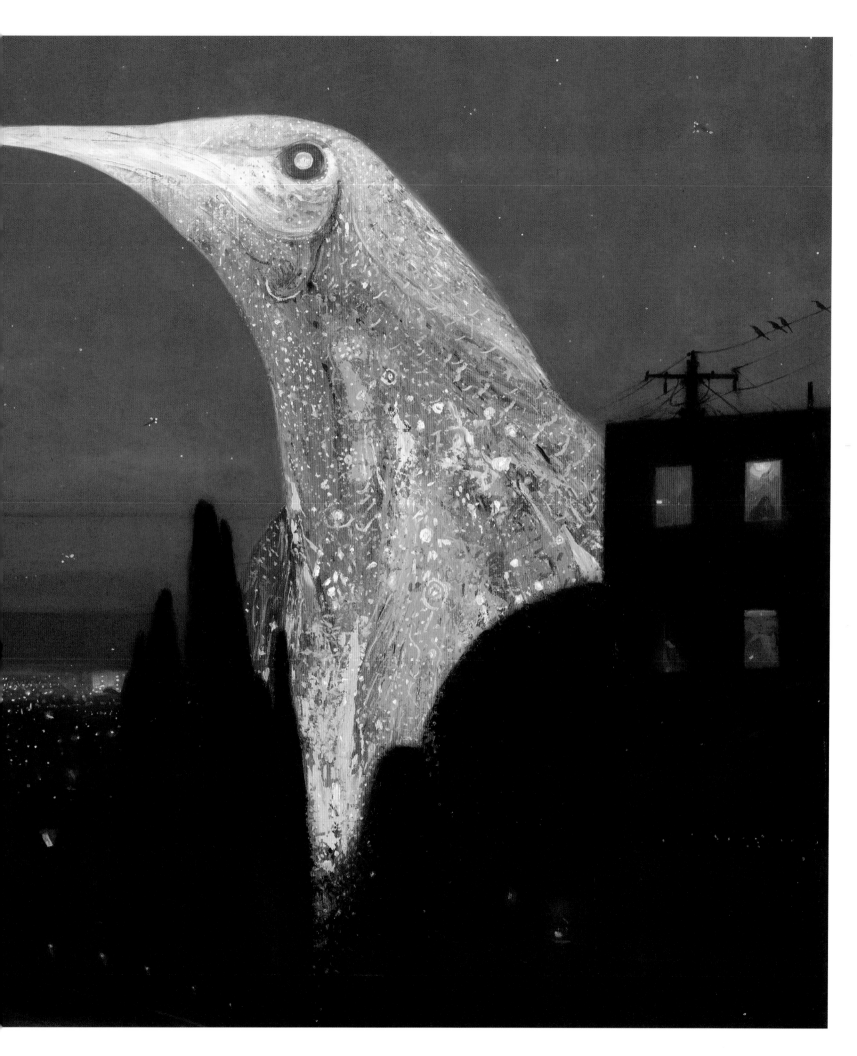

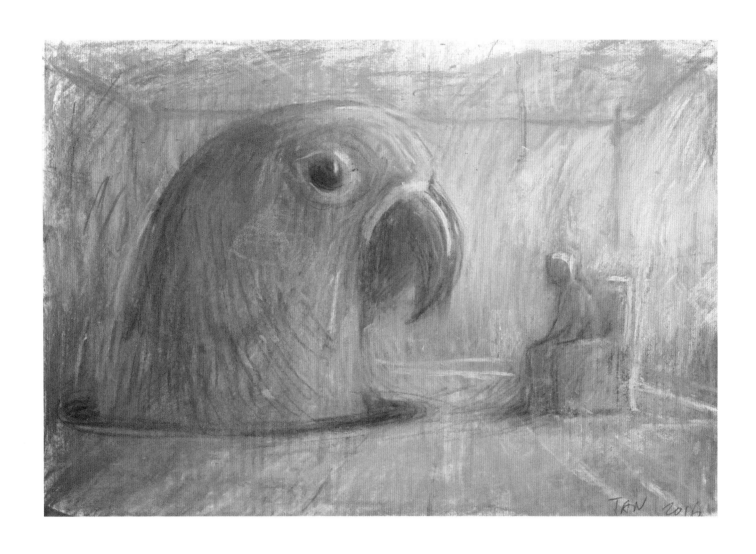

Previous: DIEGO | *Above:* TALKING ROOM

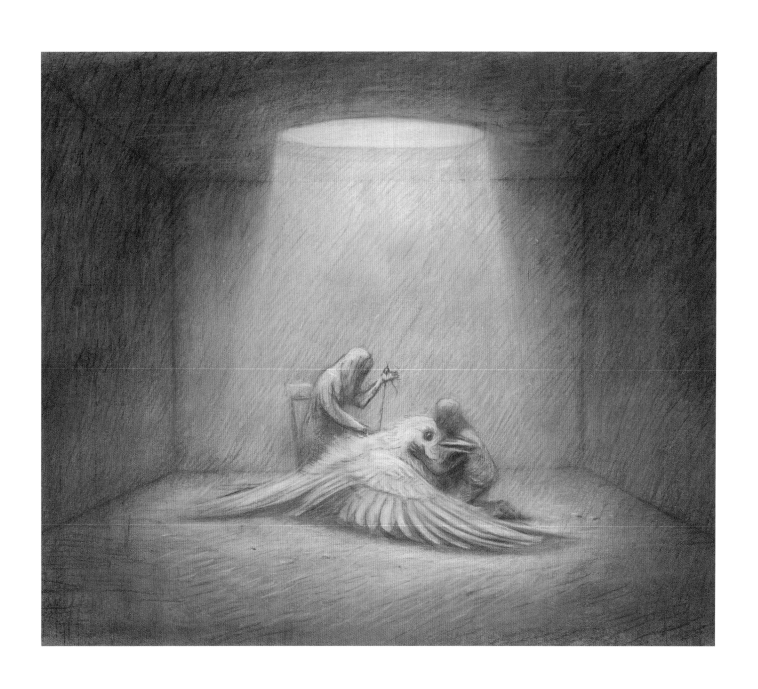

Above: MENDING ROOM | *Overleaf:* BLUEBELL

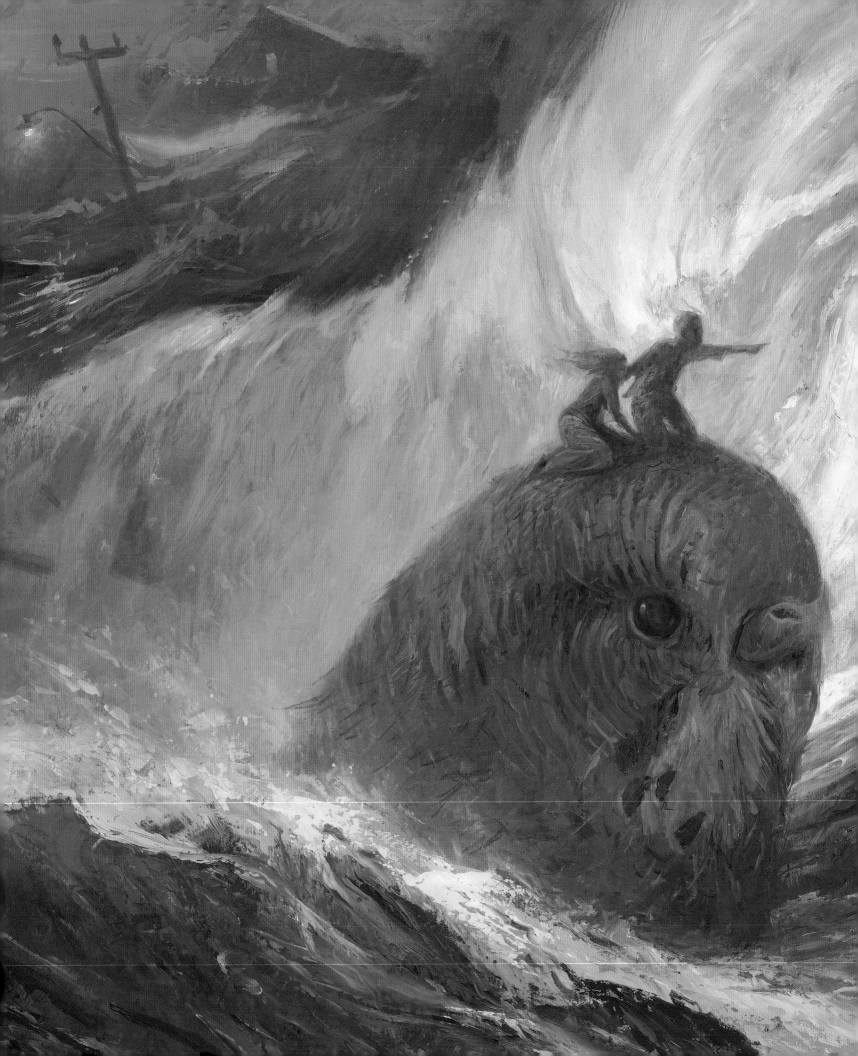

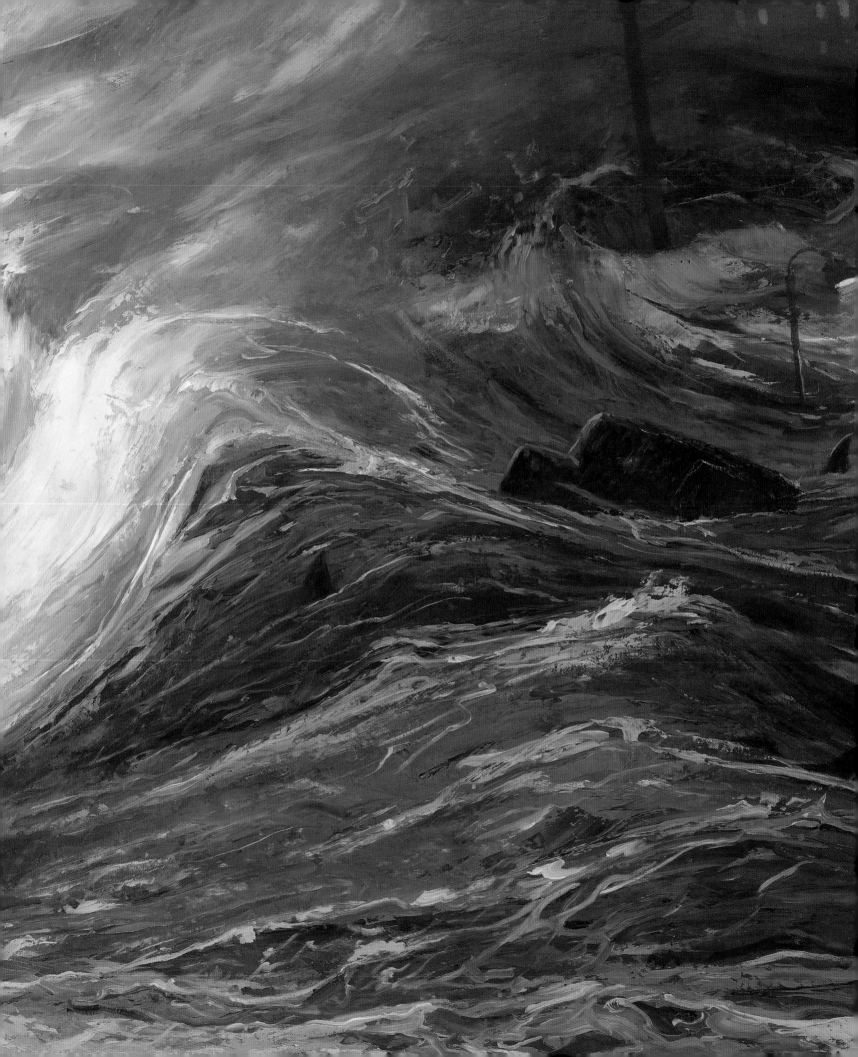

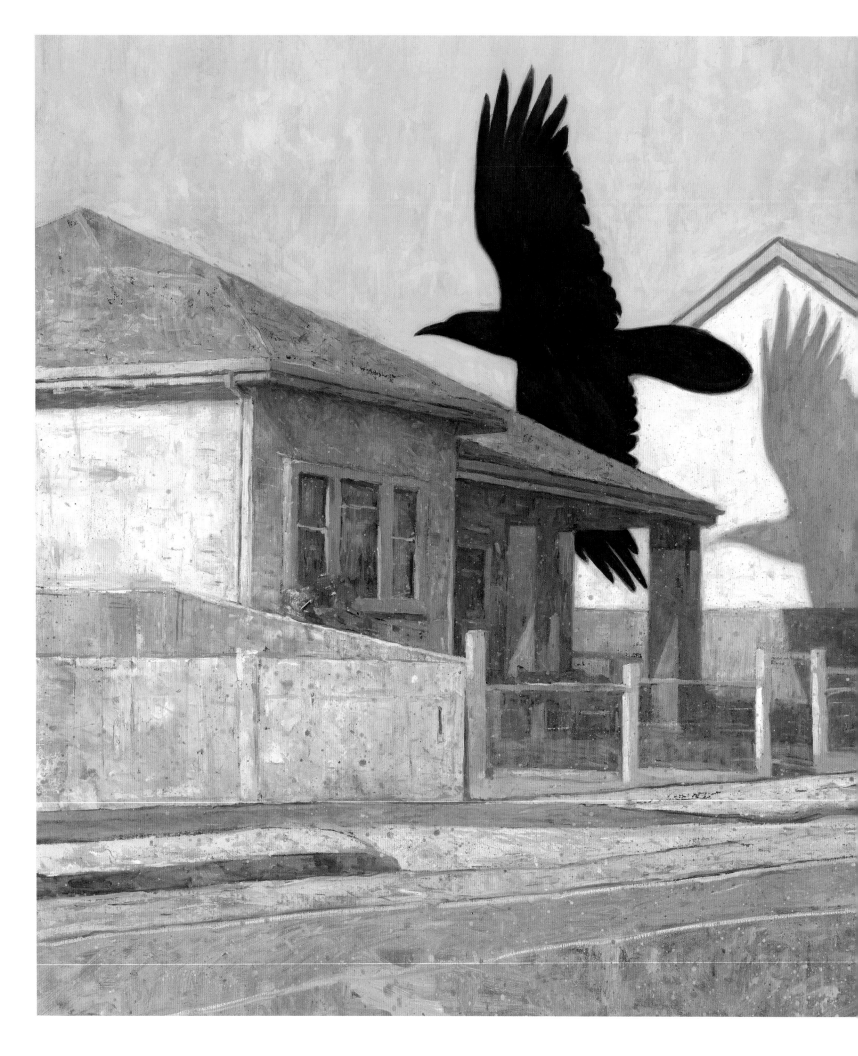

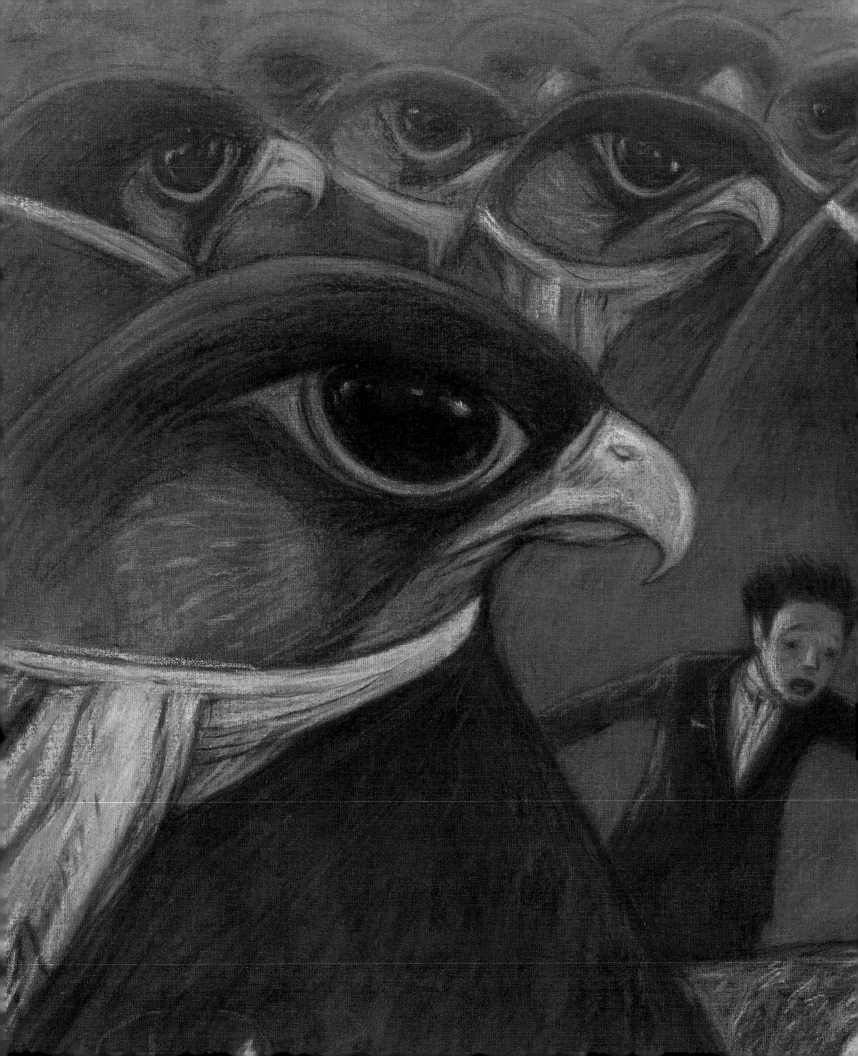

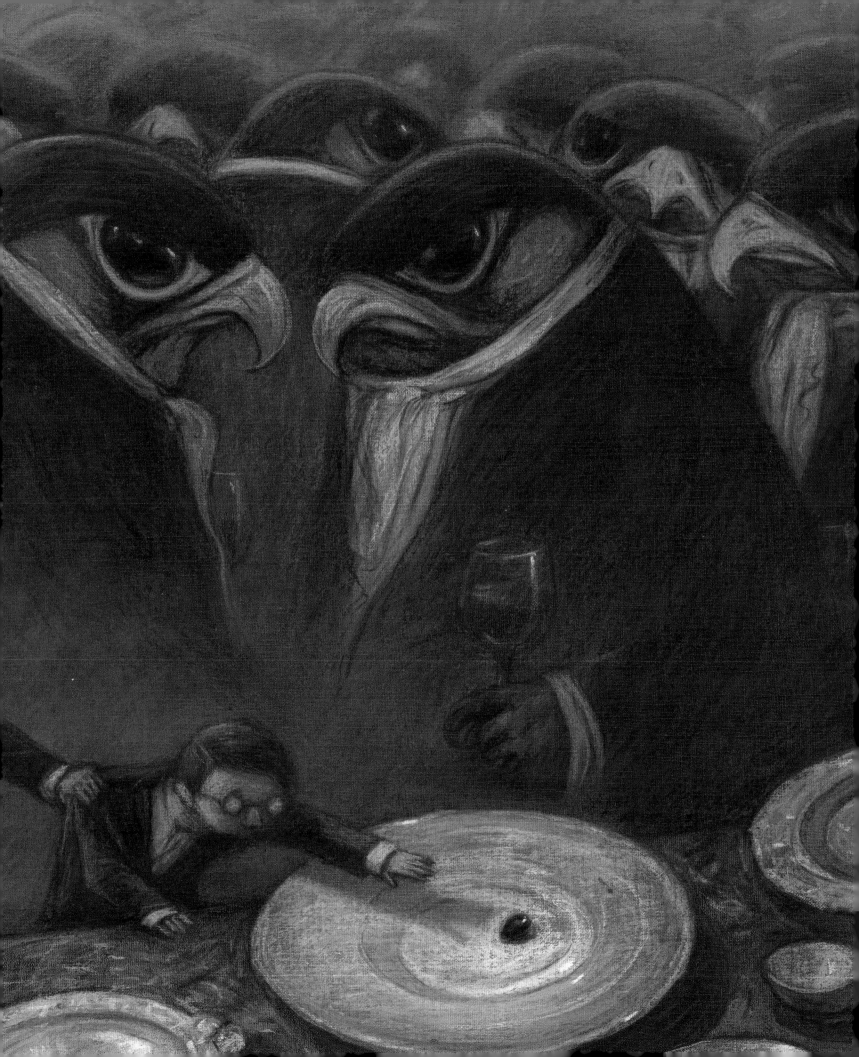

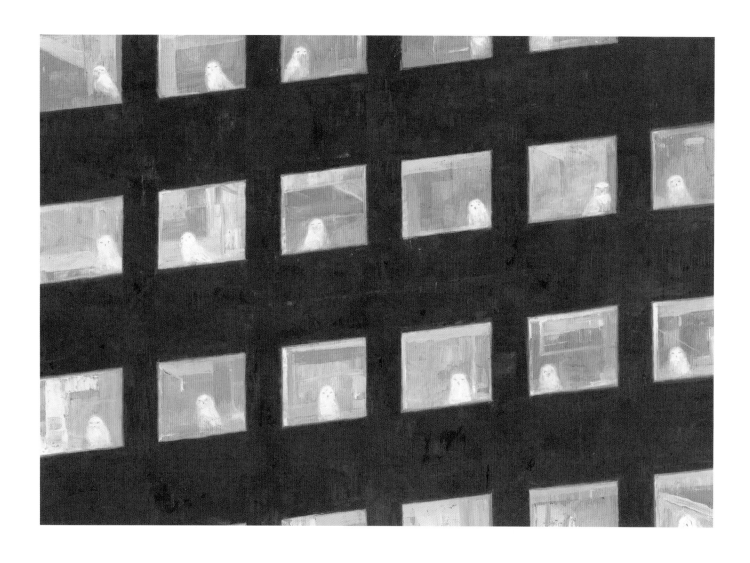

Previous: NEVER EAT THE LAST OLIVE | *Above:* HOSPITAL WITH SNOWY OWLS

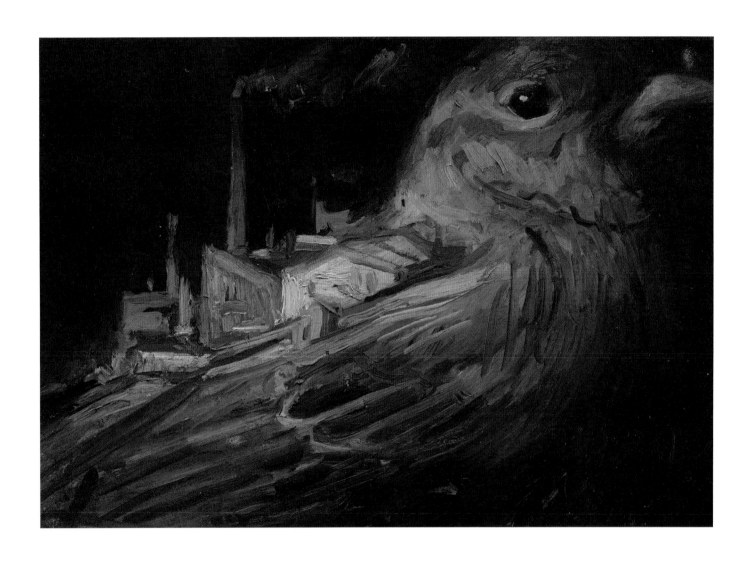

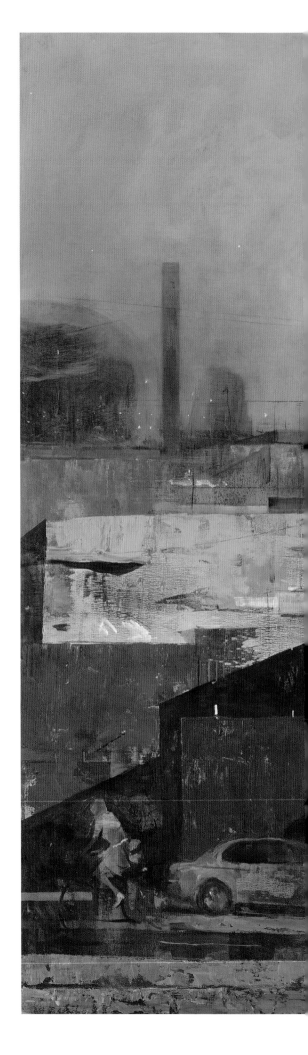

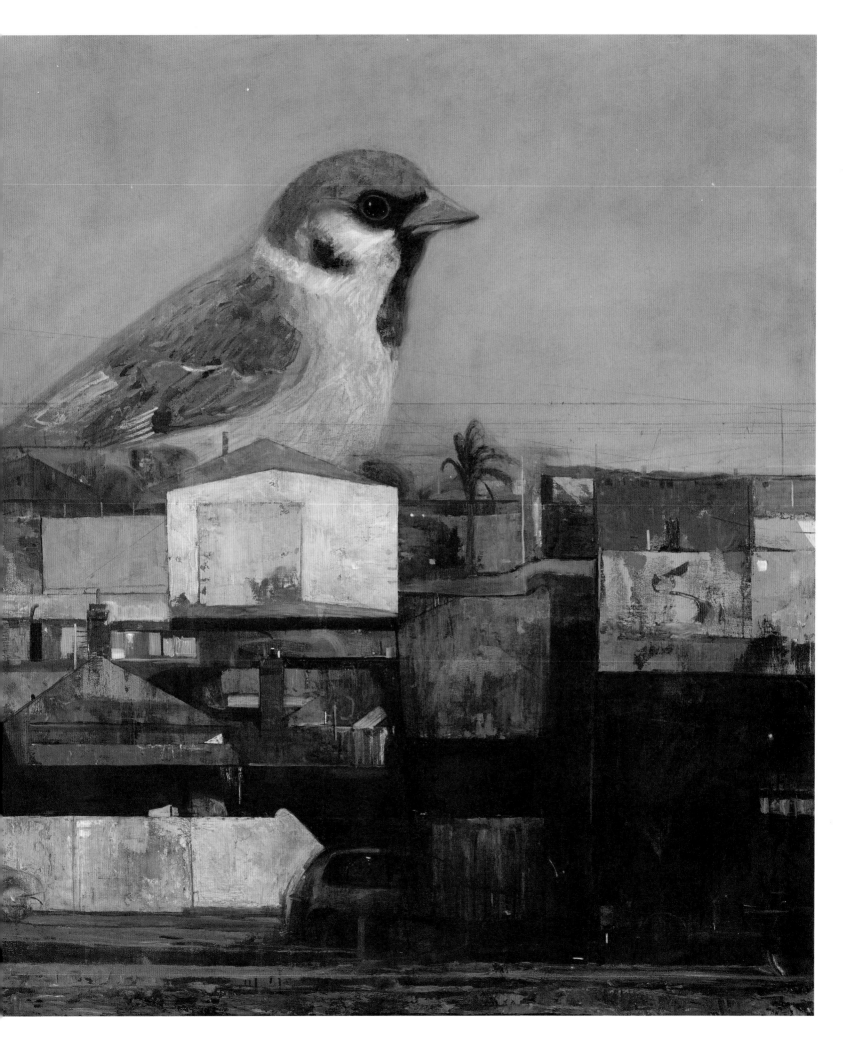

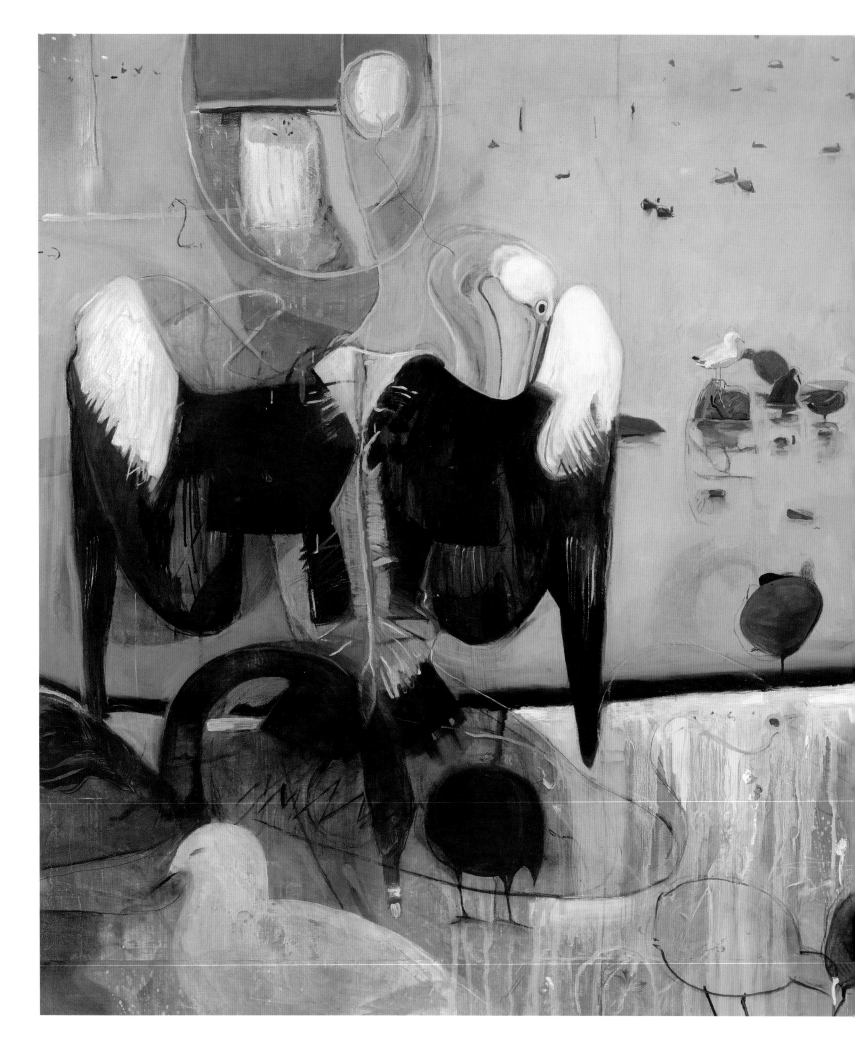

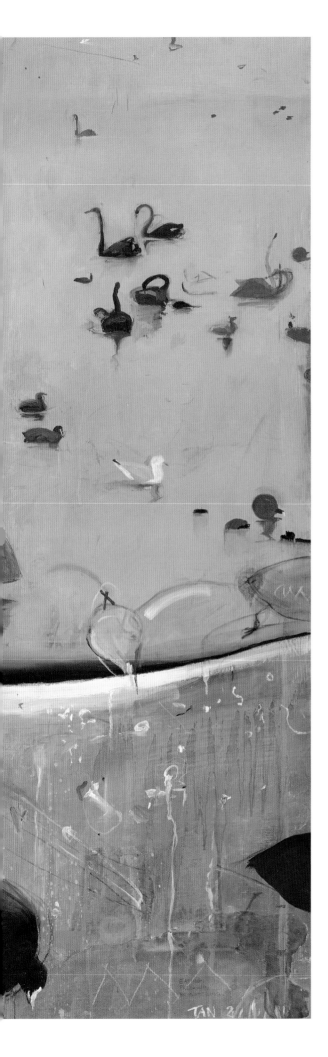

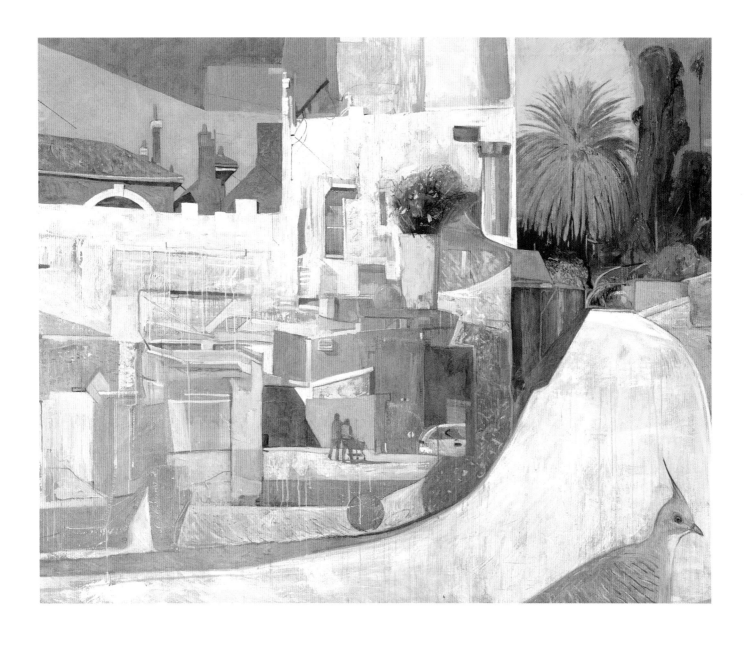

MORNING RELIGION

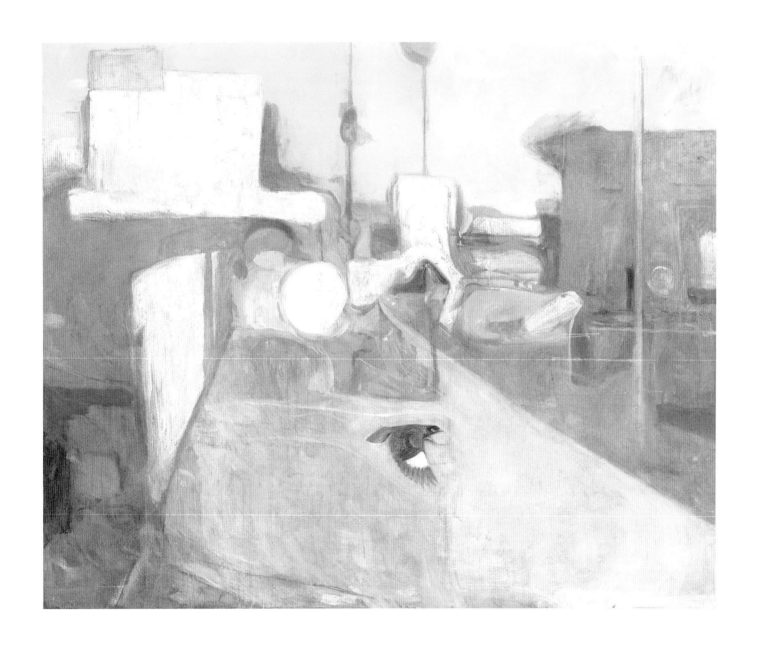

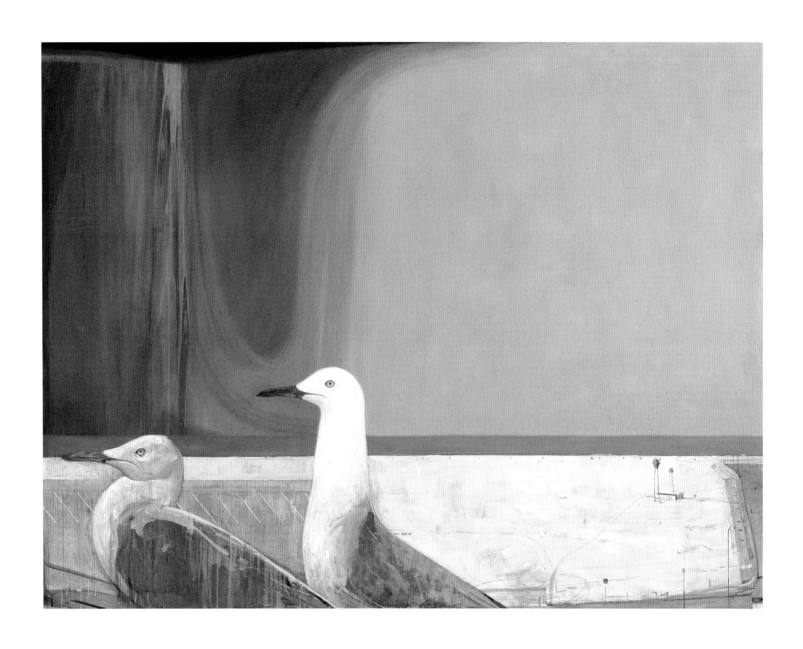

SURVIVORS

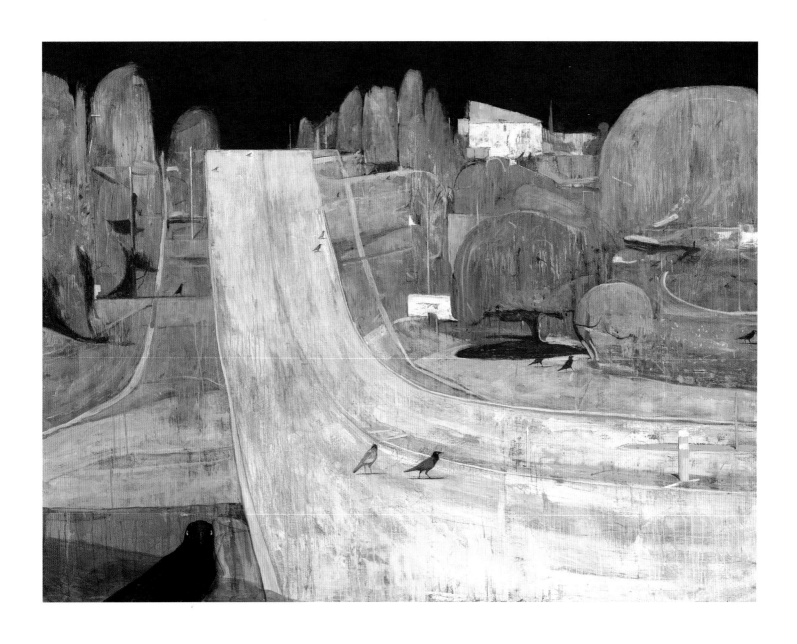

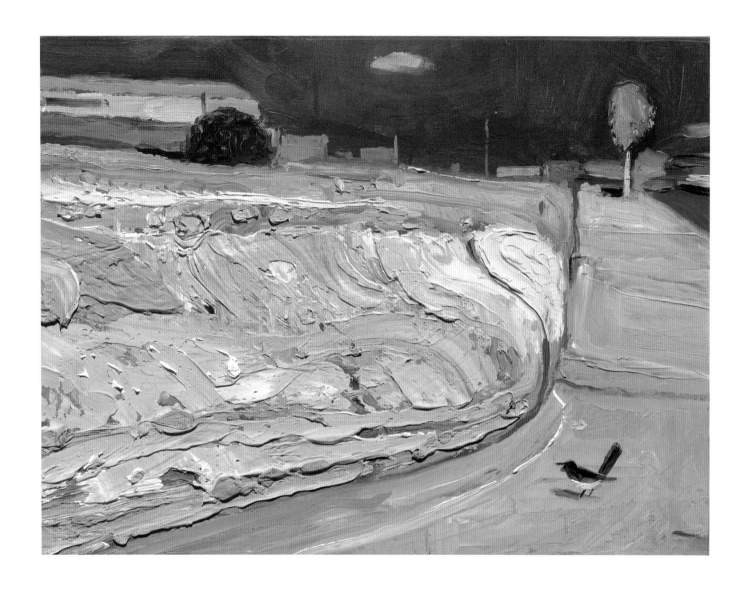

WILLY WAGTAIL

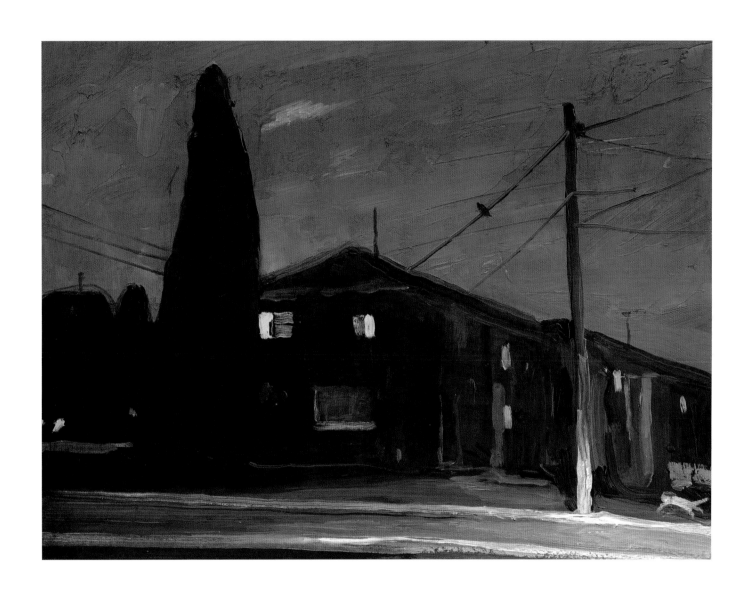

BIRD AND CAT

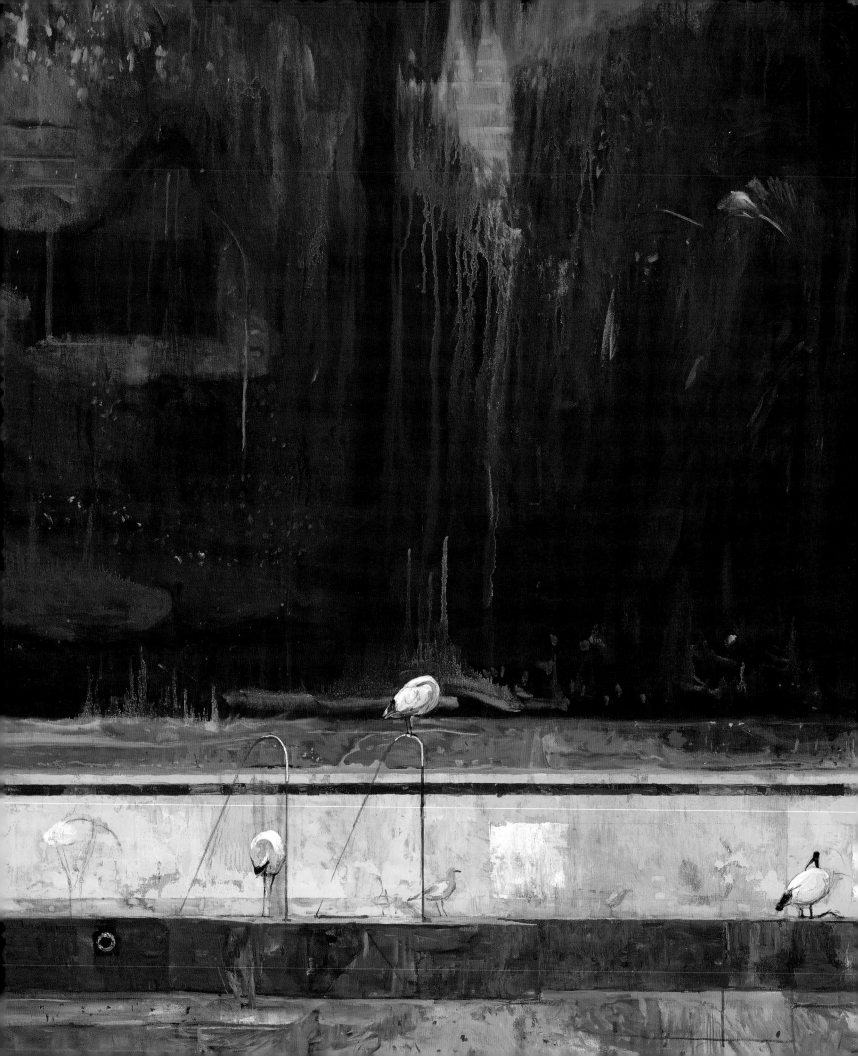

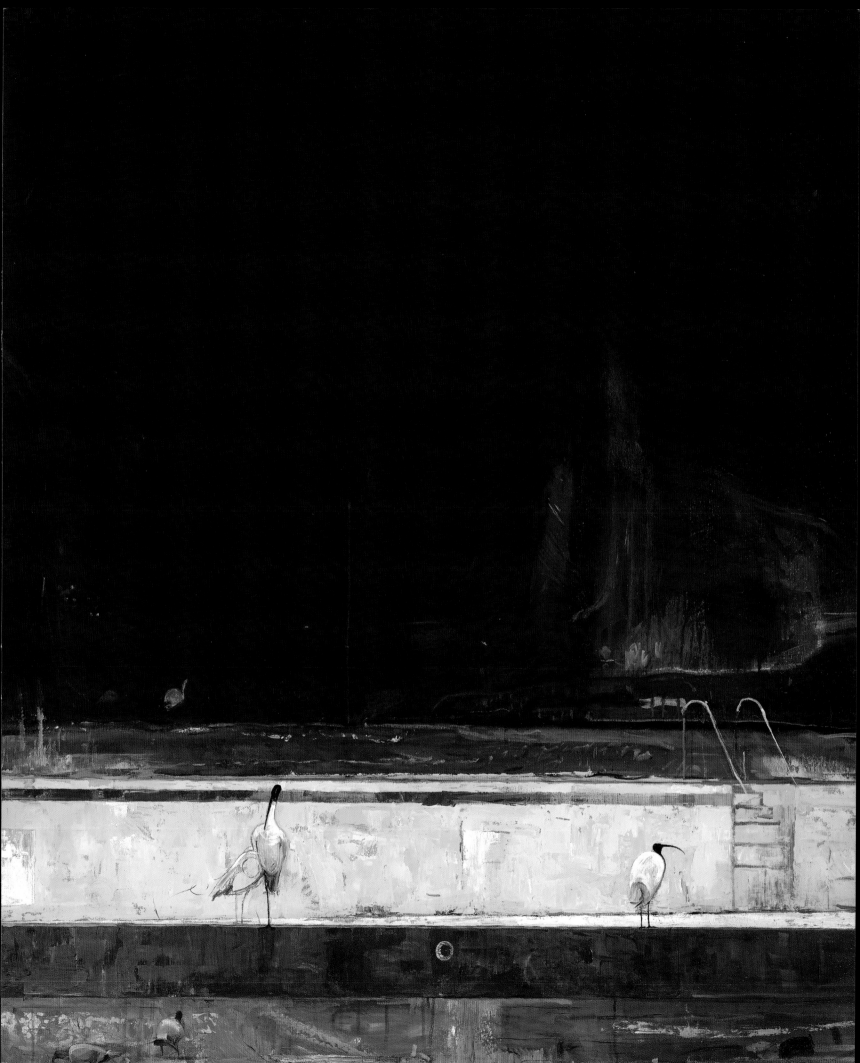

Previous: STYX | *Opposite:* THE CROSSING

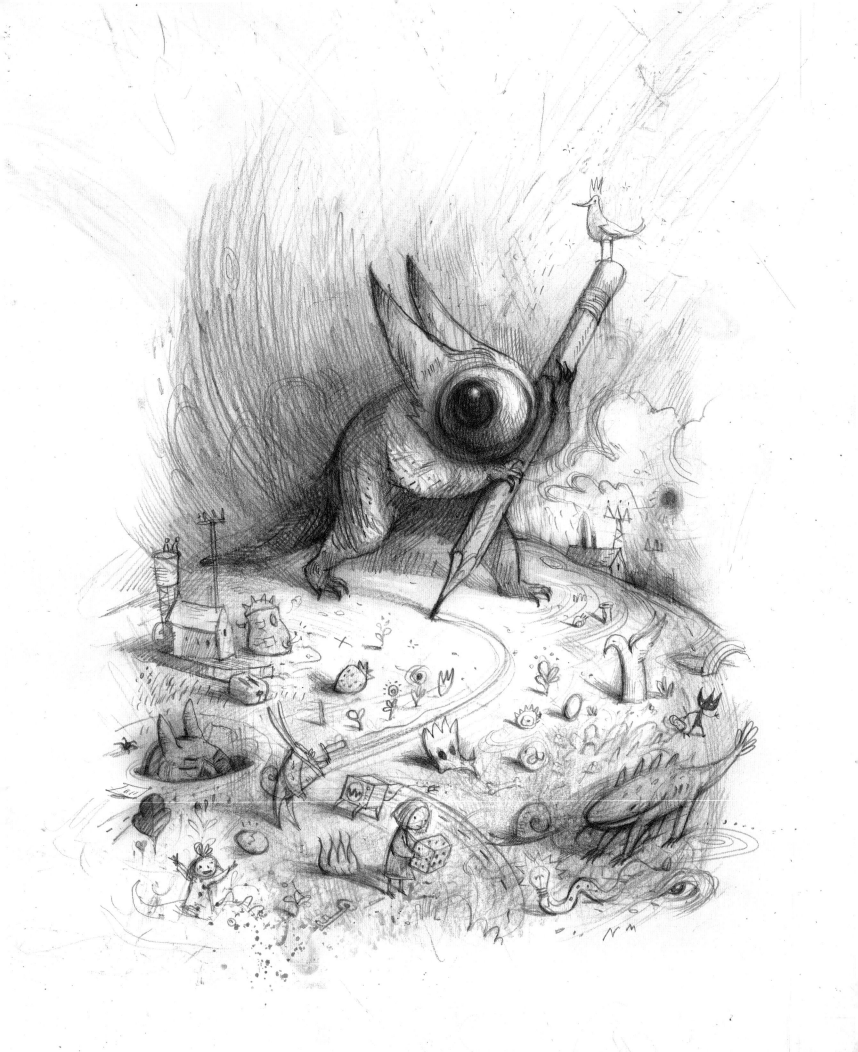

AFTERWORD

The images in this collection span the period between 1995 and 2021, during which I often wrestled with my identity as an emerging artist and writer, as is standard practice for any beginner. Throughout many ups and downs it's been consoling to fix upon the theme of "creature" as at least one anchor in a sea of apparently random freelance projects: gallery painting, science fiction illustration, picture books, cartoons, comics, film design, stage plays, and other things harder to define. In spite of differences, all projects share a bloodline, consciously or otherwise, noticeable whenever a furry, feathery, riveted, or big-eyed relative makes an appearance at the studio table. It's a pattern I've both embraced and resisted at different times, wondering if imaginary creatures are profound or trivial, limiting or expansive, silly or serious, maybe little more than a stylistic habit or, worse, an affectation. These ambivalent feelings probably come from the central dilemma of any art making, of trying to represent something truthful about real, everyday experience in the world, while at the same time creating things that are fictional. In other words, trying to be honest while making things up, an exercise that naturally breeds doubt.

Often my solution to that self-conscious dilemma has involved casting back to a time before self-consciousness: my thoughts and feelings as a child, hence the essays in this volume which refer to early picture books, movies, and drawing experiences from when I was between the ages of three and twelve. Before I ever thought of calling myself an artist, an illustrator, a writer, or any other title that might carry due expectation, I was a kid fascinated by creatures, without knowing or caring why. I think all of us were, and many of us still are. Creatures are one of the things I honestly enjoy drawing most, before all questions of style, substance, meaning, or use, and I'm glad that I never grew out of it. I like to think that I grew into it.

Opposite: SELF-PORTRAIT WITH A PENCIL

Of course it's always interesting to reflect on that passion later on, to think about meaning and use, fortified by years of practice, experimentation, discussion with friends and colleagues, academic research and writing—to assemble a retrospective—but at the end of the day, I trust those earliest juvenile instincts for creative guidance. Drawing has taught me that practice comes before theory, action before thought. When I pick up an HB graphite pencil and a piece of paper—my go-to materials for as long as I can remember—I feel no older than the youngest version of myself and, luckily, not too much wiser. I happily revert to the simple enjoyment of drawing a creature, an unknown thing, a character without preconception or pretense. Even as it takes shape with the usual stumbling, sketch-and-erase uncertainty, I do my best to let it evolve however it seems to want, without too much exertion or manipulation on my part, just letting shapes adjust themselves until there is a satisfying illusion of independent life.

I also try hard not to put my thoughts into a creature's mind. So I withhold words, which is one reason my characters often lack a mouth and titles are restrained. A well-drawn creature will find its own voice and story all the same, in looks and gestures, strange interactions with its fellow beings and provisional surroundings, all propped up in a playful world of pencil, ink, and paint, and it will speak different things to different people. I never fail to be surprised by the ideas and feelings that follow, always something new to whatever intention may have taken me to the sketchbook or drawing table in the first place: silly things become serious, sad things become happy, amusing things become frightening, or vice versa. Moreover, all things become stranger and far more interesting on paper and canvas, more open. Like my very first drawings of birds and robots and dinosaurs, the spark is always the same: finding that weird, profound thing you never knew was hiding in your imagination and seeing what it looks like, letting it out.

ARTWORK NOTES

I'm often wary of commenting on specific images in case my ideas overly influence a reader's own impressions, which of course should always come first. But it's also interesting, especially for other artists and students, to know something of the background and inspiration behind each artwork, so long as any personal meaning is not taken to be definitive or exclusive. Many readers have offered alternative interpretations of my work over the years, to which I can only reply, "Gosh, I wish I'd thought of that!" Every picture, if it's any good, should naturally transcend whatever circumstances brought it into being, and mean different things to different readers.

Almost all the work in this book has been rendered in pencil, pastel crayon, acrylic and oil paint on paper, canvas, and board, which are the same materials I learned to use as a high school art student. Unless described otherwise, drawings and paintings have not been digitally edited aside from modest color adjustments and resizing to assist the transition to print.

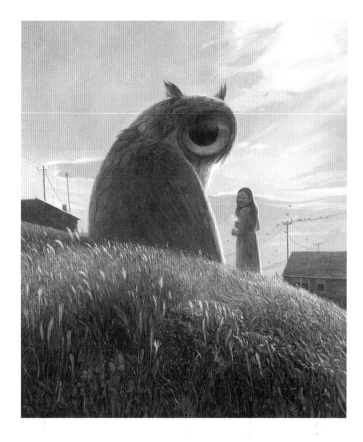

DUST JACKET: OWEN
2021, oil on canvas, 76 × 86 cm
• The image of a person accompanying a large, silent creature on a grassy hill is a common one in my drawings and paintings, like something from a recurring dream or distant memory, probably a visual amalgamation of friends, family, pets—mostly cats and birds—and other things less identifiable. Much of the enjoyment of painting a scene like this comes from its simple matter-of-factness, of making odd things feel familiar. The flecks of light in an impossible eyeball become no different from the strokes of bending grass, a feathered shoulder no less ordinary than a cloud or window frame. After some time that backward glance is not the cool stare of a stranger, but the warm acknowledgment of a friend, inviting you to come a little closer, be yourself, and just accept things as they are.

ENDPAPERS
1995-2021, pen, ink, graphite pencil and coloured pencil, digitally composited from several sketchbooks
• Sketchbooks are my most important testing ground for ideas. Some of these drawings are preliminary concepts for book, theater, and film projects; others are playful doodles without clear purpose, the best way I know to stumble across meaning. I most often use small, inexpensive sketchbooks using simple ballpoint pens, which makes the activity feel closer to research than art making.

1. TOLD YA!
2017, pen and pencil on paper, 10 x 10 cm
• A sketchbook drawing for a proposed animated dramatization of a story, "The Water Buffalo," originally published in *Tales From Outer Suburbia* (2008).

2-3. ON MY WAY TO PARADISE
2021, oil on canvas, 136 x 90 cm
• One of several images of rabbit-headed individuals moving through quiet urban landscapes, towards dark trees. For me this painting recalls long drives to Australia's South West, the mental shift of passing through a freeway nexus, under a series of bland overpasses, down a long serpentine flow of highways, and finally towards wild trees and ocean.

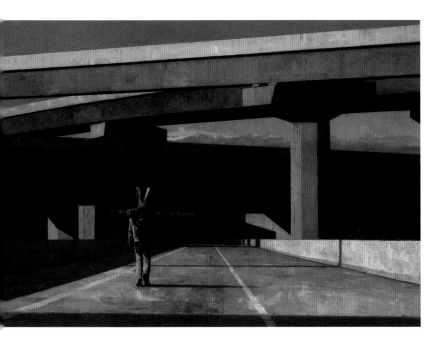

4-5. LIFE GOAT
2010, pencil on paper, 30 x 40 cm
• A working drawing produced alongside the animated adaptation of *The Lost Thing* (2010).

6. THREE DINOSAURS
1977, pen and watercolour on office paper, 30 x 20 cm

LOST THINGS

10. THE CLEANER
2006, pencil on paper, 20 x 30 cm.
• The mysterious hero from my story *The Lost Thing* (2000), here redrawn as a concept sketch for the short film adaptation, the basis for creating a digital sculpture, as with many other drawings in this series.

13. LIGHT CHICKEN ASKING FOR DIRECTIONS
2007, pencil on paper, 40 x 30 cm
• Many "lost things" are inspired by street objects such as hydrants, booths, ducts, and mailboxes, and retain a natural affinity for those industrial fixtures that humans rarely notice. I'm occasionally sent pictures by friends of "lost things" found in the street, all sorts of broken machines and dumped furniture. It's interesting how many of these surrogate animals you can find if you really look for them, and how they elicit sympathy and narrative if you grant them a moment of attention.

14-15. A MEMORY OF LIGHT *(detail)*
2010, pencil on paper, 40 x 30 cm
• The idea for this drawing came from my bottom drawer of dead batteries, VHS tapes (with no working player), and various precious memories locked in redundant technology, sliding into the natural entropy of dusty spaces. Perhaps there is some afterlife where all such things are reviewed with archaeological reverence, or so we like to think as we move them dutifully from home to home.

16. WRITER
2007, pencil on paper, 20 x 30 cm
• A drawing often used as a self-portrait. Drawing or writing seems at its best when there is a sense of automatic flow of the eye, mind, and hand as tools through which things pass, relatively untroubled by planning or calculation—an instinctive, semi-automated creature.

17. PHILOSOPHER
2006, pencil on paper, 20 x 30 cm
• I spent a couple of years at university studying philosophy, which continues to have some bearing on my drawings, particularly the questioning of perception, and uncertainty concerning notions of subjective and objective reality. These all seem like very fluid and fragile questions, like a piece of string tied to an unseen kite, a thing we enjoy reeling in and out so long as the breeze keeps up.

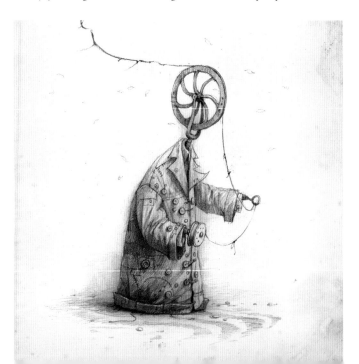

18-19. CONGREGATION

2006-10, pencil on paper, 40 x 30 cm

• The accumulation of my "lost thing" drawings over time led to ideas of alternative ecology and community, or how these things might live together and interact as disparate pieces of repurposed junk. In each case, any scene may be read as an equivalent to human social activity. Here, for example, a teacher with students, a courtroom, concert, or church, whatever comes to mind when we see such a gathering, abstracted from any familiar form or context.

20. HERMIT HORN, FRONTGAMMON TURTLE AND DEEP-AIR DIVING BELL

2010, pencil on paper, 40 x 30 cm

• A drawing about the universal appeal of board games, regardless of cultural—or interdimensional—background. In the film adaptation of *The Lost Thing*, the "turtle" scuttles freely between players, perhaps itself a third strategist. As a child I always wanted to create my own version of the stop-motion-creature chess game briefly seen in *Star Wars: A New Hope* (1977) and finally got my chance.

21. CATHODE RAYFISH

2007, pencil on paper, 20 x 30 cm

• Our family's first TV was a wood-veneer, black-and-white number that took a few minutes to warm up, smelt of burning dust on vacuum tubes, and channeled every grainy episode of *Doctor Who* offered by the Australian Broadcasting Commission throughout the late '70s and '80s. Those of us who remember must retain a certain nostalgia for these imperfect analog machines, and I like to imagine that their spirit still resides somewhere, in some other form, never entirely extinct.

22-23. FRENCH DEW-BOTTLER AND SYMBIOTIC TRAVELLER

2010, pencil on paper, 40 x 30 cm

• This floating creature was inspired by an 1850 illustration of Cyrano de Bergerac, flying with the help of bottles of dew strapped around his waist, a fluid that would naturally evaporate upward as the sun rises.

24. WATER GRINDER AND PROTÉGÉ

2010, pencil on paper, 40 x 30 cm

• From an old coffee grinder in our kitchen, never used. I will typically start with a found object, especially something obsolete or defunct, and improvise. When two objects are put near to each other, their relationship is suggested almost axiomatically and any changed or added elements, from scale shifts to sprouting limbs, follow from that simple proximity. The partnership elaborates itself. It's often easier to create one character in relation to another this way, which is why so many of my "lost things" come in pairs.

25. MICRO-DOG AND ACCORDIO

2006-10, pencil on paper, 40 x 30 cm

• These two creatures were among the first elements to be developed for the animated film adaptation of *The Lost Thing*, as an initial test of character rigging (body articulation). It's a great deal of fun trying to think of how personality might be expressed only through motion, especially with faceless, non-human entities. Our minds so readily transfer emotion onto objects at the merest hint of familiar gesture or nervous energy, arguably the basis of all puppetry and animation.

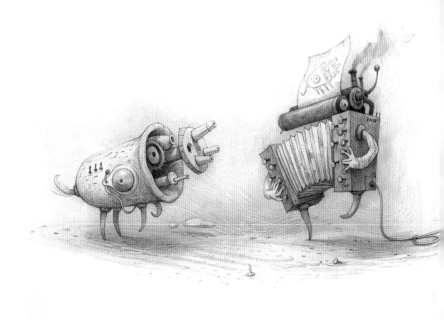

26. AMOROUS DIAL DUCK OF 1983

2006-10, pencil on paper, 20 x 30 cm

• Some things are not missed, but there's something to be said for old dial telephones, offering a little mechanical ritual as one mentally prepares to speak, the countdown as all those numbers clack back to zero. Especially if a difficult or awkward conversation is to follow.

27. KITE BOY

2006, pencil on paper, 20 x 30 cm

• My earliest memory is of flying a kite on a windy day. My dad is particularly skilled in making kites from rice paper and home-grown bamboo, the familiar craft of his childhood in Penang, and kites remain a common motif throughout my illustrations, often transforming into other creatures—fish, serpents, oversized microbes, winged suns or just abstract compositional devices.

28-29. SLEEPER AND STORYTELLER *(detail)*

2006-7, pencil on paper, 40 x 30 cm

• Another symbiotic pairing, inspired by equivalent pairings in nature, such as clown fish and sea anemones, bees and flowers, oxpecker birds on the backs of hippos, and other animals that have co-evolved to help each other without being genetically related, a phenomenon of both scientific and poetic fascination.

30. BLOSSOM EATER

2010, pencil on paper, 40 x 30 cm

• Many "lost things" of mine (and creatures in general) are influenced by pre-Columbian ceramics, including this one, inspired by an oil lamp with long spout, and the falling blossoms of a backyard plum tree.

31. GATEKEEPER

2007, pencil on paper, 20 x 30 cm

• In the animated version of *The Lost Thing*, the smallest of all creatures guards the door to "utopia", an alternate world of freedom and imagination hidden within a bleak metropolis. It was based on our feisty pet budgerigar, Snowball, whose recorded chirp features in the film.

32-33. COELACANTH AND DAUGHTER

2007-10, pencil on paper, 40 x 30 cm

• Another symbiotic pairing, partly inspired by the way mouthbreeder fish carry their babies gently in their mouths. The coelacanth is a rare fish, thought to have gone extinct 66 million years ago, until one was discovered alive in the twentieth century. There's always hope for the lost.

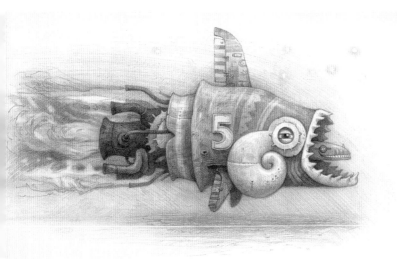

34. COUPLE

2007, pencil on paper, 20 x 30 cm

• It's always interesting to see how far a creature can be reduced to simply elements and still feel full of character and independent purpose, even some degree of romance.

35. WAX-POWERED THRONE WITH UNIDENTIFIED DEITY

2010, pencil on paper, 30 x 40 cm

• Inspired by antique dental and hairdressing chairs, as well as various pet birds.

36-37. CAGEBIRD AND OBSTETRICIAN

2006-10, pencil on paper, 30 x 40 cm

• Experimenting with internal and external forms, finding beauty in unexpected places. I spent many hours of my childhood helping my dad and older brother clean fish caught off local beaches, developing an appreciation for the refined shape, color and function of internal parts.

38. CIRCUMNAVIGATOR

2007, pencil on paper, 30 x 40 cm

• One of hundreds of drawings using light bulbs as the basis for creature personality—yet another miraculous and poetic household invention that we often take for granted.

39. BEANFINDER

2007, pencil on paper, 20 x 30 cm

• Very little needs to be done with many home appliances to give them personality: forks, taps, door handles, kettles, and other devices typically escape everyday notice but are full of imaginative possibility. I often like to examine them as if I were a confused paleontologist from the distant future. What were these weird creatures like when alive? How did these body parts function? I often think about the parallels between rapid industrialization and the Cambrian explosion, where an immense diversity of animals suddenly appeared in the fossil record. What contemporary things might eventually join that record long after we've disappeared?

40-41. BERRY OIL GECKO WITH BIG GAME

2010, pencil on paper, 30 x 40 cm

• Large strawberries recur in my sketchbooks, which probably has to do with many childhood hours spent in our backyard strawberry patch, always looking for that bright red treasure in a field of tangled green groundcover.

42. HORTICULTURAL UNIT AND CARETAKER TWIN

2010, pencil on paper, 30 x 40 cm

43. BEST FRIENDS

2007, pencil on paper, 20 x 30 cm

• Wingnuts and vacuum tubes are among my favorite objects in the world, and naturally make perfect companions.

44-45. PROUD PARENTS

2010, pencil on paper, 40 x 30 cm

• These creatures here were central to the "utopia" scene in the *The Lost Thing* film, a playground or nursery where mismatched creatures live, work, and play together harmoniously, possibly even procreating in unexpected ways—a nice metaphor for both creativity and the unpredictability of parenthood.

COMPANIONS

46. CHANCE ENCOUNTER

2010, acrylic and oil on paper, 40 x 60 cm

• A painting of the central image that inspired *The Lost Thing*: a boy finding a strange creature beached on a junk-littered shore and trying to converse with it. I've come to realize that one of the key triggers for storytelling is the unexpected or illogical reaction of one character to another. In this case, speaking in a familiar way to a thing that would normally inspire apprehension or confusion. I'm always interested in those situations where an individual responds positively to an unexpected encounter, of a kind that most others fear or avoid: an open door reveals more than a closed one.

50. SHADE

2015, pastel on paper, 50 x 60 cm

• A drawing produced during a workshop with children, resolving loose rounded shapes into unexpected forms. One of the key principles I enjoy presenting to students is that of unexpected relationships. The best narratives begin with discrepancies—scale for instance, as I commonly use—and also an unlikely familiarity with an unfamiliar object, person, or animal. I will then explore light and shadow as a way of enhancing these concepts.

51. I KNOW

2021, pastel on paper, 50 x 70 cm

• A drawing of the girl from my picture book *The Red Tree* (2001) and a creature nicknamed "tappy" that I've drawn repeatedly over the years. The shape of a common garden or laundry tap always looks like an animal's head to me, a quietly observant and sympathetic creature.

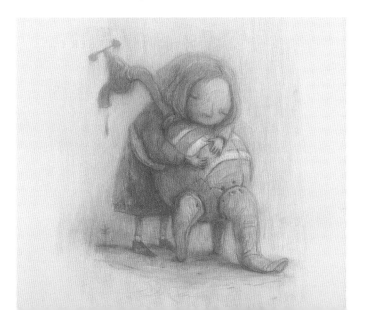

52-53. JUST DO WHAT THEY TELL YOU

2021, pastel on paper, 70 x 50 cm

• A revisited scene from *The Red Tree*, based on a claustrophobic nightmare about a weird stage performance, and more broadly, about the feeling of being confused, out of one's depth, and prone to follow the instructions of others in the absence of personal understanding. To just do as you are told, even when it doesn't make sense or feels wrong. This is something that we all experience, especially as young people, and not infrequently as adults. Interestingly, this scene has been literally adapted for the stage several times, given that *The Red Tree* has always held special appeal for theater creators, and I've always encouraged improvisation when it comes to theatrical adaptation. In 2004, I helped with the construction of some of these creatures as puppets, and I loved the resulting ambivalence, seeing them realized in their natural habitat, moving, illuminated, engaging with a real audience. Each creature seemed both benevolent and menacing, at once mentor and tormentor. How do we discriminate? What is the compass within us that directs compliance or rebellion? This is probably the central question of any fiction that enters the realm of fantasy. The guise of creatures is incidental. How we discern their nature, and thereby find our own, is the real test.

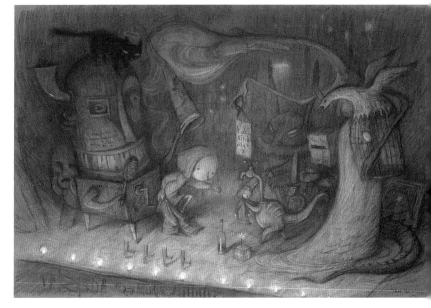

54. LITTLE FARMER

2020, colored pencil on paper, 15 x 20 cm

• A drawing inspired by pre-Columbian sculptures at the National Gallery of Victoria.

55. ERIC

2021, charcoal and pastel on paper, 50 x 70 cm

• Eric is a small foreign exchange student that comes to live with an ordinary suburban family, in a tale of cultural misunderstanding and reconciliation originally published in the anthology *Tales from Outer Suburbia*. It was based on the experience of hosting a reticent international house guest, and uncertainty over how our hospitality was being received when so little was said. Speaking the same language is not always speaking the same language, and sometimes other small actions and gestures can connect more deeply than words: growing a plant in a bottle-top, for instance.

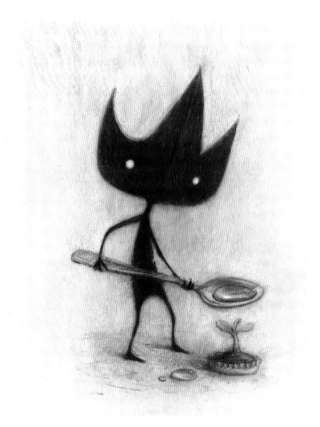

56-57. A DANGEROUS GAME

2018, pastel on paper, 70 x 50 cm

• This image draws upon early memories of playing cards with my grandparents and cousins around a kitchen table hazed by cigarette smoke, endless hands of poker late into the night for small piles of five-cent coins. All generational and cultural differences were leveled by the singular pursuit of a lucky streak, and the door would then easily open for jokes and funny stories, something for which my Anglo-Irish grandparents had a natural talent. Here the mood is far more ambiguous, drawing also on the texture of dreams, woven through as they are by danger and anxiety. My favorite detail is the distant boy visible through the window, a bit like my older brother calling out, either upping the stakes or urging, in vain, to fold and run.

58. NEVER FORGET TO BRING A GIFT

2004, pencil on paper, 20 x 30 cm

• An early sketch for *Tales from Outer Suburbia*, transmuting real childhood memories of growing up in suburban Australia into more fanciful equivalents. Here, a dreamlike illustration about feelings of longing, exclusion, and self-blame; all of which can simply be overturned with any number of title revisions (a fun experiment with any drawing). With so many daylight hours whiled away in suburban backyards, these places become the perfect stage for dreams in the dark.

59. WHY DID YOU MAKE ME THIS WAY?

2020, pencil on paper, 20 x 30 cm

• A character from an undeveloped story about two brothers building sentient companions from roadside junk, and the ethical problems that transpire when things go wrong. Although I never completed this book, elements of it came to inform the largely unnarrated series of paintings *Rules of Summer* (2013), and I still like to draw these "story orphans" from time to time.

60. THE FAVOURITE AUNT

2020, pencil on paper, 15 x 20 cm

• This figure with a voided face, like a shallow empty bowl or cave, appears in a number of my sculptures and sketchbook drawings. I always see it as a potentially friendly or benign character rather than something scary. Perhaps it's the sense of a someone ready to listen without judgment, or otherwise knowing things without the distraction of eyes or ears, sharing the same wisdom one might find in rocks, plants, and empty spaces.

61. READER *(detail)*

2010, pastel on paper, 50 x 70 cm

• One of many "sun creatures" drawn and painted over the years, the familiar motif of so many mythological tales, both old and new, in which giant beings are befriended by small human companions, whose only real power is a quick wit and an empathetic heart.

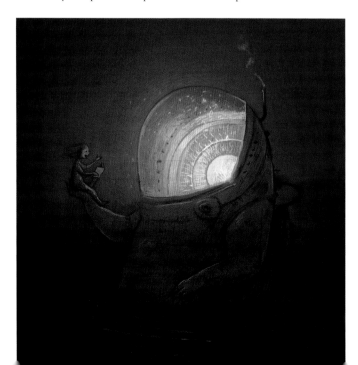

62-63. THE WAY

2020, pastel on paper, 70 x 50 cm

• Revisiting a character from *Tales from Outer Suburbia*, an old water buffalo that lives in a vacant lot and offers slow, cryptic advice for anyone patient enough to ask. The title here draws from a familiar Taoist saying, "the way that can be named is not the way," which I think also applies to creative practice. Preconceived goals can be limiting and misleading: such things often reveal themselves only after the journey commences.

64. WALKING WITH MOTHER

2017, pencil on paper, 40 x 30 cm

• Maternal figures as mythological beings with multiple limbs, that let you ride on their hair, naturally.

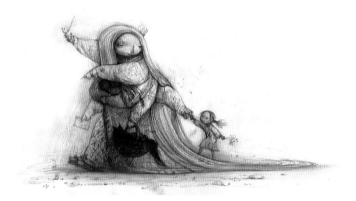

65. TALKING WITH FATHER

2017, pencil on paper, 40 x 30 cm

• Playing with the idea of a completely inert, silent mentor who is nevertheless wise and caring.

66. HOME-MADE OWL

2010, pencil on paper, 20 x 30 cm

• The concept of the home-made pet developed from a small comic I created to support an animal welfare charity, which was itself inspired by the experience of adopting an unwanted, short-sighted cat. It was a set of simple instructions: collect roadside junk, put it in a cardboard box, draw a picture of your favorite animal on the side, bury it in your backyard, whisper a few secrets and wishes. Soon enough your animal companion will emerge. The central metaphor of abandoned objects finding love persists in this and other forms throughout my sketchbooks and stories, and always comes to mind whenever I see roadside trash: objects once loved and cherished, now left to the curbside rain. Some lingering spirit always seems embedded in such junk, and these fun sketches of "home-made animals" are an attempt to recover those joyful ghosts, of finding newness in oldness, no small degree of autonomous mischief: the possibility of ongoing narrative long after the plug has been pulled.

67. HOME-MADE CHAMELEON

2010, pencil on paper, 20 x 30 cm

68-69. HOME-MADE PETS:

68. MAIL PARROT

2010, pencil on paper, 20 x 30 cm

68. TENNIS MOUSE

2010, pencil on paper, 20 x 30 cm

68. BEE-EATER

2010, pencil on paper, 20 x 30 cm

68. WOMBAT

2010, pencil on paper, 20 x 30 cm

69. CARPET SHARK

2010, pencil on paper, 20 x 30 cm

69. HOUSE CAT

2010, pencil on paper, 20 x 30 cm

69. MINI HUMAN

2010, pencil on paper, 20 x 30 cm

69. COIL SPRINGBOK

2010, pencil on paper, 20 x 30 cm

70-71. ANYTHING YOU CAN DO, I CAN DO BETTER

2015, pastel on paper, 70 x 50 cm

• Another playful illustration on the theme of artificial friends, exploring the idea of sibling rivalry, open to a light or dark interpretation. One of the defining qualities of childhood is powerlessness. Those stories in which children gain some special ability to augment reality beyond the expectations of peers—to fly, to build, to know—never fails to fascinate, appealing to some latent or not-so-latent desire to overcome that state of powerlessness, to be strong, independent, unafraid and free. This particular red-domed junk creature and the blue-green "dinosaur" are characters I've sketched on and off for many years, alongside brothers or sisters, with this in mind. They are each a manifestation of specific individual yearning that, once constructed and imbued with life, gradually spirals out of control: a wish to compete, impress, or outdo that soon corrupts into something else, and defeats the original purpose, thereby destroying the very relationship to the world that one seeks to master. The home-made creature or robot is a terrific metaphor for this, an idea that feels authentic, a false memory equivalent to some other real one.

72. NEVER BE LATE FOR A PARADE

2012, pencil on paper, 30 x 20 cm

• A preliminary drawing for the picture book *Rules of Summer*, a series of open-ended images about friendship and rivalry between two boys. This one concerns a small army of tin-toy companion animals, which grew out of my home-made pet sketches.

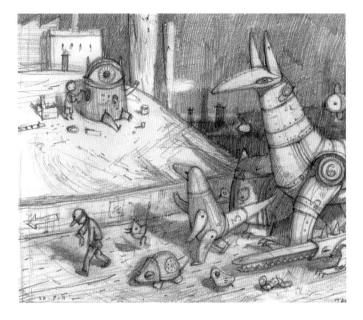

73. NEVER GIVE YOUR KEYS TO A STRANGER

2012, pencil on paper, 30 x 20 cm

• Another drawing for *Rules of Summer*. Each drawing was meant to suggest an entire self-contained chapter, left to the reader's imagination to elaborate. This scene was based on a memory of my older brother locking me out of our childhood home so as to watch TV in peace with the family cat on his lap, clearly visible through the impenetrable glass door. (Needless to say the tables were later turned, all in good fun.) Here the idea of exclusion has a more complex dimension, with unclear responsibility and a sinister edge, which I think is true of many childhood experiences. The absence of any parental figures, or indeed any other human characters besides these two boys, throughout this series of images emphasizes the private universe that exists between close friends or siblings. It's a circumstance that can be tremendously fun, but also bewildering and isolating when things go wrong.

74-75. ENEMIES

2021, pastel on paper, 70 x 50 cm

• I've been interested in the early nineteenth-century "Black Paintings" of Spanish artist Francisco Goya ever since seeing *Saturn Devouring His Son* (1819-23)—surely one of the most horrific visions ever put to paint—a print of which some troubled or inspired teacher decided should permanently adorn the wall of our high school art room. Well, it certainly left an impression, not least that art could be many things besides beautiful. This pastel drawing is inspired by my own sketchbook reiterations of another of Goya's "Black Paintings," *Fight with Cudgels* (1820-23), in which gigantic men appear to beat each other endlessly with clubs, trapped knee-deep in a desolate landscape, the intended meaning of which is uncertain and allows multiple readings. My own more frivolous version could also be about any number of possible things, including feelings of anger and entrapment, of out-scaled enmity and drama, the familiar fixtures of suburban childhood and adolescence. The landscape here is the one in which I grew up, peppered with a low sprawl of clay-tile roofs, trimmed lawns, and stasis. As kids we'd ride our bikes around quiet streets and watch the smoke of distant bushfires assume monumental forms across the expansive horizon—a silent warning, a metaphor for some other hidden trouble brewing much closer to home.

76. SECRET

2020, pencil on paper, 20 x 20 cm

• The beauty of illustration is its silence, the ability to provide a vessel for words without necessarily revealing anything of their content. This extends not only to the actions of characters, but the nature of whatever universe is presented on the page. It's all a space to be colored in by whatever thoughts are whispering at the front or back of our minds.

77. TENDER MORSELS *(detail)*

2009, acrylic and oil on paper, 46 x 68 cm

• A cover illustration for the visceral and moving novel by Margo Lanagan, *Tender Morsels*, reminiscent of the Grimm fairy tale "Snow-White and Rose-Red." The style of this painting is influenced by the work of Arthur Rackham, the prolific illustrator of fairy tales in the late nineteenth and early twentieth centuries.

78-79. MERCENARY

2018, oil on canvas, 135 x 90 cm

• I often base paintings on old found photographs, in this case of children playing in a bleak landscape (as so many children around the world do). My own vague memories of childhood play, messing around with rocks and sticks in the bush and empty building sites, often involve roiling tides of emotion, both positive and negative, and the kind of dubious moral thought experiments that parents would never understand, let alone condone. Children also observe their neighborhoods with keen intelligence, recognizing the world itself as a kind of moral experiment, or at the very least, ethically confusing. I'm reminded of anecdotal stories told by parents and grandparents, witnessing the questionable behavior of their own parents and grandparents, from Malaysian village to Australian suburb, things gone wrong and dealt with poorly, still yearning for some measure of reconciliation.

80. THE GREATEST CAT IN THE WORLD (detail)

2016, oil on canvas, 150 x 100 cm

• A painting for *Tales from the Inner City* (2018), based partly on another of Goya's "Black Paintings," a particularly mysterious image of a dog sinking into the earth or the sea. My own illustration connects to a story about a mother and child mourning the death of a cat.

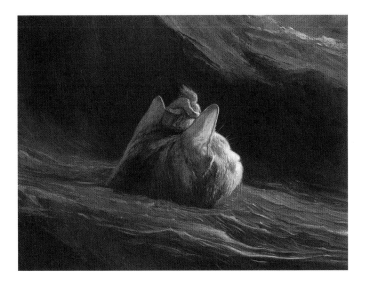

81. TELLING YOU EVERYTHING

2004, pencil on paper, 30 x 20 cm

• A drawing for an unrealized narrative about friends or siblings who can only talk openly about their inner fears and aspirations within a kind of shared dream. It was also inspired by the way that cats can deftly stride over a clutter of objects—or a suburban landscape—without disturbing anything with their footfalls. The style and feeling of this drawing later informed *Tales from Outer Suburbia* and *Rules of Summer*.

82. UNDERTOW

2007, oil on board, 20 x 20 cm

• A painting for *Tales from Outer Suburbia*, concerning a beached dugong, a sea mammal I've once seen off the coast of Western Australia. As with many stories in this collection, the subject is not so much the creature itself, but how different people react—well or poorly—to an unexpected problem.

83. NIGHT OF THE TURTLE RESCUE

2007, pencil on paper, 30 x 40 cm

• I grew up by a large pond in which my brother and I would often catch frogs and turtles before taking them home to look at them in an aquarium for a day or two, like alien abductors, and then returning them with post-traumatic stress disorder to their natural habitat. The lasting impression of these close encounters was of gentle fragility, and some sense of trespass on our part, at least on later reflection.

It's no surprise that frogs and turtles are so vulnerable to climate and other environmental change, going extinct at an alarming rate around the world. While this fact leads some to despair and resignation, for others it provokes bold action. The image here of a turtle rescue was partly inspired by a parable told to me by Haida artist Michael Nicoll Yahgulanaas, who in turn borrowed it from a Peruvian folktale. One day a huge fire engulfed a forest, and all the animals fled to the river, lamenting their inability to do anything about it. Only the hummingbird flew back and forth, ferrying drops of water in a vain attempt to quench the flames. When the other animals asked, "Hummingbird, what are you doing?" she simply replied, "I'm doing what I can." This is one of my favorite fables, particularly in suggesting that perceived success or failure is not the most important measure of true and noble action. And we never really know how that particular story ends, which draws the fable insistently into the real world.

84-85. MOTHER AND CHILD

2021, charcoal and pastel on paper, 70 x 50 cm

• The triceratops has been a dinosaur of particular fascination for me since early childhood. The first book I ever bought with my accumulated savings at the age of seven, *A Natural History of Dinosaurs* (1977) by Richard Moody, featured on its dust jacket a motherless baby triceratops menaced by a tyrannosaurus rex. I studiously traced this and all other images from the book using translucent baking paper. In fact, this may have been the one book that cemented my interest in drawing, skills honed by the eagerness to simply grasp the magic of dinosaurs. That magic remains even now, as compelling as always. I think it's rooted in the realization that something necessarily imaginary can also be absolutely real. That is, we will never know what a triceratops actually looked like, being nothing more than petrified bone and footprint, so utterly extinct—except in our human minds. Because there it continues to live and breathe, to walk, fight, love, and survive. Hence the compulsion to draw, to give life back to something that died sixty-six million years ago, and, in this case, to return a child to the protective shadow of its mother, armed against a lost and dangerous world.

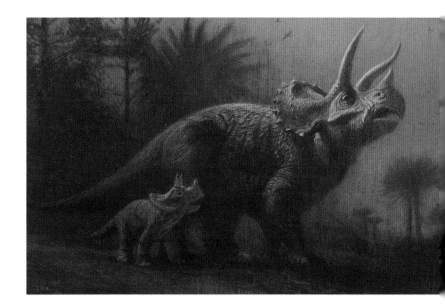

86. LOCKDOWN

2020, sketchbook page, pen and colored pencil on paper, 20 x 16 cm
• Sketched during the mid-2020 lockdowns in Melbourne, a time when so many people seemed to be out walking dogs or, depending on the soupy mist of some mornings, other things. This drawing was an attempt to capture simultaneous feelings of gloom, hope, solitude, and companionship, all under the pandemic umbrella of displaced reality.

87. ALL YOU NEED

2020, pencil and pen on paper, 20 x 15 cm
• What's better than an empty cardboard box? Another sketch from the Covid-19 pandemic and subsequent need for resourceful self-isolation.

88-89: THE MUSEUM OF ALTERNATE HISTORY

2020, pencil on paper, 20 x 30 cm
• I once saw a museum display in which a human skeleton was mixed into a crowded room of other animal bones, apparently due to a space shortage. The effect of it was to diminish any sense of significant difference between humans and other animals. That said, the strange bubble shape of the human cranium did appear odd, like a hiccup of natural history, an evolutionary blooper, and I loved this brief glimpse of alien-ness within a form so familiar—the human skull—so often loaded with symbolic meanings that we don't pause to recognize its basic animal form. Neither do we think much about its arbitrary history, as the fossil record appears to show a thing far from absolute or preordained. With any other roll of the evolutionary dice, things would have turned out very differently—and still might.

90. WALKING HOME

1998, pencil on layout paper, 20 x 26 cm
• A layout composition for *The Lost Thing* which captures all the key elements of this tale: an imposing factory wall, an absurd creature with a jaunty gait, and the nonchalant boy who leads it home, not knowing what else to do. The outlines for shadows cast on the wall by the setting sun seemed an especially important detail, as shadows often are. They not only create atmosphere, but also subtly suggest the way all objects touch and relate to their surrounds, even when not in contact.

91. THE MOTHER THING

2020, pastel and charcoal on paper, 50 x 70 cm
• A drawing related to a short comic "Here I Am" (2017), about what is perhaps the strongest bond that can exist between two people, regardless of whether they are biologically related.

92-93. THE GOOD LISTENER

2020, pencil on paper, 40 x 30 cm
• The best interspecies friendships don't need a common language. The idea of "listening creatures" is a recurring motif and seems to bridge some gap between ourselves and broader nonspeaking nature. These quiet, motionless beings are not unlike therapists, asking questions and silently fielding each response with infinite patience, something that pictures and stories can also do.

94-95. EMOTICONS

2016, pencil on paper, digitally composited, various sizes
• This library of "emoticons" was drawn for an irreverent Australian magazine, *The Stick*, printed to raise money for cancer research. The monocular creature is one that I've frequently drawn as a self-portrait, and originally appeared in the German weekly news magazine *Der Spiegel*.

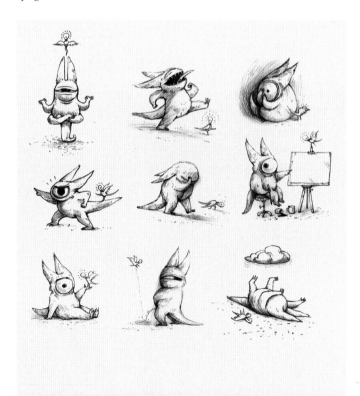

96. A GIRL AND HER CAT

2020, pencil on paper, 30 x 40 cm

97. FAMILY PORTRAIT

2018, pastel on paper, 70 x 50 cm

• An early concept sketch for the comic "Here I Am," and a good example of creatures as the perfect metaphors for a unique family group, the intricate dynamics of which could never be entirely understood by an outsider.

MYTH & METAPHOR

98. THE COG

1998-2015, pastel on paper, 50 x 70 cm

• An old sketch for *The Rabbits* (1998), revisited many years later, of a marsupial-looking animal contemplating a mechanical cog as a "rabbit" surveys the background landscape among gathering clouds. It was based on various accounts of Indigenous Australians encountering European visitors for the first time, and being given gifts such as beads, looking glasses, and British toys, things which were politely accepted but later discarded as useless.

102. FOUNDLING

2020, charcoal and pastel on paper, 50 x 70 cm

• This and the following drawings are part of an unnarrated series of personal works, a kind of post-industrial creation myth. I wondered what some future civilization, say ten thousand years from now, might make of the fragments left by our own age: what ruins, bones, and mechanical parts might explain the rise of industry, of magnificent cities, creativity and self-destruction, especially if all books and other narratives fall by the wayside, as vast libraries of paper and intangible data inevitably will. Perhaps stories in which cars grow like trilobites, factories emerge from complex viscera, buildings are sentient and machines godlike? It might not be so far from the truth, in a roundabout way. What kind of insightful meaning might come from this bizarre reconstruction, about the way things rise and fall? It all begins with the hatching of a mysterious egg, an unknown force let loose upon the world, upsetting an otherwise timeless equilibrium.

103. FUTURE EATER

2020, pastel on paper, 50 x 70 cm

• This is a creature I've drawn multiple times, with different meanings, ever since a trip to Mexico City in 2007, where I was much influenced by folk art in museums and on the streets. It's at once a happy and unhappy thing, not quite animal or machine, a voracious eater and also the producer of wonderful, outlandish ideas. It's both conscious and unconscious, a good metaphor for cultural or industrial progress. That is, as humans we have certain aspirations and intelligent foresight, but often falter when it comes to grasping the bigger picture, the

long-term consequences of our innovation, and how opportunity can quickly sour into exploitation. We know what we are doing, but we also don't know what we are doing. The title comes from an ecological history of Australia, *The Future Eaters* (1994) by Tim Flannery.

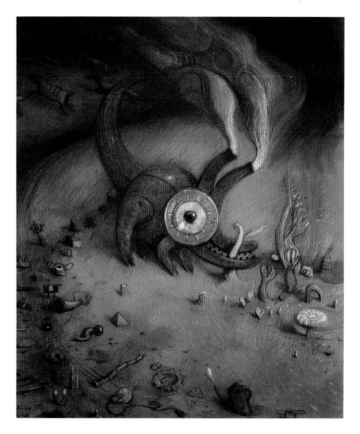

104-105. BIRTH OF COMMERCE

2018, pastel on paper, 50 x 70 cm

• This drawing was inspired by the parallels between protean life, the rise of complex organisms in the sea, and the development of human culture through trade. It's another reiteration of a "lost thing" world, where living and nonliving things might be interchangeable. Not just creatures and objects, but also ideas, words, beliefs, and feelings, those deeper and more enduring articles of commerce.

106-107. MARCH OF PROGRESS

2021, pastel on paper, 50 x 70 cm

• A parade is such a strange and universal cultural attraction: a variety of people and fanciful objects all moving in the same direction, with no particular destination or purpose other than to be seen, to exist. Perhaps a great metaphor for civilization at large. Here, as another kind of evolutionary progression or creation myth, of complex entities either cooperating or competing, guided by a common purpose even if it's nothing more than the idea of moving into the future, as dark and unknown as that might be.

108. SOWER *(after Millet)*

2020, colored pencil, brush pen, and ballpoint pen, 15 x 20 cm

• A drawing inspired by the painting *The Sower* (1850) by Jean-François Millet, which often comes to mind and has been frequently copied by other artists. This one is a very unplanned sketch, beginning with the random organic forms created by my quick marks with a brush pen, a playful exercise which retains some slight agricultural metaphor. I think what I like about Millet's original painting is the sense that the figure itself appears to have grown out of the landscape, like the knotted trunk and boughs of a tree.

109. TOWNSHIP

2020, pen and colored pencil, 20 x 20 cm

• One of a number of drawings in which landscapes are animals, and vice versa.

110-111. THE CITY RISES

2021, charcoal and pastel on paper, 50 x 70 cm

• The title is borrowed from a favorite painting of early modernism by Italian artist Umberto Boccioni, though without the optimistic Futurist attitude towards industry as savior. There's always some sense that underneath the civility and progressive ambition of great cities, both now and throughout history, there's a hidden military-industrial complex that threatens to bring it all undone, like a huge beast that moves beneath all foundations, either with or without a master plan.

112. THE SHIP

2010, acrylic and oil on paper, 40 x 60 cm

• A painting based on my original but unused cover design for *The Rabbits*, written by Australian author John Marsden, and as an experimental picture book, a pivotal project in my early career. The story concerns the arrival of colonial "rabbits", as told by native animals, neither of which are described by the author, leaving a great deal of room for conceptual illustration. Here the image of a strange ship crossing a moonlit ocean presages the arrival of unimaginable creatures from another land. The design of the ship is based on studies of eighteenth-century galleons, and the impressions they might have made upon any Indigenous Australians who had, up until that point, never seen a vessel larger than a bark canoe.

113. THE RABBITS

1998-2021, charcoal and pastel on paper, 50 x 70 cm

• This figure group—the first time in *The Rabbits* that we see invading creatures up close—is based on a painting at the National Gallery of Victoria by E. Phillips Fox, *Landing of Captain Cook at Botany Bay, 1770* (1902), a visual account of European arrival on Australian shores that is unashamedly grand in its portrayal of conquest, and skilfully represents the ideology of that age. In the original painting, dominant British figures lean into their 'discovered' land with dynamic

gestures, drawing the linear path of their own cultural history from past to future. My own creatures evolved from fairly realistic sketches of rabbits to much stranger, flattened and elongated forms, almost abstract shapes that cut scalpel-like into their surroundings without really touching them, their feet reduced to the points of a compass needle, and their faces impassive or obscured by sleeves of cloth. Mechanical parts mesh with the organic, all elements easily integrated on the membrane of paper, which then casts back an appropriately puzzling illusion.

114-115. THEY WON'T KNOW THE RIGHT WAYS

1998-2021, charcoal and pastel on paper, 50 x 70 cm

• The core of *The Rabbits* is not so much a lament about invasion and violence, but a cautionary tale against cultural misunderstanding and hubris. Without the pressures of strategic and economic imperialism, many encounters between Indigenous and non-Indigenous people— or any different religious, ethnic, gender, or ideological groups— have been amicable and mutually enlightening, driven by empathic curiosity rather than conquest. Reconciliation is partly a process of recovering that more ennobling spirit, of knowing the right ways, of learning the true meaning of respect.

116. SUBWAY

2000, pencil on paper, 20 x 30 cm

• A drawing for *Eidolon: The Journal of Australian Science Fiction and Fantasy*, where my earliest story illustrations were published from 1991. I basically cut my teeth as an illustrator, in the absence of much other formal training, by illustrating over a hundred speculative fiction stories for small press magazines for about $20 a piece and, commensurately, enjoying great creative freedom.

117. CICADA

2016, pencil on paper, 20 x 30 cm

• A concept drawing for a lowly office-worker who, after seventeen years of white-collar drudgery, experiences a liberating transformation. The story was inspired by a single flowering potted plant spotted in the window of a high-rise office tower, a nature documentary detailing the remarkable seventeen-year life cycle of some cicada species, and the notion of the "salaryman" in Japanese popular culture.

118. THE OLD COUNTRY

2002, pencil on paper, 20 x 30 cm

• An early concept drawing for what became a graphic novel about the immigrant experience, *The Arrival* (2006). Here the reptilian forms snaking over a wall of irregular openings may be taken as literal or figurative representation of some entrenched crisis. This particular drawing is not quite right: I think it's far too specific, and subsequent illustrations worked much more effectively when I obscured the creatures' heads, allowing them to become more indistinct and therefore more menacing, more open to interpretation. Since its publication in 2006, *The Arrival* has been cast as representative of refugee crises in many different countries in different years. In my own visual research, I began with images from the late nineteenth century, which I found offered enough reflective distance to expand my own imagination and understanding of what it means to be a refugee, beyond any single contemporary situation.

119. THE ARRIVAL

2005, pencil on paper, 30 x 40 cm

• A drawing for a cover illustration for *The Arrival*, and one of the key images that initiated this graphic novel: a man with a suitcase encountering an unfamiliar animal. The creature itself was based loosely on our pet parrot, as well as the frogs my brother and I used to raise from tadpoles in an aquarium. The man is a self-portrait, employing the most convenient model for a graphic novel project that spanned five years. The overall image itself is partly inspired by early European drawings of Australian fauna from the eighteenth century, as British, Dutch, and French artists were clearly startled by such "bizarre" creatures as kangaroos and duck-billed platypuses.

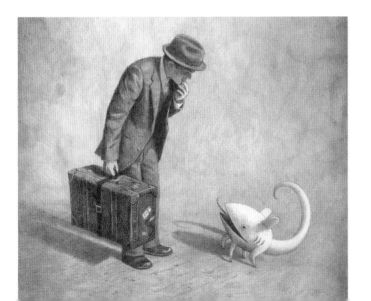

120-121. *1854*

2021, oil on canvas, 150 x 100 cm

• Since my student days I've often reimagined pictures of nineteenth-century immigrants and prospectors, considering my home state of Western Australia as a harsh "new world" for many others that came before. My brother is a geologist and as a student I would visit him at remote mine sites and paint the surrounding landscape, places that felt otherworldly for someone growing up along the suburban coast, and offering good lessons in hard, post-colonial reality. I've also had a long interest in early Chinese immigration to Western Australia, due in part to my own Chinese heritage, which was the basis for research that informed *The Arrival*. I wonder especially about the feelings of extreme physical and cultural displacement that must have been felt by so many Chinese on Australian goldfields, experiences largely unrecorded and forgotten, left to the imagination, and whatever visual metaphors might lie there.

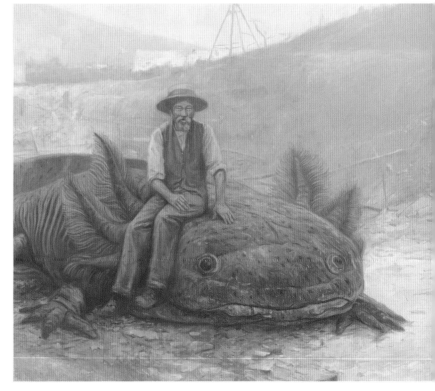

122-123. CARGO

2016, pastel on paper, 70 x 50 cm

• Originally this was a concept drawing for a large-scale, outdoor theater performance involving an enormous animatronic puppet and several human actors. For logistical reasons—none too difficult to imagine—the project never moved beyond a developmental stage. Nevertheless, the image remains a nice one to parade through the imagination on difficult days: someone peacefully gardening on the back of a giant snail as it glides down busy inner-city streets.

124. WHERE WE BURY OUR SECRETS

2014, pastel on paper, 70 x 50 cm

• This image reminds me of mines and quarries where natural landscapes are cut and reshaped, carved into sections, with some similarity to gardening as another kind of reshaping through growth. Drawing is a similar process, using charcoal and pastel, a medium I favor for lightness of touch and easy revision. Shapes are repeatedly grown, smudged and cut away to reveal some final form, some possible idea, so often a subconscious one developing from little more than a few loose charcoal strokes. In hindsight this drawing owes something to Swiss painter Arnold Böcklin's haunting *Isle of the Dead* (1880).

125. THE SOUND

2016, pastel on paper, 70 x 50 cm

• A sketch for a prospective animated project based on *Tales from Outer Suburbia*, and drawing upon memories of ominous drainage pits in the suburb where I grew up, fenced-off sinkholes where wild plants sprouted among illegally dumped appliances and spooky drainpipes. Because of suburban sprawl, the unconstrained spread of low-rise, low-density housing, there seemed to be a lot of forgotten gaps like this—empty lots, embankments, and thoroughfares nobody cared to use, "unwritten" places which have since become the basis for many stories about suburban disquiet.

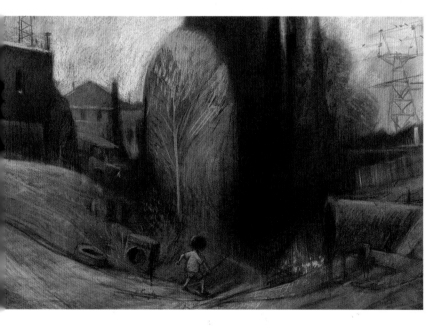

126-127. ALL WE EVER WANTED

2018, oil on canvas, 150 x 100 cm

• My early childhood memories revolve around my parents building their house brick by brick, in an outer suburb of Perth with which they had little family connection, like castaways on a sunblasted island. At the time it looked, even to my pre-school eyes, like a fairly desolate exercise: skeletal walls, piles of yellow sand, and Mum and

Dad labouring away with a cement mixer for about a century. How could it ever become a home? Of course it grew into just that, bit by bit, section by section, and sprouted the most unlikely fruits and vegetables from unpromising soil: custard apples, bananas, mangos, olives, beans, apples, all crammed together in a dense backyard. Only after laying down brushes did I think about the connection of this residential skull to memories of home, and also notice the resemblance of the two human figures, that they wear the same kind of clothes my parents wore when I was very young. I love that creativity often works this way, allowing the mind to tap certain metaphors and memories that seem always present, just not always accessible until you begin making something strange.

128. THE POISON MERCHANT

2020, pencil on paper, 30 x 40 cm

• A drawing inspired by an old wooden implement weathered beyond recognition. At one of the first local community art classes I ever attended, maybe around the age of seven or eight, our teacher asked us to draw some pears and then turn them into characters. There was an older student next to me who produced a detailed rendering of chatting heads, each with a very distinct personality, something I found profoundly impressive at the time. I often think about that student when I use a found object as a starting point for character and landscape development to get a narrative flowing. This practice also grants some artistic excuse for the compulsive habit of collecting otherwise useless knickknacks, for better or worse.

129. PILGRIMS

2020, pencil and pen on paper, 15 x 20 cm

• During initial Melbourne lockdowns in 2020 I had limited access to a painting studio and other constraints of space and time. I returned for a period to working at a smaller scale in sketchbooks, things unrelated to any larger projects, and freewheeling. The childhood impulses of drawing creatures returned in earnest, feeling very simple and unpretentious, and subsequently triggered the thought of compiling this volume of creature-related artwork. I think the appeal of small creature sketches such as this one lies in their freedom from purpose, lack of specific reference or any very measured metaphor. They are simply "taking a line for a walk," as the artist Paul Klee put it—fun, unexpected, and driven more by process than purpose.

129. SOOTHSAYER

2020, pencil and pen on paper, 15 x 20 cm

• This drawing emerged from looking at microscopic animals to find an interesting boundary between familiar and unfamiliar forms. Mouths, heads, and limbs have recognizable aspects, but are also very alien, and elicit mixed feelings of empathy and fearful distance. The space between these two states is a wonderful one to explore, and I think fertile ground for stories.

129. TANGO

2020, pencil and pen on paper, 15 x 20 cm

• If in doubt about where a creature's eyes should go, just add more of them. If uncertain about what they should do, have them dance. I'll never tire of drawing strange creatures enjoying each other's company, I think these images are a good way of representing all kinds of human desire.

129. TEACHER

2020, pencil and ballpoint pen on paper, 15 x 20 cm

• A drawing inspired by recovered footage of my Chinese grandfather, a champion fighter, demonstrating some of his martial arts moves.

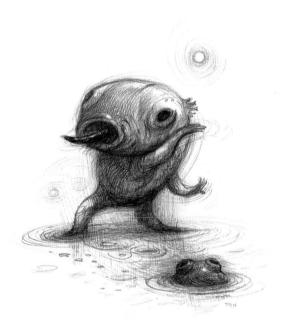

130. BLUE MOTHER

2020, colored pencil and pen on paper, 15 x 20 cm

• Parenthood is a recurring semi-conscious theme when drawing loosely in a sketchbook, a theme that may have become even more pronounced since becoming a parent myself. It could be as simple as the relationship between large and small forms (a common starting point), which to me so often implies a parent-child connection.

130. CLAY MOTHER

2020, pencil and ballpoint pen, 15 x 20 cm

• Another drawing influenced by a combination of pre-Columbian and Inuit sculpture.

130. STONE MOTHER

2020, pen on paper, 15 x 20 cm

• The work of twentieth-century sculptor Henry Moore, a modern British artist inspired by pre-Columbian sculpture and found forms in nature, has always been an influence, a modern British artist inspired by pre-Columbian sculpture and found forms in nature. One of the first big sculptures I came to know was one of Moore's reclining women, which drew some controversy from conservative Perth society when the Art Gallery of Western Australia originally acquired it for an undisclosed sum and set it outdoors in the forecourt. I was fascinated at the way it resembled those casts of tragic figures from ancient Pompeii, frozen in volcanic ash (an exhibition that came to the nearby museum), as well as old pieces of worn limestone and shells we would find at the local beach. The reclining woman was more fossil than figure, and I think that was something Moore had in mind, the human form cast as an object distorted by time, worn by an ocean of experience, reduced to an elemental remnant in bronze or stone. Image below.

130. STORY MOTHER

2020, colored pencil and pen on paper, 15 x 20 cm

• An offshoot of concepts for a project I called "aqua terrestrials," playing with the idea of sea creatures that develop above-water "diving" technology (calcium carbonate casings, shell-like gears, membranous pumps) that facilitates terrestrial research, essentially an inversion of human scuba exploration. I've always been interested in the parallels and possible exchange of organic and industrial parts, given that all technology, no matter how abstracted, ultimately draws from ideas and resources found in nature.

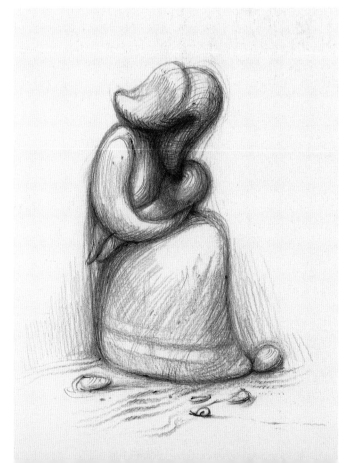

131. THEORETICAL PHYSICIST

2020, pencil on paper, 30 x 30 cm

• Looking at the sheer multitude of stars and galaxies, it's natural to speculate that there are distant intelligences out there also looking for answers, with their own systems of measurement, calculation, and theoretical discussion. We are all probably trying to access some universal truths from within the limited experience of a certain type of planet and physical body, through the sensory perception and brain of a particular animal. Maybe those truths intersect and maybe they don't. But in our separateness, at least we are remotely connected by the pursuit of a common ideal, a search for clear and wakeful knowing. It would be nice to think so, casting our academic orbit as something a little less lonely.

132-133. ELEMENTAL FORM MOVING TOWARDS A LAGOON TO BE BORN

2014, pastel on paper, 70 x 50 cm

• With the advent of digital media, I notice that very small thumbnail photos are often so indistinct and pixelated as to be incorrectly perceived. A tiny picture, blurry, poorly scaled, might look like a face, a crouching animal, a landscape, whatever the mind struggles to decipher. I've always enjoyed these kinds of misperceptions, finding shapes in clouds, stains, or scribbles for instance, and I think it's an artist's job to explore these rather than correct them as we are normally programmed to do. In this case, a photograph of a family group sitting together on a local beach was blurred to the point of zero recognition, and then reinterpreted at the easel. The result is an amorphous creature of a shape and color that I would otherwise be unable to imagine. Once blessed with new definition and background detail, it takes on a life—and universe—of its own, while still retaining some faint trace of its original reference. This exercise of willful misperception is one I find useful, an important part of imaginative painting or storytelling, a way of disrupting predictable patterns of recognition—something I think all art aspires to do to varying extents.

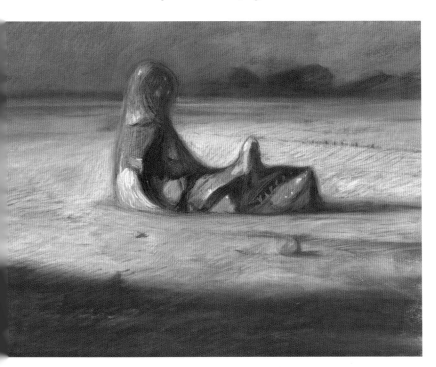

134. THE STUDENT

2008, pencil on paper, 20 x 30 cm

• A sketch for a collection of magic realist stories by Kelly Link, *Pretty Monsters* (2009). One of the problems of using animals in human contexts is that they often come loaded with unwelcome cultural symbolism, which can vary from place to place. The style and context of a drawing can hopefully loosen those associations, allowing for the creation of new, more personal interpretations.

135. THE GIFT *(detail)*

2009, acrylic and oil on paper, 36 x 56 cm

• Originally a painting for the Deutscher Jugendliteraturpreis (German Youth Literature Award), which followed from a trip to Berlin in 2009, coinciding with celebrations marking the anniversary of the Berlin Wall coming down. I was interested to learn about the significance of bananas during the Cold War: a tropical fruit symbolic of freedom and prosperity in the West, where they were in plentiful supply, while at the same time being a rare and exotic luxury in the strictly controlled East. Something of that division—and the idea of special fruit—is transferable to thoughts on literature for young readers, that things are only made accessible by the concerted effort of creative minds, of adults who devote themselves to granting children the gift of literacy and, by turns, of free and self-empowering imagination. Always in the world there will be walls going up, and always there will be writers, artists, activists, and educators working to breach them, to make "exotic fruit" available for everyone.

136-137. OLD SCHOOL

2019, colored pen and pencil, 20 x 15 cm

• A sketchbook page, that imagines educational institutions—and architecture in general—as it might appear in alternate worlds. This is a great way of thinking about those same things in the real world: how they work, what needs they fulfill, how that is expressed through arrangements of mass, space, and time.

138. PREPARATIONS

2021, pastel on paper, 50 x 70 cm

• This drawing and the related ones that follow were created at different times for no particular project, but together work as a single untitled narrative about a gang of unlikely characters embarking on a dreamlike adventure. Sometimes drawings work best without any attendant story, where the recipe of who, what, and why is left entirely to the viewer, with just a few titles offered as serving suggestions.

139. AWAY WE GO

2015, pastel on paper, 50 x 70 cm

• One thing that fascinates me about dreams is the mind's facility for unfurling landscapes and narrative scenarios procedurally, as if laying down tracks as quickly as we can turn to face them. Nothing is around

the bend, then suddenly something is, surprising to the very mind that created it. At its most fluid, drawing often takes on this quality of dreams, where new things are constantly suggested, spaces are filled by improvised history, and forms are allowed to evolve at their own subtle insistence. Pastel is a particularly good medium for this. Its lightness of touch is forgiving, provisional, and playful, always quick to delineate something novel around each bend, to switch and change according to whim.

140. THE HARPY
2021, pastel on paper, 50 x 70 cm
• The aggressive television is a character I've been drawing for many years, which I think has something to do with the alluring and dangerous distraction of junk culture.

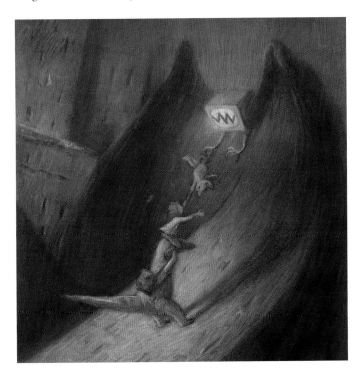

141. THE SILENT SEA
2021, pastel on paper, 50 x 70 cm
• A drawing partly inspired by a shipwreck at Half Moon Bay in Port Philip, Melbourne, and the memories of trying to avoid sticky sea anemone tentacles while wading along Western Australian shorelines.

142. THE RIDDLE
2015, pastel on paper, 50 x 70 cm
• This imaginary landscape is largely inspired by deserts and rock formations observed during long drives through Western Australia, and a little influenced by the fantastical landscapes of the fifteenth-century Dutch painter Hieronymus Bosch, whose work especially fascinated and disturbed me as a teenager.

143. THE PACIFIST
2018, pastel on paper, 50 x 70 cm
• Many of the drawings in this sequence are the product of random scribbles later translated into representational form, like the game of finding things in the shapes of clouds. I will often make very small scribbles with a ballpoint pen, only half-looking (or not at all) and see what they evoke. The Surrealists called this approach "automatic drawing," allowing the subconscious to hold sway over rational control (that's the theory at least). I think all drawing is partly "automatic": at its best: it's largely unpredictable and only ever partially planned. More often than not, accidents come first, then ideas. That is, the way a mark lands on the paper often suggests a better, more interesting direction than the original motivating thought. It's what makes drawing fun—as any six-year-old knows, being a born expert in Surrealist technique.

144. THE SOURCE OF ALL THINGS
2018, pastel on paper, 50 x 70 cm
• Another of my "face cave" creatures, here combined with the notion of European explorers searching for the source of great rivers, or in the case of Australia, a nonexistent inland sea. The deserts of Australia loom large in my imagination, as they do for many Australians, places that on the surface seem unbelievably arid and desolate, yet also hold vast reservoirs of spiritual meaning.

145. HOMEWARD
2019, pastel on paper, 50 x 70 cm
• Our heroes return from their strange journey, either to ordinary life or something else. Much of narrative painting involves trying to find a minimal way to evoke a larger story, through partial detail and framing, less "illustration" than suggestion. The most important space in a picture is the part we never see, a little beyond the curve of a grassy hill.

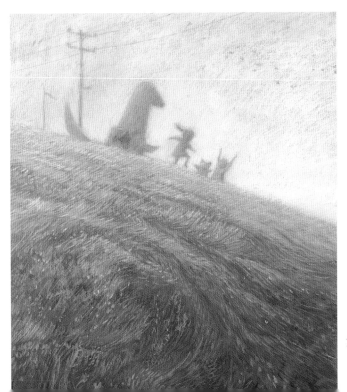

146. NEVER LEAVE A SOCK ON THE CLOTHESLINE (detail)

2012, pencil on paper, 40 x 30 cm

• A preliminary drawing for *Rules of Summer*. The central creature in this picture was originally a large dog (as there was always a dog barking menacingly behind the long fences of my childhood) but later changed to a more ambiguous threat. Somehow a rabbit makes for a more disturbing adversary, a stronger sense of something gone awry. The idea for this piece comes from my habit—very annoying I'm told, and since corrected—of leaving unpaired socks on a clothesline until their counterpart turns up, which of course it almost never does.

147. HUNGER

2012, pencil and ink on paper, 20 x 20 cm

• Another recurring creature from sketchbooks, originally inspired by a magazine photo of tribal armor in Indonesia. I've often drawn them hunting or protecting fruit, as in the book *Rules of Summer*. They no doubt have their own complex story to tell.

148. CLOUD

2013, pastel on paper, 40 x 60 cm

• From a personal series using the same featureless human head in different ways, each exploring a liminal space between landscape and portraiture. These were drawn or painted without much forethought or planning, but might be later interpreted as altered psychological states, something to do with change, persistence, time, and memory. Occasionally I return to this format as a personal exercise, using the same head-and-shoulder template as a starting point.

149. CYPRESS

2013, pastel on paper, 40 x 60 cm

150-151. HEADS:

150. BELIEF

2013, pastel on paper, 40 x 60 cm

150. LOCK

2018, pastel on paper, 50 x 70 cm

150. LENS

2013, pastel on paper, 40 x 60 cm

150. TOMB

2018, pastel on paper, 50 x 70 cm

151. FLEDGLING

2012, oil on board, 15 x 20 cm

151. EYRIE

2012, oil on board, 15 x 20 cm

151. CAVE

2013, pastel on paper, 40 x 60 cm

151. LIGHT

2012, oil on board, 15 x 20 cm

152-153. THE ROOMS

2019, graphite and colored pencil on paper, 70 x 50 cm

• A drawing for a visual narrative about the relationship between two people, illustrated as a jumble of connecting rooms containing different objects, creatures, and events, some accessible and some not. It originally evolved from prospective artwork for an indie rock band, which was never used (as often happens in the world of freelancing) but which suggested its own ongoing narrative, one I've since explored in sketchbooks over many years.

154. THE VILLAGE WEAPON

2016, oil on board, 25 x 20 cm

• I've always been attracted to images of huge pieces of machinery passing through the streets of suburbs or small residential towns, such as when a ship or refinery is under construction. Not only does the scale seem surreal, but also the sense of disrupted civil peace, especially if the objects being moved have a military undertone. I'm interested in the way that society can be complicit in the creation of horrific weapons or devastating industries while also feeling uncomfortable with them, of wishing the thing so supported, so unquestioningly taxpayer funded, did not need to exist.

155. ANOTHER WAR ALREADY LOST

2016, oil on board, 25 x 20 cm

• One of several sketches of colossal, cloud-like figures wrestling along crumbling city skylines. The context varies—here drawing on news of Syrian conflict—but the central impression remains constant: ordinary people at the mercy of violent games played by those in power.

156-157. THE LAST DEMON

2019, charcoal and pastel on paper, 70 x 50 cm

• The simplest marks can be the most suggestive—small shadows, silhouettes, and points of isolated color that invite narrative elaboration.

BIRDS

158. ENDGAME

1998, oil on plaster on plywood, 115 x 120 cm

• A favorite painting of my early twenties, the culmination of a number of sketches of local suburban streets featuring ravens. Aside from scavenging, worrying smaller birds, or fighting over territory, the ravens of suburbia always seemed involved in complex games around certain landmarks, particular old trees, and electrical transformers, something I'd only notice in the long, silent moments of drawing trees and roads. Drawing in that sense is essentially about noticing things, perhaps even more so than making marks or producing a picture; of examining in stillness the things you would normally pass by, of taking time to think about what you see.

162-163. EMPIRE

2015, acrylic and oil on canvas, 180 x 150 cm

• This painting of a red wattlebird is partly drawn from the memory of the native bird my family once rescued and rehabilitated, and the wattlebirds I see everyday in my local neighborhood, moving with swift ease through every space they claim. Here I imagine a wattlebird as a kind of ancestral spirit, something invisible to the human environment, but with a possibly more profound sense of belonging and authority.

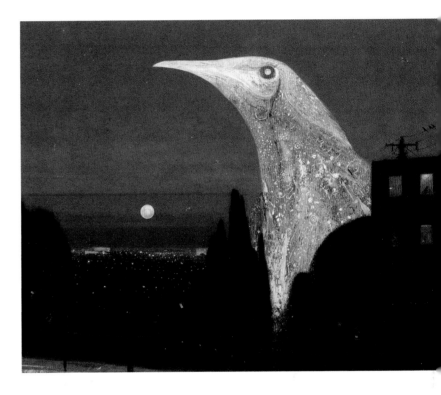

164-165. DIEGO

2021, charcoal and conte crayon on paper, 70 x 50 cm

• It's a joy to reflect that birds have more in common with dinosaurs, my other early fixation, than the small mammals that ran about their feet, our distant ancestors. I've thought about this a lot in relation to our own pet parrot of some twenty years, a sun conure called Diego (although actually female, having laid eggs some years after being named). The physical and social behaviors of humans and parrots have a lot in common: we are companionable, interested in conversation and play, stand upright on two legs with a tendency to gaze in a knowing way. Behind that façade, however, there's a mystery that only deepens with familiarity. Squawks, dances, kisses, and bites have purposes often different to any human equivalent, for which these words are all misplaced. Our parallel evolution remains just that, very much parallel, close but never intersecting. When we spend time with a bird, we appreciate a thing that will never be fully understood, which adds to its beauty.

166. TALKING ROOM

2017, pastel and pencil on paper, 13 x 20 cm

• A sketch for *Tales from the Inner City* featuring our parrot Diego.

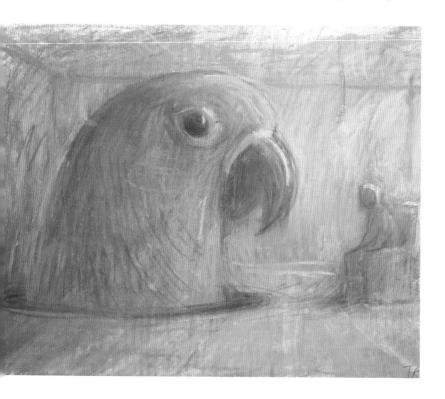

167. MENDING ROOM

2021, charcoal and pastel on paper, 70 x 50 cm

• A drawing related to *The Rooms* (pp. 152-153), and one of many sketches featuring people stitching injured birds.

168-169. BLUEBELL

2017, oil on canvas, 136 x 90 cm

• My family has kept many budgerigars as pets over the years, birds which are as intelligent and bold as they are tiny. Originally coming from arid environments, they also have a special affinity for rain, for water of any volume, which in the Australian outback signals survival and new life. As hand-raised companions they are steadfastly loyal, and those birds rescued from homelessness—as many of ours have been—would probably return the favor if only they could. Perhaps they do in many cases, at least metaphorically: I'm always drawn to stories of people in states of emotional crisis who are 'saved' by companion animals, where one act of rescue comes to be unexpectedly reciprocated.

170-171. THE QUIET TOWN

2021, oil on canvas, 136 x 90 cm

• A painting inspired by the sight of a raven gliding effortlessly between houses during an afternoon walk.

172-173. NEVER EAT THE LAST OLIVE *(detail)*

2012, pastel on linen, 85 x 75 cm

• Another preliminary work for *Rules of Summer*. This scene draws upon memories of social anxiety at formal events (painted in the year following an Academy Award presentation) as well as seeing our pet parrot narrowly escape the clutches of a falcon that once descended into our backyard. It also owes something to the perceptive drawings and paintings of lawyers by the nineteenth-century French painter Honoré Daumier.

174. HOSPITAL WITH SNOWY OWLS

2017, oil on canvas, 90 x 60 cm

• A developmental painting for a story in *Tales From the Inner City*, inspired by a visit to the Royal Children's Hospital in Melbourne, where each ward is named after a particular animal. There is something reassuringly ancient about this association, that in times of human crisis, surrounded by modern medical technology, we might turn our thoughts to some sort of animal benefactor or totem, something beyond our own biology. Given the whiteness of many hospital spaces, I thought of arctic snowy owls, quietly camouflaged in the corners of rooms and operating theaters, patiently observing with big, yellow eyes. Like medical treatment itself, which is disconcerting and frequently frightening—especially for children—these owls, for all their ominous stares and razor-sharp talons, are ultimately a reassuring presence, never leaving the patient's side, helping each to master their fear.

175. SMALL INDUSTRIAL ESTATE ON THE BACK OF A SPARROW

2015, oil on board, 20 x 15 cm

• One of a series of small paintings imagining a mythological fable about sparrows and their relationship to the urban landscape. I grew up in one of the only cities in the world without sparrows, and am always impressed to see them elsewhere, these bold and resourceful miniature citizens, with a special penchant for finding their spiritual homeland in warehouses and factories.

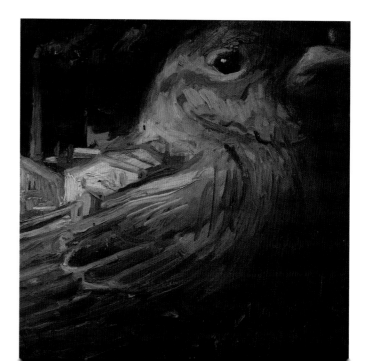

176-177. THE KINGDOM

2015, oil on canvas, 180 x 150 cm

• An ode to the sparrows of inner Melbourne suburbs, whose territorial claims seem far more extensive than our own. From the point of view of some animals, humans may be nothing more than a welcome anomaly, the fortuitous creator of nesting sites, wire perches, food, and other votive offerings. Birds may have their own ideas about who owns the landscape, and, in the longer term, are probably right.

178-179. PELICAN THINKING, LAKE MONGER

2001, acrylic, oil, and collage on board, 120 x 110 cm

• An early painting of waterbirds around an urban lake, considering the alternate perception of time and space that birds may experience. Pelicans and black swans, those very large and familiar birds of the landscape in which I grew up, have always seemed to me very sentient and wise. I often wonder what a pelican thinks about during all those hours spent preening feathers, what shape and color those thoughts might take, what things are remembered and imagined, casting backwards and forwards through time.

180. MORNING RELIGION

2015, acrylic, oil, and paper collage on canvas, 180 x 150 cm

• A reflection on meandering walks through suburban streets, pushing a toddler in a pram. Crested pigeons are a familiar sight on these walks, always moving skittishly away, out of frame, with berry-red eyes and tribal quiffs. The shifts of scale in this painting, the melding and compression of architectural elements, divisions of earth and sky built up with a collage of found paper and cardboard, have something to do with the way a passing bird might grasp our shared geography, probably quite differently from our own mental maps. We occupy each other's land whenever we pass through it, each species filling it with some sense of purpose and meaningful ritual, like superimposed transparencies that occasionally intersect when we stop, notice each other, and skitter away.

181. THE NEW WORLD

2015, acrylic and oil on canvas, 180 x 150 cm

• The bird here is a common Myna, an invasive species responsible for the decimation of other native bird populations in eastern Australia. They prefer built environments as nesting sites, and so proliferate alongside human incursions into native vegetation, sharing our "new world" with an imperial gusto that very nearly matches our own. For me this is a painting about the ambiguity of that freedom, the impressive spirit of mynas against the disquiet of a world in flux, always in a balance of life and death, of blessing and curse.

182-183. JACARANDA

2015, acrylic and oil on canvas, 180 x 150 cm

• Based on sketches from the inner Perth suburb of Mount Lawley, where I lived for some years, among rows of purple-flowering jacaranda trees. My relationship with wild magpies, as for most Australians, ranges from convivial coexistence to antagonistic terror: they are amiable and intelligent birds with a proclivity to swoop without mercy during nesting season. As a child I dreaded the coming of spring, having to go to and from school through an unavoidable tree-lined avenue of doom. But I also admired the complex relationships these flying samurai enjoyed with each other, with the land, weather, time, and space, things that may well condense into something like spiritual feeling, for want of a more expansive, non-human term. As misguided as that idea might be, I think it favorably broadens any mind to consider these kinds of possible realities, that other animals could have mystical experiences as much as many humans do, perhaps even to a greater degree. When passions cool and we observe each other in the calm shade of trees, these are not difficult things to imagine.

184. SURVIVORS

2015, acrylic, oil, and wax on canvas, 200 x 150 cm

• I grew up a few minutes from Perth's northern beaches, which at the time were long, wild stretches of seemingly limitless sea and sand, traversed by the odd seagull or two. Seagull scouts would diligently haunt any furtive land claim made by a beach towel, descending like weightless, tantrum-prone ghosts, but otherwise impeccably still, armed with hard stares that spoke of attrition, endurance, and a connection to place that would outlast any religion or fallen chip. This painting is also based on some sketches of Santa Monica from a visit some years earlier, noting the stark spatial divisions of city and beach. Like many coastlines around the world, it's vulnerable to sea level rise and other vagaries of climate change, things that gulls might also observe in their own stoic way, bred by millennia of salt and storm to know every crisis as an opportunity. When humans finally depart— one way or another—the gulls will be standing by I'm sure, watching us go, with those same hard stares.

185. WHILE YOU SLEEP

2016, acrylic and oil on canvas, 200 x 150 cm

• Almost all the streets in my home suburb were named after European explorers, reflecting a colonial mindset so entrenched it drew no notice, and this one, Cook Avenue, was a necessary route to reach anywhere of civic importance, like the supermarket or public library. I would often see ravens walking across this thoroughfare in a proprietorial way when nobody was around, which was often. The human infrastructure might grow, shift, and transform, but the ravens patrolled our dormitory suburb like the black sentinels of some other reality, one in which we barely existed, were little more than passing simian shadows. The steep road cut by a high horizon is an element I never tire of painting. To me it suggests some kind of escape, a way out, but also a sort of perceptual trick, as if there is no actual continuity beyond that point. This is an idea explored in *Tales from Outer Suburbia*, which also features ravens as ever-present "watchers," having something to say that's never said, or at least not in any language we can understand.

186. WILLY WAGTAIL

2015, oil on board, 20 x 15 cm

• One of my favorite local birds, smart, plucky, and curious, perfectly named for the tendency to swing its tail from side to side.

187. BIRD AND CAT

2016, oil on board, 20 x 15 cm

188-189. THE DEATH OF A BIRD

2015, acrylic and oil on canvas, 200 x 150 cm

• A painting developed from an observational sketch of a local cat hunting, and an overgrown camellia bush in a nearby vacant lot.

190-191. STYX

2015, acrylic and oil on canvas, 200 x 150 cm

• A painting of an abandoned public swimming pool observed in Sydney, overtaken by weeds, white ibis, and other urban birds. I imagine this scene to have mythological dimension, hence the title, recalling the ancient river between Earth and the Underworld.

193. THE CROSSING

2015, acrylic and oil on canvas, 150 x 150 cm

• A painting of a familiar inner-suburban railway crossing with an occasionally seen willy wagtail, darting with acrobatic grace when catching flying insects. For me this image is about rebirth and renewal: a monochrome bird attaining a state of momentary suspension, tilting against a clear blue sky, then falling, returning from rarefied space to the colorful jumble of earthly existence.

194. SELF-PORTRAIT WITH A PENCIL

2019, pencil on paper, digital, 20 x 30 cm

• An illustration for a revised UK edition of my sketchbook *The Bird King* (2010/2019), featuring a creature I draw from time to time as a self-portrait, usually accompanied by a small bird with a crown. This "bird king" has no specific symbolism, but carries a certain feeling of reassurance, something to do with inspiration: a flighty companion best left to settle upon you in stillness, without insistence or pressure.

220. OUR TUESDAY AFTERNOON READING GROUP

2004, acrylic and oil on paper, 40 x 60 cm

• An illustration originally produced for a newspaper's summer reading guide, later reprinted in *Tales from Outer Suburbia*. A reader once commented that this painting represents exactly how she feels when she's with her friends, in the comfortable company of oddballs and misfits. In other words, the perfect place to be.

SELECTED BIBLIOGRAPHY

1997 **THE VIEWER,** with Gary Crew, Lothian Books, Melbourne

1998 **THE RABBITS**, with John Marsden, Lothian Books, Melbourne

1999 **MEMORIAL**, with Gary Crew, Lothian Books, Melbourne

2000 **THE LOST THING**, Lothian Books, Melbourne

2001 **THE RED TREE**, Lothian Books, Melbourne

2007 **THE ARRIVAL**, Arthur A. Levine Books, New York

2009 **TALES FROM OUTER SUBURBIA**, Arthur A. Levine Books, New York

2010 **THE LOST THING** (animated film), Passion Pictures, London; Screen Australia, Sydney

2012 **SUBURBAN ODYSSEY** (exhibition catalogue), Fremantle Arts Centre, Fremantle

2013 **THE BIRD KING: AN ARTIST'S NOTEBOOK**, Arthur A. Levine Books, New York

2014 **RULES OF SUMMER**, Arthur A. Levine Books, New York

2016 **THE SINGING BONES**, Arthur A. Levine Books, New York

2016 **SOMEWHERE NOWHERE** (exhibition catalogue), Warrnambool Art Gallery, Warrnambool

2019 **CICADA**, Arthur A. Levine Books, New York

2018 **TALES FROM THE INNER CITY**, Arthur A. Levine Books, New York

2019 **THE BIRD KING** (updated edition), Walker Studio, London

2020 **ERIC**, Scholastic Press, New York

2020 **DOG**, Walker Studio, London

SELECTED EXHIBITIONS

2008 **KRAZY! The Delirious World of Anime + Comics + Video Games + Art**,
Vancouver Art Gallery (group)

2009 **Shaun Tan: Bilder & Bücher**, Museum Burg Wissem, Troisdorf, Germany

2012 **Suburban Odyssey**, Fremantle Arts Centre, Western Australia

2013 **The Lost Thing: From Book To Film**, ACMI, Australian Centre for the Moving Image, Melbourne

Shaun Tan: The Real and The Imaginary, Bendigo Art Gallery, Victoria

Rules of Summer, Brightspace Gallery, Melbourne

2014 **Rules of Summer**, State Library of Western Australia

2015 **Little Brunswick**, Tinning Street Presents, Melbourne

The Singing Bones: Sculptures Inspired by Grimm's Fairy Tales, No Vacancy, Melbourne

Go Said The Bird, 45 Downstairs, Melbourne (group)

2016 **Shaun Tan: A Surrealist Vision**, Illustration Cupboard, London

Somewhere Nowhere, Warrnambool Art Gallery, Victoria

Waking Dreams, Gympie Regional Gallery, Victoria

2016 **Every Place Is the Same Place**, Tinning Street Presents, Melbourne

The Arrival, Havremagasinet, Boden, Sweden

2017 **Radius**, Tinning Street Presents, Melbourne

2018 **Lost & Found**, Beinart Gallery, Melbourne

Shaun Tan: Lost Things, Dunkers Kulturhus, Sweden

Shaun Tan, Bror Hjorths Hus, Konsthall Märsta, Sweden

2019 **Untold Tales**, Beinart Gallery, Melbourne

Cicada, State Library of Western Australia

The Arrival, One City One Book, The Education University of Hong Kong

Rules of Summer, Art on the Move, Western Australia

2020 **The World of Shaun Tan: Welcome to Nowhere**, Chihiro Art Museum, Tokyo, Kyoto, Nagano, Yokohama, Fukuoka

Tales from the Inner City, Fremantle Arts Centre, Western Australia

2021 **Creature**, Beinart Gallery, Melbourne

Speechless: The Art of Wordless Picture Books, Eric Carle Museum, Amherst, MA (group)

ACKNOWLEDGMENTS

I acknowledge the Wurundjeri people of the Kulin nation and the Whadjuk people of the Noongar nation, the Traditional Owners of the land upon which all the work in this book was created; I give thanks and pay my respects to Elders past and present. Drawings from the chapter "Lost Things" originally appeared in the booklet **WHAT MISCELLANEOUS ABNORMALITY IS THAT?** accompanying the limited DVD release of **THE LOST THING** animated film, Madman Entertainment, 2010. *The Rooms* featured as artwork for singer-songwriter Tristan McCoppin's single "Just Maybe" (2019). A version of *The Student* appeared in **PRETTY MONSTERS** by Kelly Link, Viking USA, 2008. *Subway* was originally published in *Eidolon* magazine, Perth, 2000. *The Arrival* is a cover drawing for the graphic novel **THE ARRIVAL**, first published by Lothian Books / Hachette Australia, 2006. *Undertow*, *Night of the Turtle Rescue*, and *Our Tuesday Afternoon Reading Group* originally appeared in **TALES FROM OUTER SUBURBIA**, Allen & Unwin Australia / Templar UK / Arthur A. Levine Books, 2009. *The Gift* was commissioned by the Deutscher Jugendliteraturpreis (German Youth Literature Prize), Berlin, 2009. *Tender Morsels* was produced as a cover for the novel by Margo Lanagan, Allen & Unwin, Melbourne, 2009. *The Ship* and *Chance Encounter* featured in the omnibus **LOST AND FOUND: THREE BY SHAUN TAN**, Arthur A. Levine Books / Scholastic, 2011. *The Cog* is an editorial illustration originally commissioned by *The Sydney Morning Herald* celebrating the operatic adaptation of **THE RABBITS** by Barking Gecko Theatre and Opera Australia, Sydney, 2015. *The Greatest Cat in the World* originally appeared alongside the short story of the same title in **RICH AND RARE**, edited by Paul Collins, Ford Street Publishing, Melbourne, 2015. *Anything You Can Do I Can Do Better* was first published in **EARLY HARVEST 4**, 100 Story Building, Melbourne, 2016. *Bee-eater*, *Emoticons*, *Cargo*, *Cicada*, and *Self Portrait with a Pencil*, previously appeared in an updated edition of **THE BIRD KING**, Walker Studio, 2019. *Emoticons* were commissioned by Samuel Johnson, Lucy Freeman and Love Your Sister for **THE STICK**, Melbourne, 2016-2019. *Never Eat the Last Olive*, *Never Give Your Keys to a Stranger*, *Never Be Late for a Parade*, and *Never Leave a Sock* are preliminary sketches for the picture book **RULES OF SUMMER**, Lothian Books / Hachette UK / Arthur A. Levine Books, 2014. *Cloud* appeared as a cover illustration for Gary Crew's **STRANGE OBJECTS**, Hachette, 2015. *Eyrie* appeared as a cover illustration for Steven Paulsen's **SHADOWS ON THE WALL**, IFWG Pulblishing, 2018. *Empire* was previously published in **ANIMALS MAKE US HUMAN**, edited by Leah Kominsky and Meg Keneally, Penguin Life, Melbourne, 2020, which also features an extended version of my wattlebird story. *All We Ever Wanted* features in **TEN WORD TINY TALES** by Joseph Coelho, Walker Books UK, 2022. *Mother and Child* was originally commissioned by Melbourne Museum, with thanks to Chris Flynn, Jo Pritchard. Much appreciation to all those who commissioned, edited, art directed, and supplied permissions for these images to be reprinted here.

MANY THANKS TO Sophie Byrne, Nghiem Ta, Ben Norland, Frances Taffinder, Denise Johnstone-Burt, Non Pratt, and the Walker Studio team; Arthur Levine, Madelyn McZeal, Meghan McCullough, and the Levine Querido Team; Filomena Lauria and the Windy Hollow Books team; John Huddy, Sarah Brooks, Jeanmarie Morosin, Emma Dorph, Hachette Australia, Hachette UK, Rebecca Nash, Bonnier Books UK, Emily Clement, Scholastic Inc., US, Helen Chamberlin, Jodie Webster, Erica Wagner, and Allen & Unwin Australia, Tara Walker, Penguin Random House Canada, Julia Adams, Evan Lowenstein, Matthew Stanton, Jon and Corrine Beinart, Diego the parrot, Passion Pictures Australia, Screen Australia, Leo Baker, Tom Bryant, Splitting Image, Fitzroy Stretches, The Literature Centre, Jennifer Browne, Toppan Leefung Pte. Ltd. and my family for all their love and support.

Some Notes on This Book's Production

The text was set in Adobe Garamond Pro, designed by Robert Slimbach, recipient of the 1991 Prix Charles Peignot award, given by the Association Typographique Internationale for excellence in type design. The display type, Gill Sans, was designed by Eric Gill (1882-1940) and is based on Edward Johnston's Underground Alphabet font.
The book was printed on 157 gsm Hi-Q Matte Art
FSC™-certified paper and bound in China.

Production was supervised by Freesia Blizard
Design by Nghiem Ta
Edited by Arthur A. Levine

This is an Arthur A. Levine book
Published by Levine Querido

LEVINE QUERIDO

www. levinequerido.com • info@levinequerido.com
Levine Querido is distributed by Chronicle Books, LLC
Library of Congress Control Number: TK
ISBN: 978-1-64614-200-2
Printed and bound in China

Published October 2022
First printing

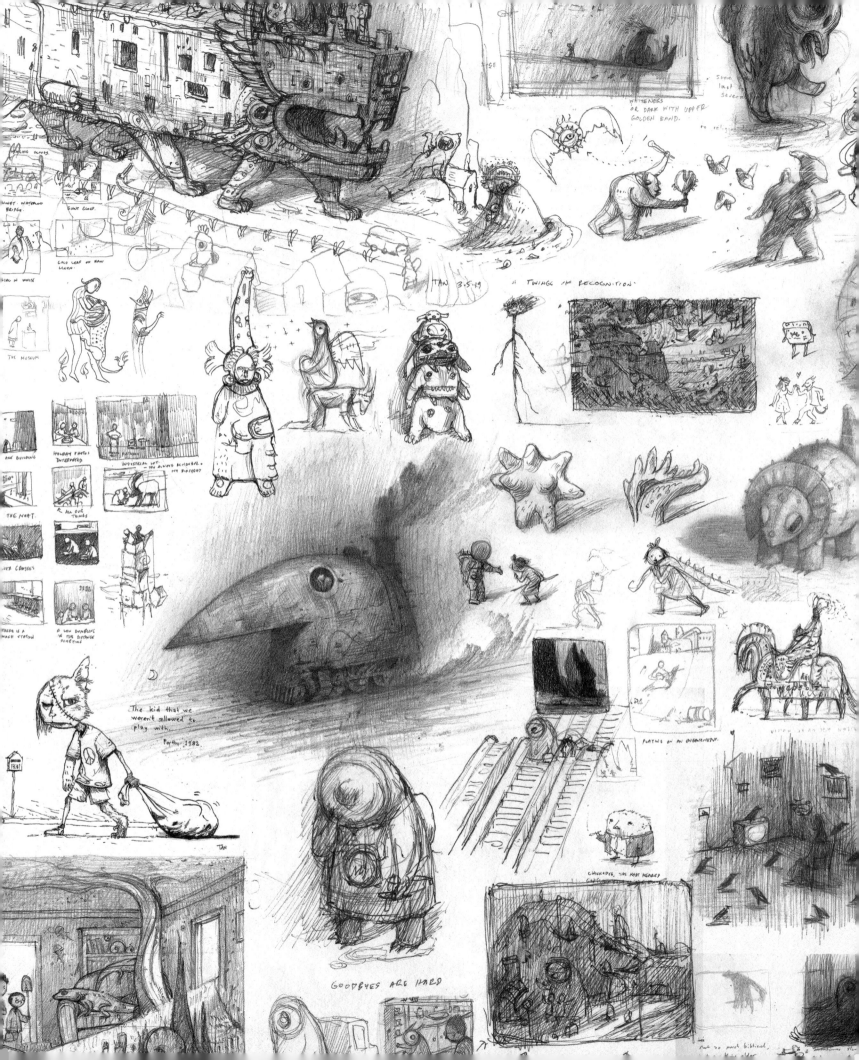

The kid that we weren't allowed to play with. *Perth, 1982*

GOODBYES ARE HARD